Van Gogh

MASTER DRAUGHTSMAN

This publication accompanies the exhibition
Van Gogh draughtsman. The masterpieces.

Van Gogh Museum, Amsterdam, 2 July 2005 – 18 September 2005
The Metropolitan Museum of Art, New York, 11 October 2005 – 31 December 2005

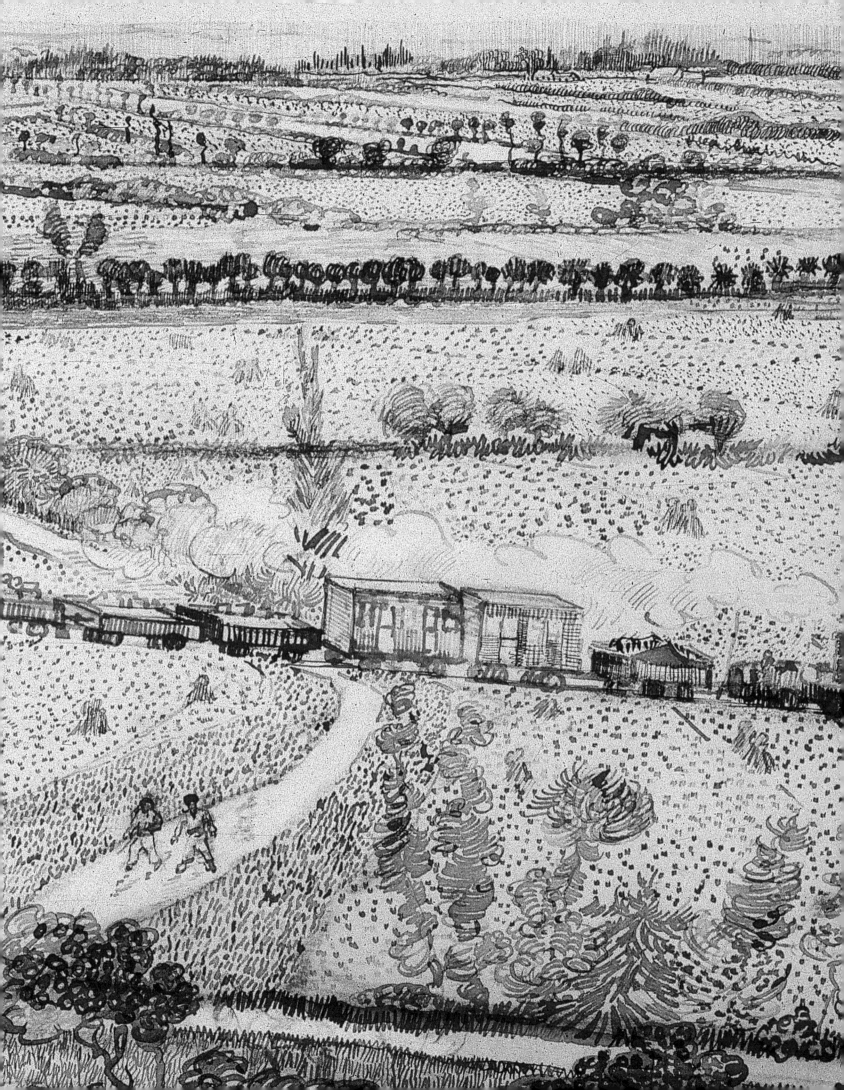

Van Gogh

MASTER DRAUGHTSMAN

SJRAAR VAN HEUGTEN

with Marije Vellekoop *and* Roelie Zwikker

HARRY N. ABRAMS, INC., PUBLISHERS

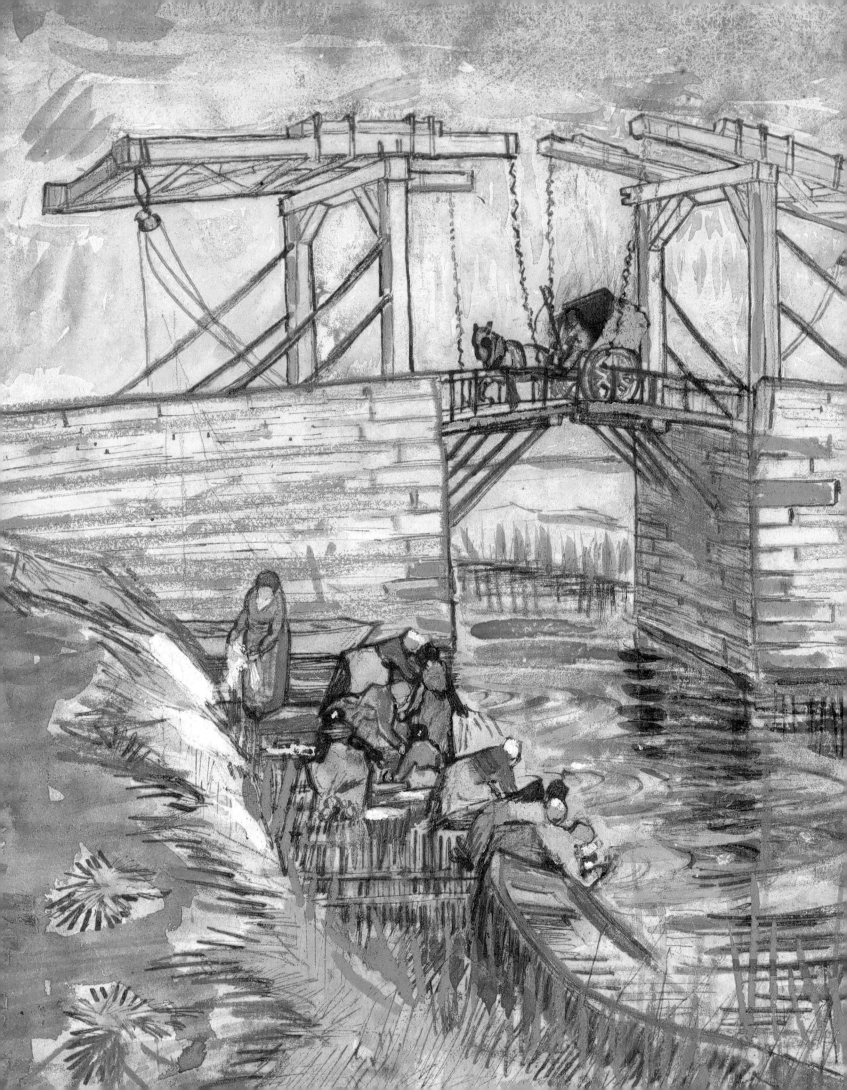

Acknowledgement

This book was written for the exhibition *Van Gogh draughtsman. The masterpieces.* I would like thank my many colleagues at the Van Gogh Museum and the Metropolitan Museum of Art who have contributed towards the realization of the exhibition, this book and the scholarly exhibition catalogue *Vincent van Gogh. The Drawings.* The catalogue and the exhibition were developed in close collaboration with Susan Alyson Stein and Colta Ives.

I would like to thank the following people for their support in the preparation of *Van Gogh draughtsman*: Marije Vellekoop, Roelie Zwikker, Chris Stolwijk, Aukje Vergeest, Monique Hageman, Patricia Schuil, Suzanne Bogman, Ellen Jansen, Jantien Luttikhuizen, Aggie Langedijk, Michael Raeburn and the staff of Tijdsbeeld & Pièce Montée in Ghent and Mercatorfonds in Brussels.

SJRAAR VAN HEUGTEN, *Head of Collections, Van Gogh Museum*

Foreword

Vincent van Gogh is best known for his work as a painter. Most people will associate him with his extraordinary talent for colour and his ability to create unforgettable compositions in oil paint thickly worked on canvas. The fame of his painted oeuvre has long overshadowed his work as a draughtsman. Yet Van Gogh made many more works on paper than on canvas. Indeed, before he even picked up a brush he was determined to master the basics of manipulating pencil, crayon or pen on paper. And his emergence as a draughtsman is every bit as fascinating and as dramatic as his parallel development as a painter in oils.

This book offers a rare chance to encounter a side of Van Gogh's art that still remains unfamiliar and underappreciated. Illustrated with some of his finest drawings, the text explains how draughtsmanship became an essential part of Van Gogh's artistic activity. From his first hesitant experiments in hybrid techniques through to the breathtaking power of his later compositions in reed pen and ink, drawing was much more than just a medium in which to study, practise and prepare for his paintings. The energy and vibrancy of his graphic style fed into his paintings. In turn, his drawings were informed by the brilliance and luminosity of his paintings. Many of his drawings were intended as works of art in their own right, and at their best they surely count among his finest creations as an artist.

The impetus for this publication came from a joint exhibition project of the Van Gogh Museum in Amsterdam and the Metropolitan Museum of Art in New York in 2005. The author, Sjraar van Heugten, is one of the world's foremost experts on Van Gogh and has spent many years studying and cataloguing the drawings collection in the Van Gogh Museum. The museum now holds the largest collection of works on paper by Van Gogh anywhere in the world, amounting to roughly half of his surviving drawings. These remained in possession of the artist's family and were passed to the present owners, the Vincent van Gogh Foundation, on permanent loan to the Van Gogh Museum. We can be grateful that so many of these fragile and potentially vulnerable works have survived. For reasons of conservation they can rarely be shown in public. Based on the detailed study of the Van Gogh Museum collection as well as works in public and private collections all over the world, this publication allows the reader to view reproductions of the very best of Van Gogh's drawings and to understand why they were made. By following his techniques and processes in drawing we can come ever closer to the artist, and we can recreate something of the extraordinary energy and vitality that underlies all his work.

JOHN LEIGHTON, *Director, Van Gogh Museum*

1880–1881

Borinage, Brussels, Etten

The early years

WHEN VAN GOGH STARTED DRAWING in 1880, at the age of twenty-seven, to embark upon an artistic career, there was little to suggest that this might become successful. He had already done some drawing in his younger years, but the only result had been a few reasonably well-executed landscapes and unpretentious townscapes (ill.1). Unlike Henri de Toulouse-Lautrec and Pablo Picasso, who were already gifted draughtsmen in their youth, Van Gogh had to master the techniques of drawing the hard way: through trial and error.

Up until that time his working life had been unsettled. In 1876, he made a far from glorious exit from the established art firm Goupil & Cie., after having worked there as a dealer for several years. After this, he was to fail as a teacher and book salesman, and his attempt to study theology ended disastrously. The final straw came when the authorities decided not to prolong his temporary appointment as a preacher in the Borinage in Belgium. By 1879 Van Gogh was at his wit's end; and his family, too, had completely run out of career advice to give him. His brother Theo proposed occupations as varied as working as a lithographer, a bookkeeper or a carpenter's apprentice, and Vincent was shocked when his sister Anna suggested he should become a baker.

Eventually it was Theo who gave him the idea of training to become an artist, undoubtedly in response to his brother's nostalgia for 'the land of paintings'. Vincent's initial reaction to his brother's idea was incomprehension, as he reminded him some years later when writing to him from The Hague: 'I remember quite well, now that you write about it, that at the time when you spoke of my becoming a painter, I thought it very impractical and would not hear of it.' [213/184]

Despite his reservations, Van Gogh, who at that point was still living in the Borinage, made a serious start. He did not have the benefit of a teacher

1
Canal
autumn 1872–spring 1873
25 x 26 cm
Van Gogh Museum,
Amsterdam

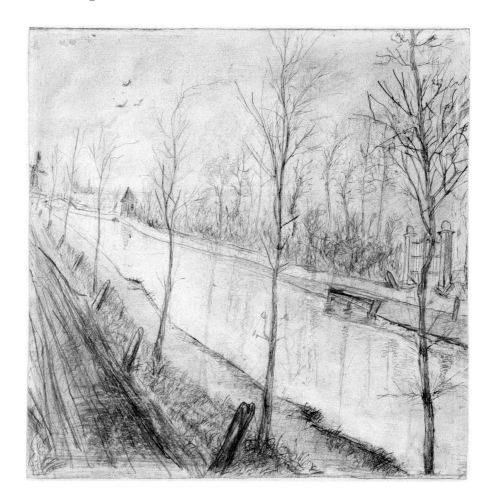

2
Miners in the snow
September 1880
44 x 56 cm
Kröller-Müller
Museum,
Otterlo

to convey the basic principles of draughtsmanship and help him overcome his initial anxieties, so he had to resort to learning from textbooks. This method quickly gave his self-confidence a boost, and he wrote in retrospect: 'What made me stop doubting was reading a clear book on perspective, Cassagne's Guide de l'ABC du dessin; and a week later I drew the interior of a kitchen with stove, chair, table and window – in their places and on their legs – whereas before it had seemed to me that getting depth and the right perspective into a drawing was witchcraft or pure chance.' [213/184]

In the early years of his career the instruction manuals written by Armand Cassagne (1823–1907) continued to be indispensable for Van Gogh. Cassagne had little success as a landscape painter, draughtsman and lithographer, but his publications went through several editions, because he had a talent for representing and describing difficult concepts such as perspective and proportion in a simple, lucid way. At any rate, Van Gogh read his *Guide de l'alphabet du dessin* (the actual title of the book he refers to in his letter), as an introduction to these subjects. Later on, he studied a few more profound dissertations by the same author. He was also helped by Hermanus Gijsbertus Tersteeg (1845–1927), his former manager at the Hague branch of the art dealers Goupil & Cie., who sent him two textbooks. One of these dealt with perspective, while the other was probably *Esquisses anatomiques à l'usage des artistes* by John Marshall; at least he later had this comprehensive manual on human anatomy in his possession in Brussels. [159/138]

He also designed a study programme for himself, which included copying examples of drawings and graphic works by well-known masters.

3
The bearers of the burden
beginning 1881
43 x 60 cm
Kröller-Müller
Museum,
Otterlo

Clearly he was familiar with contemporary academic art courses, in which these activities played an important part. In the first category, he received from Tersteeg two portfolios with exercises composed by Charles Bargue: the *Exercices au fusain*, examples of diagrammatically rendered nude models that were meant to be copied in charcoal (*fusain*); and the *Cours de dessin*, which provided examples of drawings after compositions by the great masters. To help him practise, Theo also gave him prints after work by Jean-François Millet (1814–1875), whom he greatly admired.

From his correspondence, it is clear that Van Gogh made scores of full-sized copies of Bargue's work. This meant that he used quite a large format, and he became so accustomed to this that he continued to use it later for drawing from life. None of his copies has survived, because he destroyed them when his artistic skills improved. In his first few months of practice Van Gogh also made a few independent drawings, of which only one is known through a sketch of it in a letter: a rather crude depiction of miners in the snow (ill. 2).

The systematic way in which Van Gogh approached studying is characteristic of his ten-year career. Generally speaking, he is thought of as a spontaneous artist, who worked intuitively and who was averse to rigid rules and thorough preparation. The expressive power of his work and the fluent style of his drawn and painted oeuvre support this view, and in his letters too he often comes across as a sensitive, impulsive, and sometimes intractable, man. However, as an artist Van Gogh always worked in an organized way and never stopped studying seriously, without this in any way affecting his inventiveness and tendency to experiment.

BRUSSELS 1880–1881: EXPLORING NEW POSSIBILITIES In order to develop his talents further, Van Gogh moved in October 1880 to Brussels, a town with a rich artistic tradition where many artists lived and worked. Thanks to Theo, he became acquainted with the well-known Dutch landscape painter Willem Roelofs (1822–1897), who advised him to work more often after nature. What Roelofs meant was that he should give up copying graphic works and drawings and start to work from three-dimensional originals: plaster casts and living models. In response to this, Van Gogh enrolled in the free course at the Brussels Art Academy for drawing after models from Antiquity. It seems unlikely that he ever attended the classes, since no corresponding work has ever been found, nor did he mention it in his letters. He did, however, soldier on with his textbook studies, even though he found the material dreadfully boring, for he realized that a solid foundation was essential if he were to become a successful artist.

Above all, Brussels boosted his morale: here he was in a truly artistic and stimulating environment, with both refined artists like Roelofs who could offer him good advice and young artists with whom he could share

his enthusiasm. One of the latter was Anthon van Rappard (1858–1892), who had already been an art student for four years and from whom Van Gogh was able to learn a great deal. The two of them were almost the same age and became firm friends; they also greatly influenced one another's working methods and artistic points of view.

During his time in Brussels Van Gogh tried to make drawings with more character, but he did not altogether succeed. His subjects were bound to the social-realist art he so greatly admired, but he tended to depict things in an awkward, rigid way. One surprising highlight from this period is the pen-and-ink drawing *The bearers of the burden* (ill. 3), in which the labouring figures with their sacks of pit coal are quite successfully executed, while the composition of the partly industrial landscape is excellent.

ASPECTS OF PEASANT LIFE AND FIRST LANDSCAPES In April 1881, Van Gogh moved in with his parents in Etten, in North Brabant. Although he did not entirely abandon his practice of copying, he concentrated mainly on motifs based on nature. It was easy to find subjects in the rustic surroundings where he was living, and he could also draw the local peasantry. As a boy growing up in Zundert, in another part of Brabant, he had developed a deep love of the countryside, which also determined his preference for work by artists like Millet and Jules Dupré (1811–1889). His admiration for painters of this kind verged on idolization, and Millet in particular was later to become his spiritual and artistic guide. He wanted to follow in their footsteps by becoming a painter of peasant life.

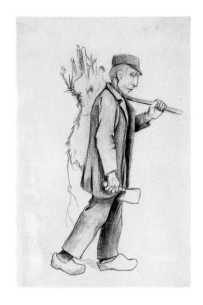

4
*Man with
a sack of wood*
autumn 1881
61 x 42 cm
Van Gogh Museum,
Amsterdam

5
Boy with a sickle
end October–beginning
November 1881
47 x 61 cm
Kröller-Müller
Museum,
Otterlo

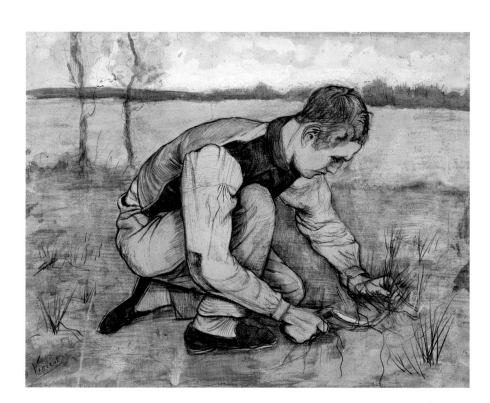

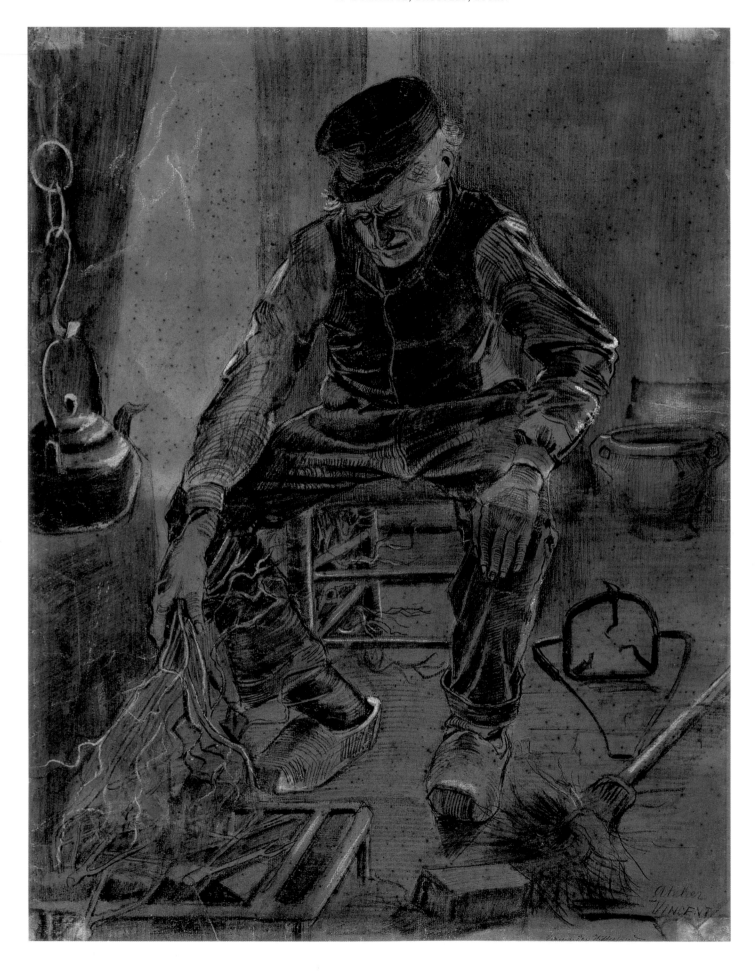

Van Gogh had no trouble finding models in Etten and made scores of studies, many of them in a large format. Their quality varies, but they clearly show that he was making progress. To make things easier for himself, Van Gogh tended to show his figures from the side to avoid problems of perspective, such as the foreshortening of arms (ill. 4). But at the same time he did not hesitate to ask his models to take on complicated poses that made considerable demands on his skills, as in his drawing of the young gardener who worked for the Van Goghs, Piet Kaufmann, who is shown cutting the grass with a small sickle, crouching on one leg and kneeling on the other (ill. 5).

Occasionally he would hazard an attempt at a more complex view of a model. Without doubt the finest example of this is the man throwing dry twigs onto a fire (ill. 6). The figure is rendered in a very convincing way, not just from the front, but at a slight angle from above, a *tour de force* in which Van Gogh was completely successful. Not only are the proportions convincingly rendered, but the artist has also managed to give the man and the simple interior an expression of weariness and frugality.

Van Gogh made several interior scenes with figures in Etten, including a few exceptionally well-observed women occupied with their household chores (ill. 7). It was here too that he first drew a subject characteristic of his early work: a sorrowful figure next to an extinguished fire, cradling his care-worn head in his hands (ill. 8). He gave the drawing the forthright English title 'Worn out', making an association with the mainly English tradition of imagery in which scenes from daily life were given a meaningful, sometimes dramatic title. This first version was ambitious in theme and carefully

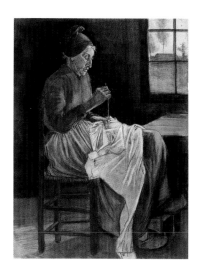

‹ 6
*Old man putting
dry twigs on the fire*
November 1881
56 x 45 cm
Kröller-Müller
Museum,
Otterlo

7
Woman sewing
end 1881
62 x 47 cm
Kröller-Müller
Museum,
Otterlo

8
Worn out
summer 1881
23 x 31 cm
P. and N. de Boer
Foundation,
Amsterdam

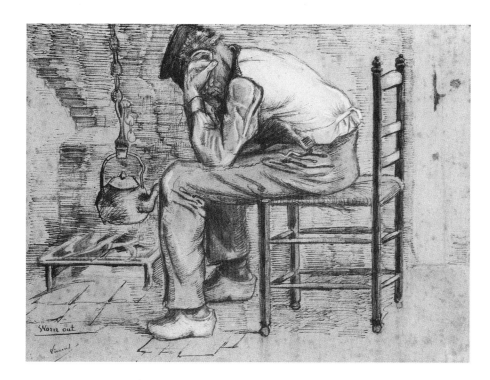

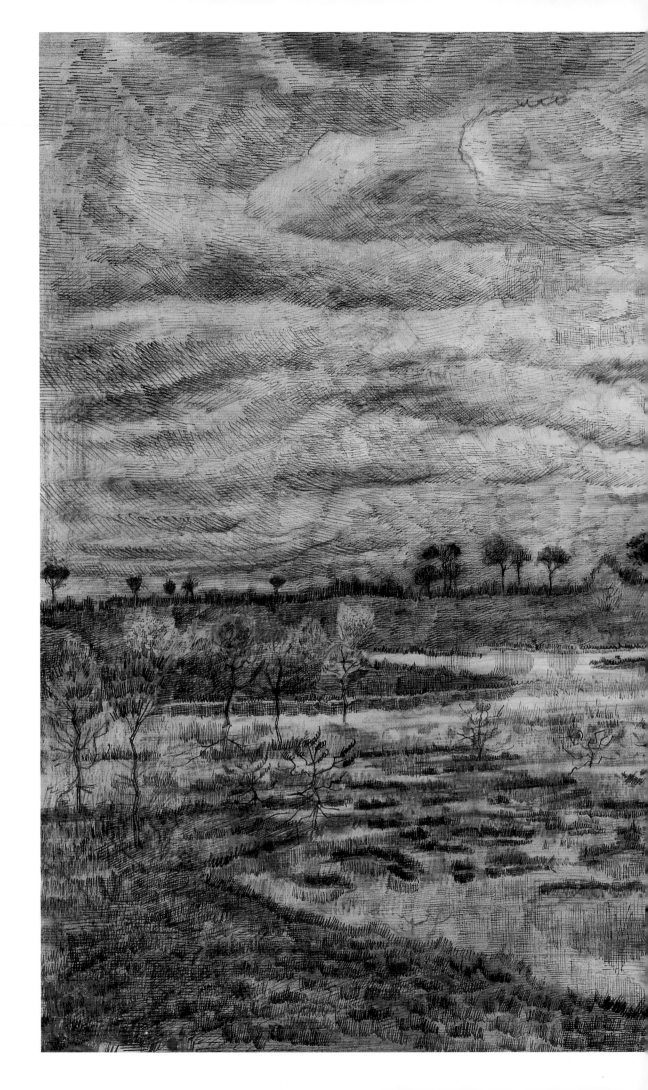

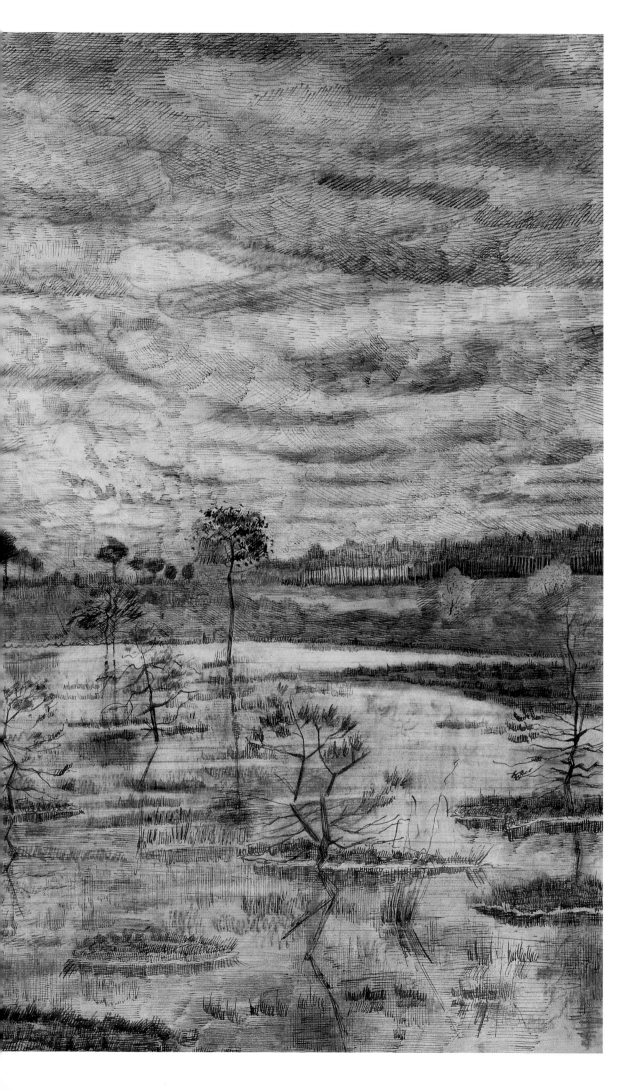

9
A marsh
June 1881
47 x 59 cm
National Gallery
of Canada,
Ottawa

detailed, and Van Gogh intimated in his letters that he was very attached to it. The drawing represented the change of course he wanted his artistic career to take. In comparison to the detachment of the man throwing wood onto his fire, the message here seems somewhat exaggerated, while the proportions of the sorrowful figure, whose upper legs are much too long, are awkward.

The country setting of the village was an invitation for him to make his first landscapes, a genre in which he was to excel in his later French work. These earliest explorations show his natural genius for finding simple but convincing subjects, portrayed in refined compositions. A pen-and-ink drawing of a marsh is an eloquent example of this (ill. 9). Here he was exploiting his skill with the pen, but he could also capture landscape characteristics flawlessly using other techniques, as can be seen in the elongated picture of the Weeskinderendijk windmills in Dordrecht (ill. 10). He had seen the windmills from the train when he was on his way to visit his cousin (by marriage) Anton Mauve for a few days in August 1881. On the way back he got off the train to make a record of this typically Dutch scene.

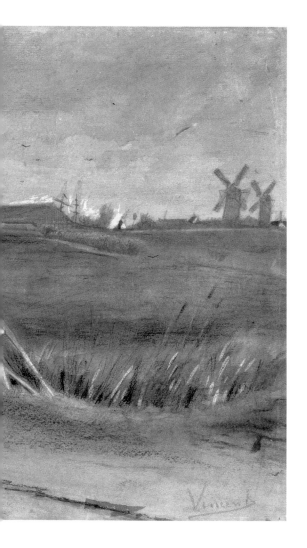

AT MAUVE'S Anton Mauve (1838–1888) was one of the most outstanding painters of the Hague School and very gifted in the techniques of both drawing and painting. It is understandable that Van Gogh had selected him as a tutor to give a stimulus to his art. The short visit mentioned earlier was a first investigation and had provided him with important new insights. At his own request, Van Gogh worked for three weeks at Mauve's studio from the end of November to the middle of December 1881. It was hard work, painting during the day and drawing in the evening. Painting was new to Van Gogh, but even while drawing he discovered things that had been virtually unknown to him up to that point. Van Gogh had already made watercolour drawings, but it was Mauve, a brilliant watercolourist himself, who taught him the rudiments of this technique. This resulted in several large watercolours and a number of smaller works, described by Van Gogh as 'scribbles' [190/163]. Although they were well executed and done in a large format, they were studies made in order to learn how to master a technique. In their subject matter – women doing their sewing – and in their composition there is no doubt that they were kept intentionally simple, as Van Gogh was trying to master the basic principles of his craft. Mauve pointed out to him that he was studying his models at too close quarters, which meant that he was not capable of assessing the proportions properly. When working in Etten, Van Gogh had been inclined to put in details when doing clothing, faces, hands and the like, but after three weeks with Mauve (and thanks to the lessons he was to get after he went to live in The Hague at the end of December 1881) he realized that too much detail detracted from the principal motif, so he often attempted to give a more generalized view.

10
Windmills at Dordrecht
August 1881
26 x 60 cm
Kröller-Müller
Museum,
Otterlo

1881–1883
The Hague and Drenthe
Townscapes and popular characters

AN ESCALATING CONFLICT WITH HIS PARENTS and the appeal of The Hague, with its many artists, led to Van Gogh's decision to move there at the end of 1881. He knew the town well, having worked at the Hague branch of the art dealers Goupil & Cie. for four years, and he also knew that it offered him ample opportunity to develop his talents further. He wanted to concentrate in particular on drawing after live models. Quite unexpectedly, he was presented with the ideal opportunity when he met Sien Hoornik, with whom he soon set up house. She and her family regularly posed for Van Gogh in The Hague.

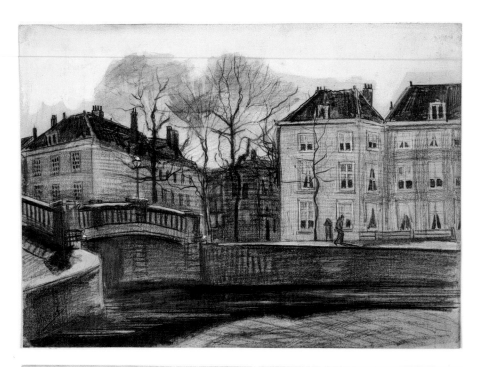

11
*Bridge and houses
on the corner of Herengracht
and Prinsessegracht,
The Hague*
March 1882
24 x 34 cm
Van Gogh Museum,
Amsterdam

12
*Entrance to
the Pawn Bank,
The Hague*
March 1882
24 x 34 cm
Van Gogh Museum,
Amsterdam

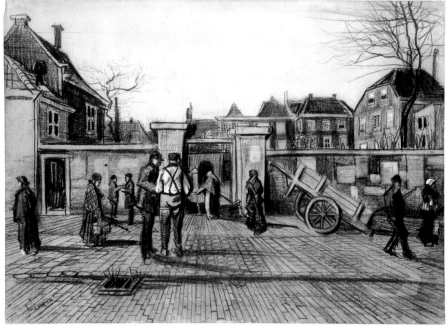

Van Gogh started on his study of models as he had intended, but townscapes were soon to make great demands on his time. In the second week of March 1882, his uncle, the Amsterdam art dealer Cornelis Marinus van Gogh, had visited him at his studio and commissioned him to make twelve townscapes. Van Gogh's price for the works, 'either in pencil or pen', was ƒ 2,50 each, and his uncle promised that if they turned out well, he would ask him to make another twelve and would pay a little more for them [210/181]. Van Gogh began immediately and was able to tell Theo two weeks later that the series was finished. Uncle Cor evidently liked them, because he gave his nephew a new order for six more detailed Hague views, which were completed in May.

The townscape was to become one of the permanent genres in Van
Gogh's oeuvre, but it is striking that only on rare occasions did he depict
the most obvious sights of the towns in which he was staying. This was also
true for the drawings he made for his uncle. A view of the bridge and houses
on the corner where the Herengracht and the Prinsessegracht meet could
just about be considered to represent the old quarter of The Hague, but even
here he did not exploit the picturesque character of the town (ill. 11). Van
Gogh preferred to show the modern aspect of the city, as in his depiction
of a group of people waiting at the *Entrance to the Pawn Bank* (a state-
controlled bank that offered loans without charging a high rate of interest)
(ill. 12). He also chose gas tanks, a deserted park with houses and an equally
unappealing railway station as subjects for the series. With this un-
emotional portrayal of urban views Van Gogh was in tune with contempo-
rary 'realist' literature, but there is a more prosaic explanation too: for him
the drawings were also studies in perspective, attempts to solve artistic
problems of a technical nature, and this motivation affected the character
of the works.

The second series commissioned by uncle Cor, which consists of larger,
more detailed drawings, has, understandably, more appeal than the first.
In a few of the drawings Van Gogh's potential as a draughtsman becomes
clearly visible. In his view of a nursery garden (ill. 13) and in another over-
looking a carpenter's yard and the laundry of the artist's neighbour (ill. 14)
there is originality and daring in the compositions, and Van Gogh seems

13
*Nursery garden
on the Schenkweg*
April 1882
30 x 58 cm
The Metropolitan
Museum of Art,
New York

>> 14
Carpenter's yard
April 1882
28 x 47 cm
Kröller-Müller
Museum,
Otterlo

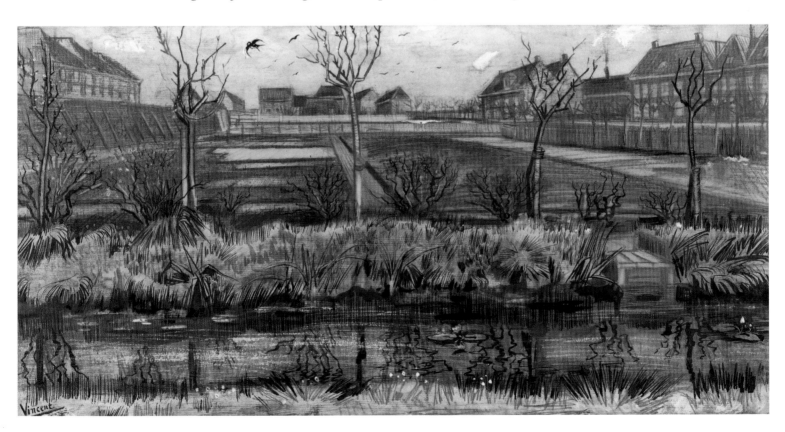

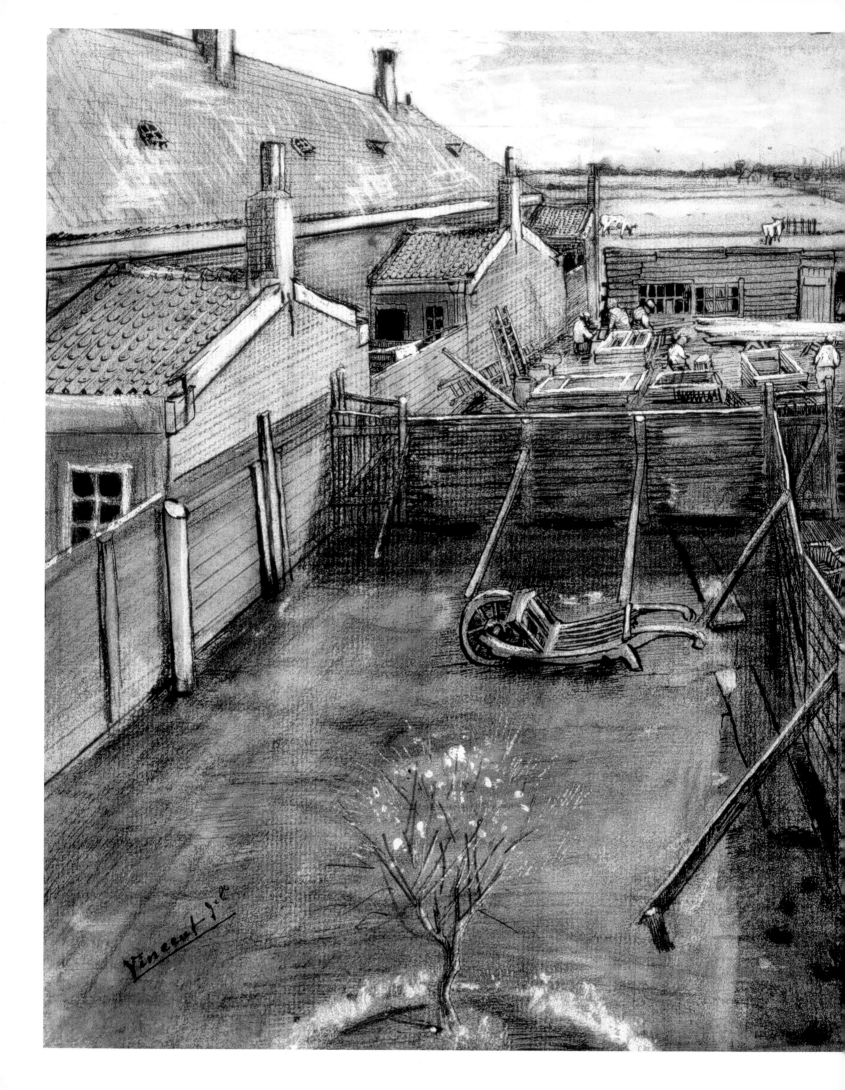

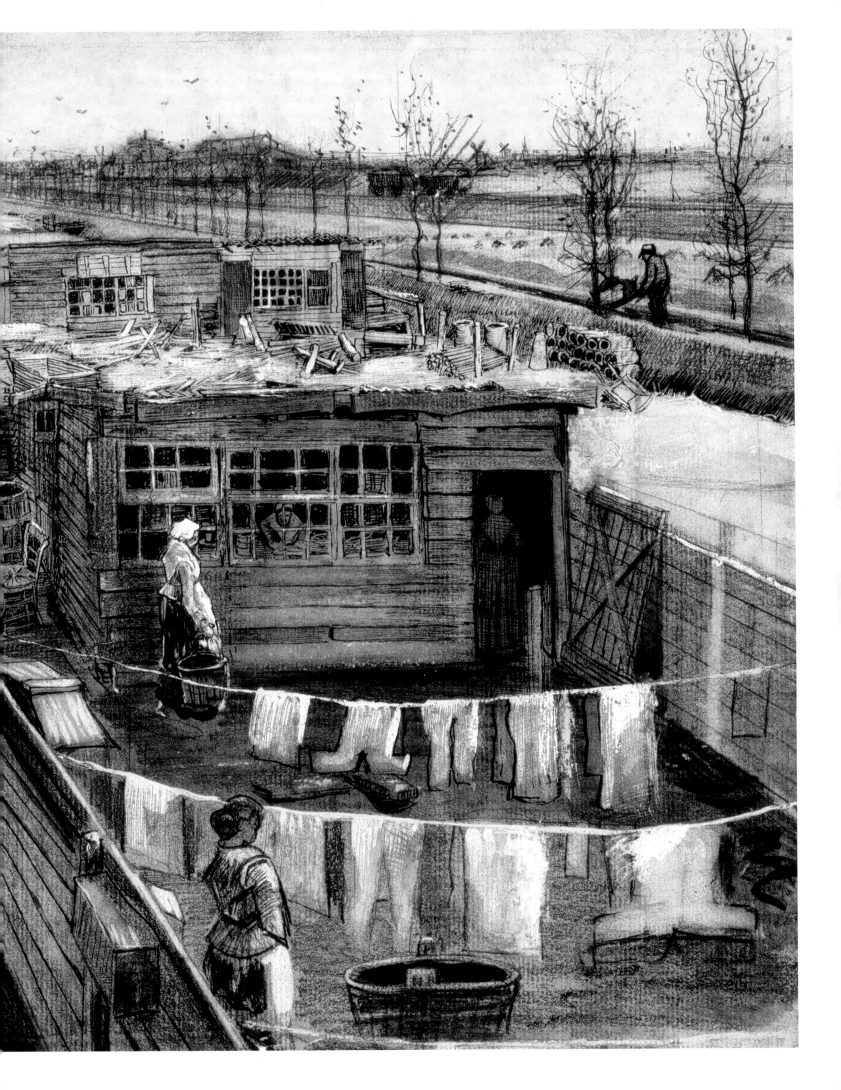

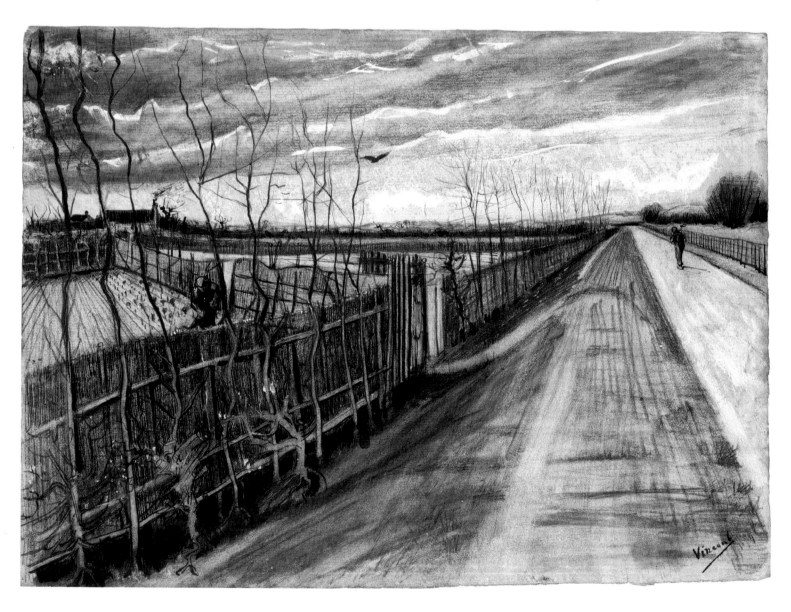

to be challenging the spectator by presenting so many different pictorial elements to capture his attention.

EXERCISES IN PERSPECTIVE AND PROPORTION In the end, Van Gogh did not find the tutor he had hoped for in Mauve. Their relationship came to an abrupt end at the beginning of 1882, partly due to Mauve's disapproval of Van Gogh's domestic relations: his living with Sien, an unmarried mother and former prostitute. Van Gogh learnt a certain amount from his artist colleagues in The Hague, including the young George Hendrik Breitner (1857–1923) and the well-established painter Johannes Hendrik Weissenbruch (1824–1903), but he relied mainly on self-education.

With the help of his textbooks Van Gogh was able to master perspective. This enabled him to depict a row of trees quite effectively, as can be seen in the charming view *Country road* (ill.16), executed with a little help from Cassagne (ill.15). But he did not feel competent enough to draw

The perspective frame The perspective frame works on a simple principle: threads are drawn across the inside of a frame (attached to one or two supports) in a set pattern: for instance, a square grid made up of horizontal and vertical threads; or, alternatively, one vertical, one horizontal and two diagonal threads that intersect in the middle (ill. 17). This same pattern in the correct proportion – sized up or sized down – is copied onto a sheet of paper or a canvas. The artist places the frame between himself and the subject, enabling him to estimate depth and proportions quite easily. Nevertheless, it is essential for him to keep his eyes in the same position in relation to the frame and the subject. This can be done more easily with a pattern of four lines that intersect in the middle – because that point is the immediate focus – than with a square grid with its many intersecting threads. In The Hague, however, Van Gogh used only the latter type, as can be seen in the many traces of square grids still visible on drawings from the period. Strangely enough, in the letters he wrote at the time there are references only to the first type (ill. 18), which he was to use frequently when he was working in France.

 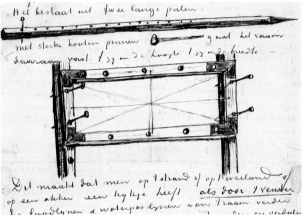

from nature, because he could not always estimate the depth and proportions correctly. To help him with this, he used an instrument that he had discovered in his textbooks: the perspective frame. He knew that the great German artist Albrecht Dürer (1471–1528) had worked with a similar device and had written about it, and he expected, quite rightly, that he too would find this a useful aid in his work. At first he used a small model that was based on Cassagne's method, but in the second half of 1882 he generally used a larger version of the same device.

The townscapes of March 1882 are some of the earliest works he produced using this aid. It helped Van Gogh to transfer the *Entrance to the Pawn Bank* and the complicated architecture of other buildings onto a flat surface in a convincing way (ill. 12). The figures in the picture, added later in the studio, prove that he was still having problems with perspective. Their proportions in relation to one another are not very reliable: the two men in the foreground, for example, make all the others look like midgets.

The use of the perspective frame is in evidence everywhere in Van Gogh's drawings from The Hague. He used it to master the difficult composition of a townscape or to estimate the accurate proportions of a figure; and for the rest of his working life – perhaps even when he was in Auvers-sur-Oise – he was to continue to depend on it.

< 15
Allée d'arbres en perspective
illustration from Armand Cassagne,
*Traité pratique de perspective appliquée
au dessin artistique et industriel,*
Paris 1879

< 16
Country road
March–April 1882
25 x 34 cm
Van Gogh Museum,
Amsterdam

17
Sketch in a letter to Theo
of 5 August 1882 [254/222]
Van Gogh Museum,
Amsterdam

18
Sketch in a letter to Theo
of 5 August 1882 [255/223]
Van Gogh Museum,
Amsterdam

19
Old woman with a shawl
March 1882
57 × 32 cm
Van Gogh Museum,
Amsterdam

> 20
Sorrow
April 1882
44 × 27 cm
Walsall Museum &
Art Gallery, Walsall

FIGURE DRAWING Although the unexpected commissions for townscapes had taken up a great deal of his time, Van Gogh had not lost sight of drawing after live models. Thanks to Sien and the members of her family, there was a continuous, if somewhat limited, supply of models, and Van Gogh made grateful use of them. He also found interesting characters when he was wandering around town, whom he recorded, like the old woman he saw when he and George Breitner were looking for suitable subjects (ill. 19).

In April 1882, he told Theo that he was working very hard on his figure studies, even though landscape and townscape motifs were also on his mind: 'I cannot stop drawing from the figure, this comes first with me, but sometimes I cannot keep from working outdoors. But I am busy with very difficult things which I must not give up. Recently I have made many studies of parts of the figure – head, neck, breast, shoulder. [...] I should love to make more studies from the nude.' [214/185] However, many of the figure studies he made have been lost, presumably because at a certain point they would have outlived their usefulness and were therefore destroyed by the artist.

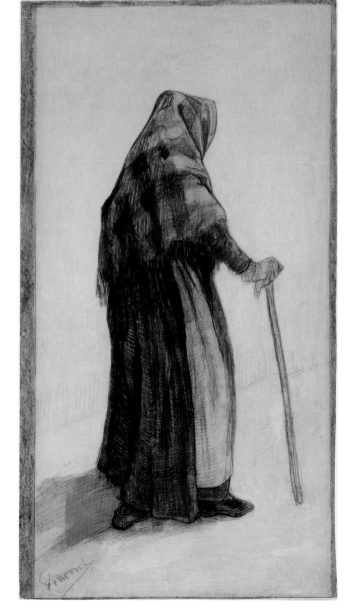

One ambitious work was *Sorrow* (ill. 20), which depicts a mournful woman in a composition closely related to *Worn out* (ill. 21). The naked woman, sitting on a stone or tree trunk in an oppressive empty setting, had strongly symbolic connotations quite unprecedented in Van Gogh's work. Although he was enthusiastic about *Sorrow*, the subject remained exceptional in his oeuvre, and he was never again to make a composition in which the message was so insistent.

WATERCOLOURS: VILLAGE VIEWS, TOWNSCAPES AND LANDSCAPES Until well into the summer of 1882, Van Gogh's oeuvre was dominated by townscapes, views of villages and landscape subjects. It was at this time that he started his explorations with colour. Theo and Tersteeg had pointed out to him earlier that year that watercolours were more marketable than his work using black drawing materials, but Van Gogh had obstinately refused to change his practice: he wanted to restrict the number of artistic problems he was struggling with to a manageable minimum. In the summer of 1882, he felt strengthened in his resolve

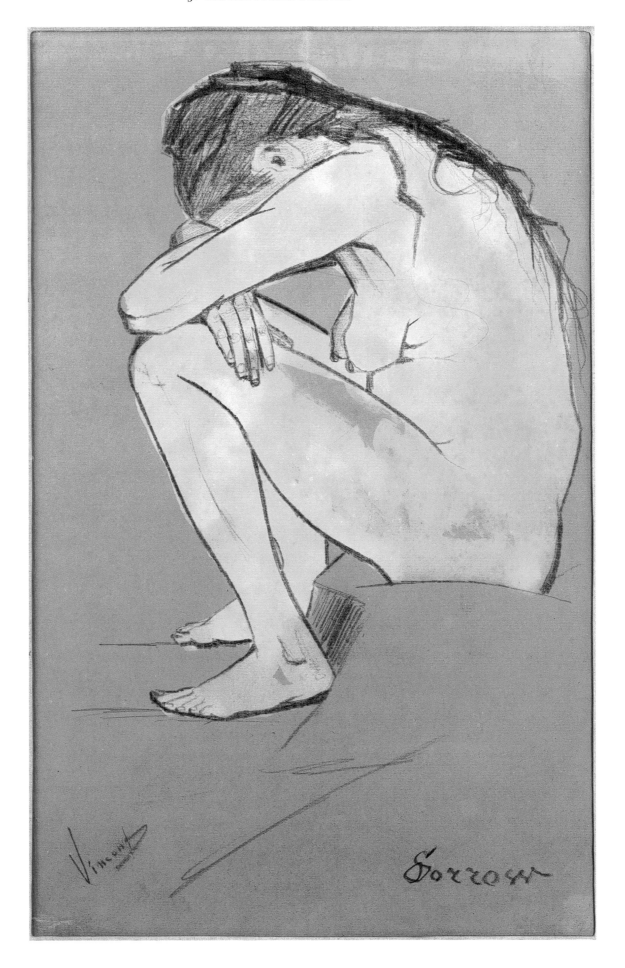

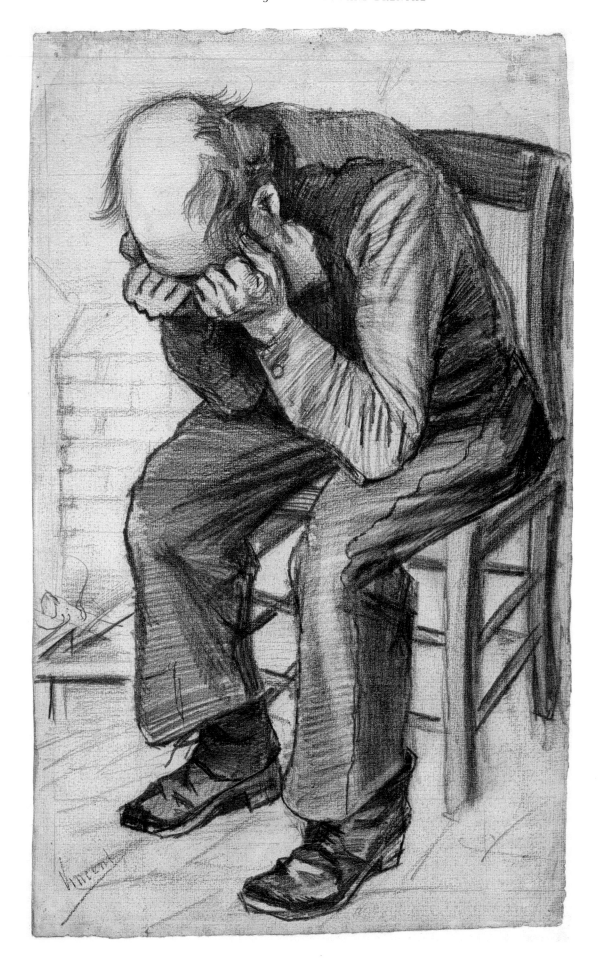

because he had produced a few successful drawings in the preceding months, such as the works mentioned earlier with The Hague as their subject (ill. 11–14, 16). Furthermore, he had also been to Scheveningen to look for subjects. This fishing village had long been popular among artists, and Van Gogh, who knew it well from the many walks he had taken there when he was working for Goupil's, was equally taken with its charm. His faith in his own ability gradually increased, and Vincent assured Theo that he would show him some watercolours when he next came to see him in The Hague at the end of July. On the basis of a few works–depicting a Scheveningen fish-drying shed–he tried to convince his brother that his self-imposed learning process had been necessary: 'In the black-and-white "Fish Drying Barns" that is already apparent, I think, for in them you can follow everything and see how it all fits together. And look here, I think the reason for my working so much more easily in watercolours now is that for such a long time I did my best to draw more correctly.' [252/220]

The progress Van Gogh felt he had made is quite apparent in his different pictures of the fish-drying shed. One of them, a view of the establishment from the side, shows several houses and even includes a small view of Scheveningen. It is a colourful summer picture with its baskets sprouting fresh greenery in the foreground (ill. 22). The quick growth that Van Gogh was making as an artist can clearly be seen in a spectacular view looking out over the rooftops from his own house on the Schenkweg in The Hague (ill. 23). The perspective of the line of roofs seems to draw the spectator into the scene, which includes the already familiar carpenter's yard and the Rijnspoor station wedged between the road on the right and the horizon.

NEW FIGURE STUDIES. VAN GOGH'S MODELS In September 1882, Van Gogh devoted himself once again to his greatest passion: drawing figures. His discovery of the Dutch Reformed Old People's Home allowed him, quite unexpectedly, to gain access to a varied supply of models, as several of its residents were willing to pose for him on a regular basis. For him they were ideal, because they were usually readily available, cheap in comparison to professional models ('a few sixpences for an afternoon or morning' [273/238]), and their faces and bodies showed the signs of the hard lives they had been forced to lead.

Until well into November, Van Gogh drew them dozens of times, making large pencil drawings in a vigorous, angular style. He worked with

< 21
Worn out
November 1882
50 x 32 cm
Van Gogh Museum,
Amsterdam

Aquarelle? Van Gogh always labelled his watercolour drawings 'aquarelles', but strictly speaking this is incorrect. During his years in the Netherlands he nearly always used gouache, an opaque water-based colour, which he thinned down to various consistencies. When much diluted, this material is similar to transparent watercolour (aquarelle), but it fails to produce the same airy, bright character. In June 1881 Van Gogh had read Armand Cassagne's *Traité d'aquarelle* (Paris 1875), and his method is presumed to be his own particular variety of a technique described in this handbook, the *aquarelle gouachée,* which does indeed involve working with diluted gouache to achieve a watercolour effect.

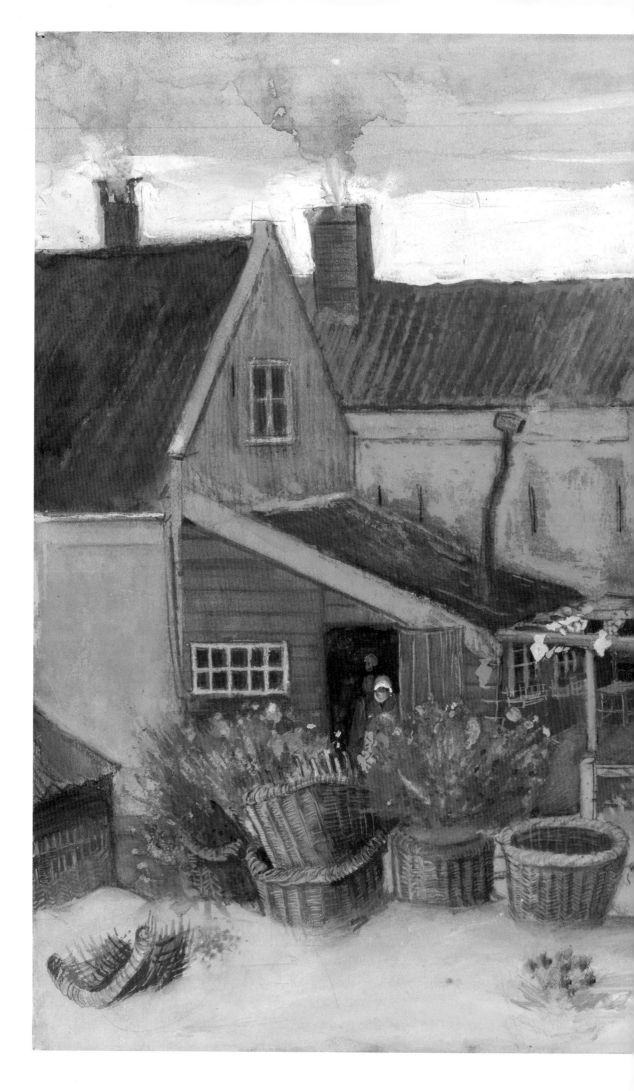

22
*Fish-drying shed
at Scheveningen*
July 1882
36 x 52 cm
Private collection

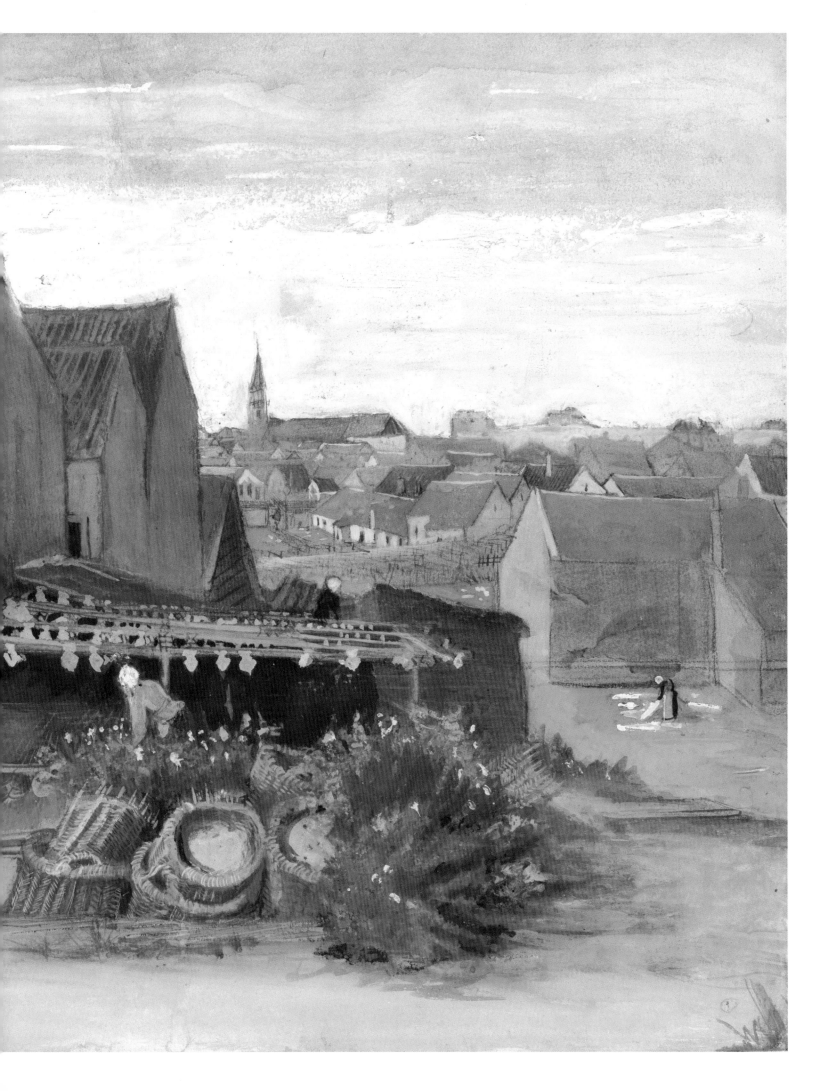

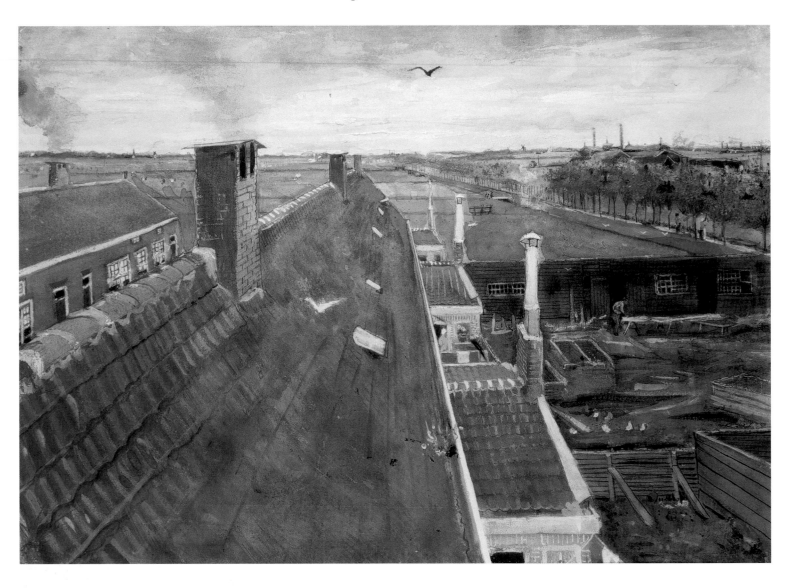

23
Roofs
July 1882
39 x 56 cm
Private collection

carpenters' pencils, which have more solid leads than ordinary pencils, so that he could press down really hard. The wide piece of graphite in the middle of these pencils allowed him to draw both broad and narrow lines. He liked to press hard, and he also liked to work with wet paper, so he used *torchon*, a strong, rough watercolour paper. This method gave to many of his figures a power of expression that does justice to the model's age and character.

After experimenting with colour in the summer, Van Gogh now focused on working in black. This choice was also influenced by his love of the prints that appeared in English and French illustrated periodicals such as *The Graphic, The Illustrated London News* and *L'Illustration*. He was an avid collector of these reproductions, which he cut out and glued onto sheets of paper. His collection, which is preserved today at the Van Gogh Museum, runs to about 1,400 prints. It is made up predominantly of wood engravings (and to a lesser extent lithographs) made by skilful graphic draughtsmen after original drawings by artists such as Hubert Herkomer

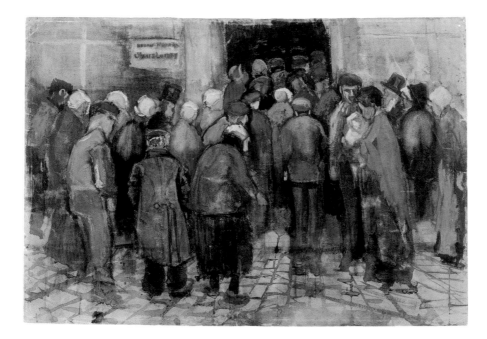

24
The poor and money
September–October 1882
38 x 57 cm
Van Gogh Museum,
Amsterdam

25
Hubert Herkomer
*Heads of the
people drawn from life, II:
The agricultural
labourer – Sunday*
from *The Graphic* 12
(9 October 1875)

26
Luke Fildes
Houseless and hungry
from *The Graphic*,
Portfolio 1877

(1849–1914) (ill. 25), Luke Fildes (1843–1927) (ill. 26) and Paul Renouard (1841–1919). Van Gogh admired all these artists for their ability to make convincing depictions of figures and to group them in a realistic way. Furthermore, their subject matter was taken from everyday life, and their main figures were ordinary people: exactly the subjects that Van Gogh wanted to imitate in his own work. At some time during September or October 1882, he made a watercolour drawing with a complex composition, *The poor and money* (ill. 24). In it he wanted to portray the contrast between 'the misery and the sort of *efforts de perdus* [forlorn efforts]' of poor people who spend their last pennies on a lottery ticket in the hope that they will find salvation [271/235]. Unfortunately, Van Gogh did not as yet have sufficient artistic skill to make a success of such a demanding composition.

THE PORTRAIT OF JOZEF BLOK In The Hague Van Gogh had drawn and painted numerous angular, rough-and-ready 'heads' in black and white, but they were studies meant to represent certain types, not characteristic portrayals of specific people. However, in November, he made a real portrait drawing, unique in his Dutch oeuvre: his *Portrait of Jozef Blok* (ill. 27), carefully executed in pencil and watercolour, with the subject's side-whiskers emphasized with black lithographic crayon. Blok (1832–1905) had a bookstall on the street in The Hague where Van Gogh bought the periodicals that contained his favourite illustrations. He admired the striking facial features of the Blok family, and in a letter to Theo he expressed a desire to portray several members of the family [281/241]. His wish was fulfilled when, in exchange for a few issues of *The Graphic,* he drew portraits of Blok's father and mother (each of them twice). These drawings, however, have not survived.

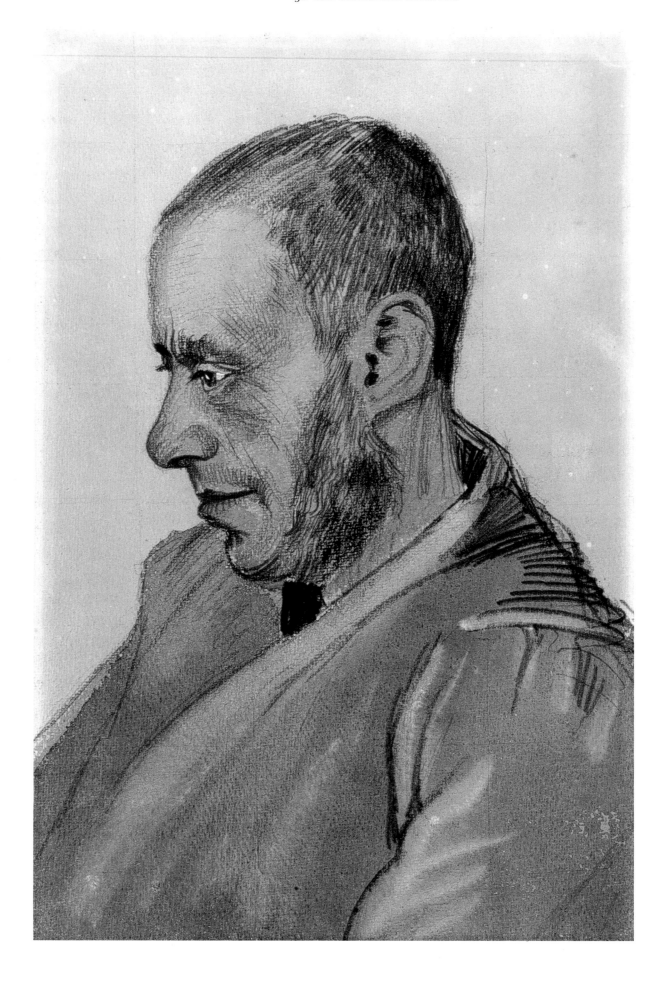

TECHNICAL EXPERIMENTS Studying prints from periodicals provided Van Gogh with technical ideas as well as subjects. He knew that the original drawings had also been done in black and white and that English artists had exhibited them from 1872 onwards at 'Black and White exhibitions', which were reviewed in *The Graphic*. Working with black materials greatly appealed to Van Gogh and fuelled a desire to experiment that was to be unparalleled in his oeuvre. In the same way as his English models, he aimed to achieve highly expressive results using only shades of black and grey, and, with this in mind, he tried out a variety of different materials. Some of these can be traced back to Van Gogh's textbooks, although he made use of them in his own idiosyncratic way. Other materials originated from his brief experiments with prints.

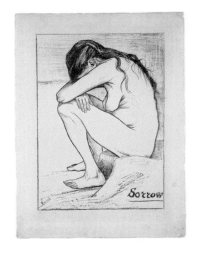

Van Gogh tried to make his pencil drawings more distinctive by fixing his graphite with milk, an idea that almost certainly came from Cassagne, who had indicated that milk could be used as a fixing agent for both pencil and crayon. Van Gogh discovered that milk, especially when used lavishly, can take the shine out of graphite and give it a velvety black quality, an effect that he greatly appreciated and that was well suited to the realistic drawings he wanted to make. His use of it as a fixative means that the sheets coated with it often have a conspicuous edge running right round the figure, and sometimes they even have white splashes where larger amounts of milk have dried in one place.

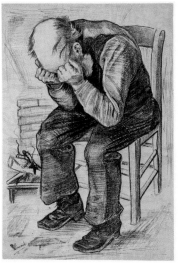

VAN GOGH'S GRAPHIC WORK Van Gogh made few prints during his career – nine lithographs and one etching – but the six lithographs he made in November 1882 had a great influence on his Hague work. Furthermore, while working on this project, Van Gogh formulated artistic principles that were important both for these prints and for his drawings of the period, principles that would, for the most part, continue to guide him throughout his entire career.

The series of six consisted of a lithograph after *Sorrow* (ill. 28) and five more or less accurate copies of recent figure drawings that he had done in pencil. They included *Worn out* (which as a lithograph was given the equally melancholy title *At eternity's gate*, ill. 29). In Dutch periodicals Van Gogh had been unable to find the kind of graphic work he collected, only mediocre substitutes, so he thought he had spotted a gap in the market. Following the example of artists like Hubert Herkomer, he wanted to make graphic art that was reasonably priced and that appealed to the lower classes, with subjects arising 'from the people for the people' [291/249, 293/251]. He even thought of forming an artists' guild to produce this kind of work, aiming to keep prices down to below fifteen cents. Quite apart from the financial gain, Van Gogh intended to comfort people with his art, and his series of prints represented one of the first concrete demonstrations of

< 27
Portrait of Jozef Blok
November 1882
38 x 26 cm
Van Gogh Museum,
Amsterdam

28
Sorrow
November 1882
39 x 29 cm
Van Gogh Museum,
Amsterdam

29
Worn out (At eternity's gate)
26–27 November 1882
40 x 34 cm
Van Gogh Museum,
Amsterdam

30
Old man with a top hat
December 1882–
January 1883
60 x 36 cm
Van Gogh Museum,
Amsterdam

> 31
*Weeping woman
seated on a basket*
January–
February 1883
47 x 29 cm
Kröller-Müller
Museum,
Otterlo

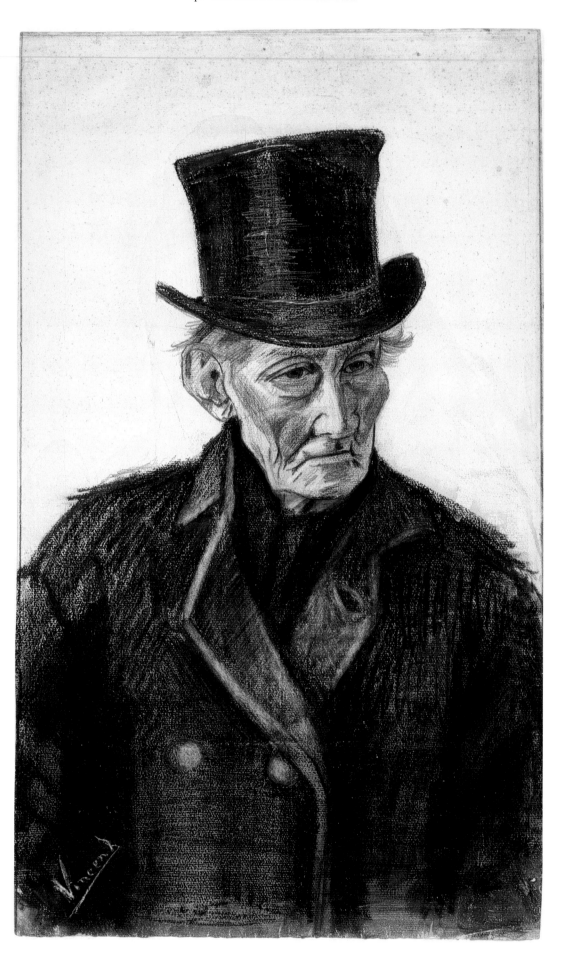

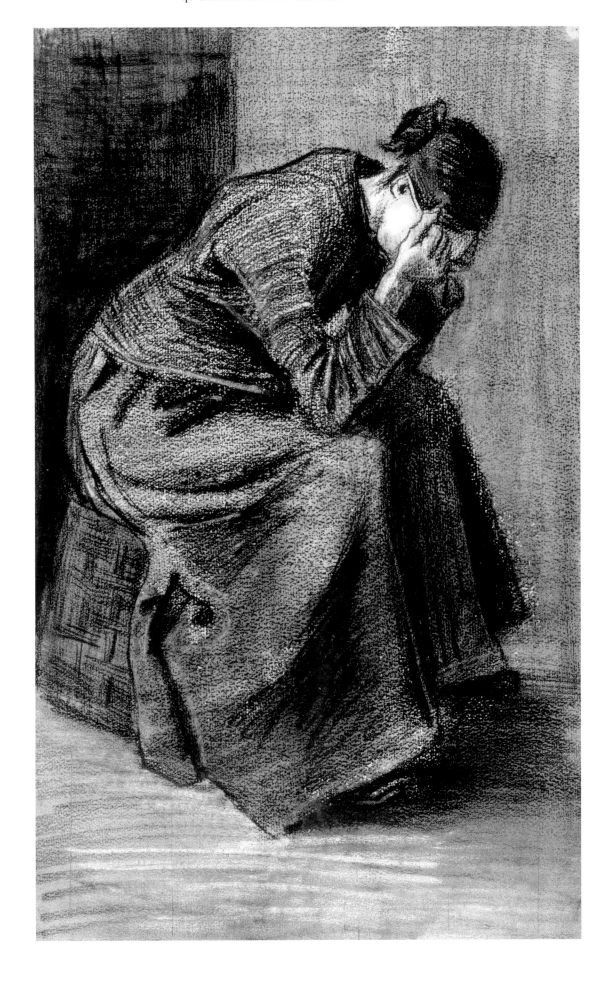

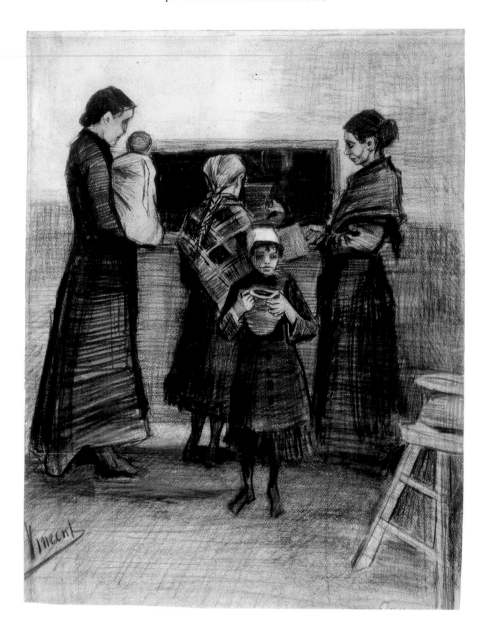

32
*Soup distribution
in a public soup kitchen*
March 1883
57 x 44 cm
Van Gogh Museum,
Amsterdam

this intention. However, the six lithographs were never taken beyond the experimental stage and were not produced in long print runs.

PAINTING IN BLACK The discovery of lithographic crayon delighted him so much that in December 1882 Van Gogh started to use this oily deep-black material in his drawings, in addition to pen or brush and black ink. In this way he could achieve a range of subtle nuances in black, and he dubbed this method of working 'painting in black' [298/256]. The expressive effect he achieved using this technique is demonstrated in the serene *Old man with a top hat* (ill. 30). Sometimes Van Gogh worked purely with lithographic crayon, and this too was very suitable for the realism he was aiming for, as in his new variation on his theme of the sorrowful figure (ill. 31). In March to July 1883 he extended his 'painting in black' even further by using printing ink in his drawings.

Van Gogh's enthusiastic research into materials also led to a rediscovery. In the summer of 1882, Theo had sent him a small amount of natural chalk – most of the late-nineteenth-century crayons were man-made – which he was always to call 'black mountain chalk'. He did not at first think it was very promising, but his experiments seem to have made him change his mind, because in March 1883 he spoke glowingly about it. It had the colour of 'a ploughed field on a summer evening' he wrote to Van Rappard [327/R 30], and he wrote to Theo in praise of the 'gypsy soul' of the chalk [326/272]. He used it in combination with other materials to make several sizeable drawings. Regrettably, many of these drawings were done on woody paper that was to become very brown over the years and rob the drawing materials of their subtle shades. However, the most important drawing, *Soup distribution in a public soup kitchen* (ill. 32), is well preserved: the typical shade of the chalk – black with a clear hint of brown – is shown here to advantage. This is a distinctly ambitious work, in which Van Gogh was imitating the illustrators he so greatly admired; the social-realist subject, distributing soup to the poor, would have been perfect for *The Graphic*. The composition with its group of figures was also ambitious, but the drawing still shows some of the rigidity so characteristic of his earlier drawings.

> *Special techniques* In lithography a needle and scraper can be used to scrape away material from the stone to create lighter areas. Van Gogh wanted to apply this technique to his drawings, but the oily lithographic crayon could not be scraped off the paper. So Van Gogh developed a special technique: first he drew in pencil and then went over it in lithographic crayon. The crayon could then be removed from the shiny graphite, enabling him to achieve lighter effects.

LEAVING THE HAGUE In the twenty-one months in which Van Gogh worked in The Hague, he had developed into a young artist who was following in the footsteps of masters of the Hague School such as Mauve and Jozef Israëls (1824–1911) and Barbizon artists such as Millet and Jules Breton (1827–1906), while he also derived great inspiration from works by artists in his own collection of graphic art. He had profited from the knowledge he had gained from the established Hague masters, but his career had not taken off in the way he had hoped. Furthermore, in the course of 1883, it became clear that his relationship with Sien Hoornik had no future, and in the late summer of that year he decided to leave The Hague and try his luck in Drenthe. He had been hearing reports of the beauty of the countryside in the region for some time, and on 11 September he went to see it for himself.

LANDSCAPES AND A LACK OF MODELS His artist friends had led Van Gogh to believe that life in Drenthe was cheap and that models could be found at very low rates. But, cheap or not, the local residents were wary about posing for him. Furthermore, he was plagued by a lack of materials, and he

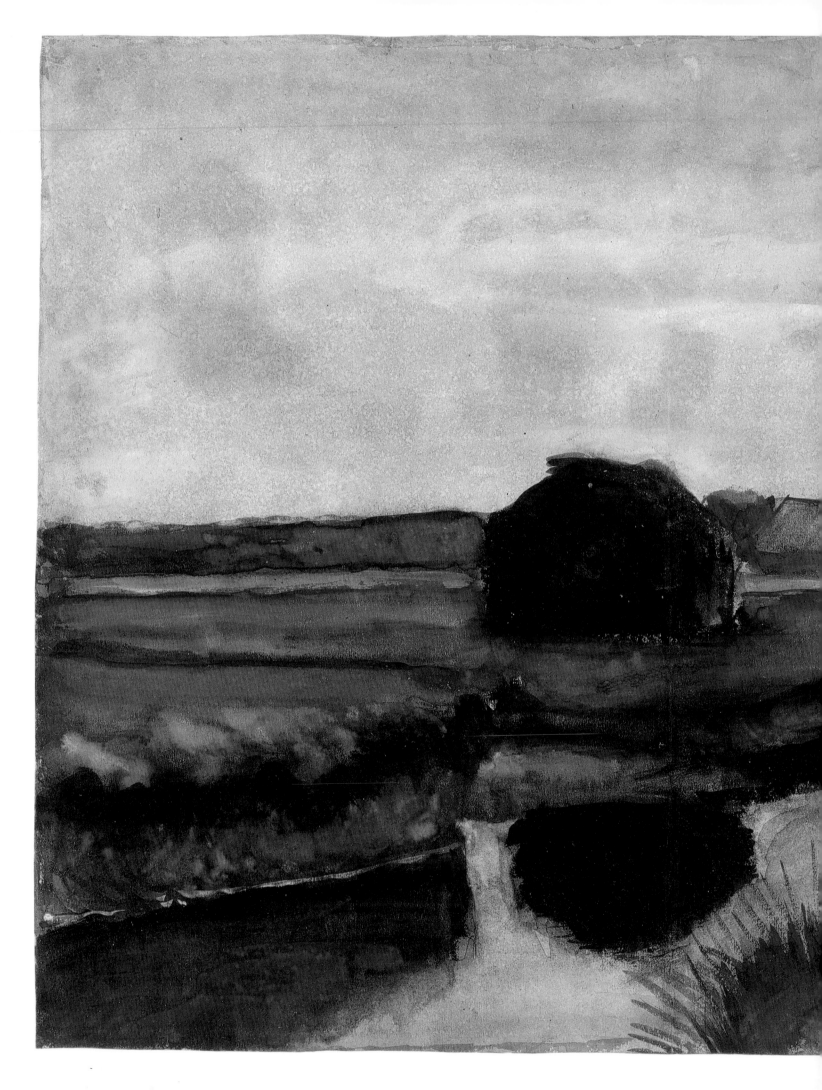

33
*Landscape with a stack
of peat and farmhouses*
September–December 1883
42 x 54 cm
Van Gogh Museum,
Amsterdam

missed having a studio where he could work properly. All his attempts to make studies of models at the Hoogeveen inn, where he was lodging, came to nothing.

The landscape in Drenthe was at first a bit of a disappointment too. In his imagination Van Gogh had transformed the reports of Mauve and Van Rappard into pastoral images of the moorland landscapes he had known in his youth, but these did not tally with the reality. The Drenthe moors were vast, desolate areas: 'as irritatingly monotonous and wearying like the desert, as inhospitable and hostile, so to speak.' [390/325] In his best drawings from that period he succeeded in portraying twilight in a convincing way (ill. 33, 34). At that particular moment of the day when darkness falls, he felt that the landscape changed its appearance in a stunning way: 'when a poor little figure is moving through the twilight—when that vast sun-scorched earth stands out darkly against the lilac hues of the evening sky, and the very last little dark-blue line at the horizon separates the earth from the sky—that same irritatingly monotonous spot can be as sublime as a Jules Dupré.' [390/325]

But, all in all, his stay there proved to be a failure. Disillusioned, he left again after only three months to go to Nuenen, where his father had recently been installed as a pastor.

< 34
Landscape in Drenthe
second half September–
beginning October 1883
31 x 42 cm
Van Gogh Museum,
Amsterdam

1883–1885
Nuenen
Rural life centre stage

VAN GOGH HAD LEFT HIS PARENTS' HOUSE two years earlier after a flaming row. Relations had improved somewhat since then, but the three of them did not envisage a harmonious future. Soon after he arrived in Nuenen, it became clear that his and his parents' ideas were still incompatible. Nevertheless, despite their differences, Van Gogh's parents were to continue to support him, and his father even went so far as to express his enthusiasm for his drawings to Theo.

Van Gogh had heard quite a bit about the picturesque qualities of Nuenen when he was living in The Hague, and that had played an important part in his decision to rejoin his family there. The Brabant village did not disappoint him at all, and it was soon to provide him with suitable subjects. He started to record his new surroundings in a series of fairly small pen-and-ink drawings of winter landscapes with motifs that were to continue to recur regularly: the old tower in the fields, the 'peasants' cemetery' near the tower and the beautiful garden behind the vicarage – sometimes all on one sheet of paper (ill. 35).

In their letters, his family had told him about the local weavers. This had aroused Van Gogh's curiosity, because he had shown a special interest in weavers ever since becoming an artist. During a long walking tour of Belgium and the north of France in 1879, on his way to visit Jules Breton's

35
Melancholy
December 1883
29 x 21 cm
Van Gogh Museum,
Amsterdam

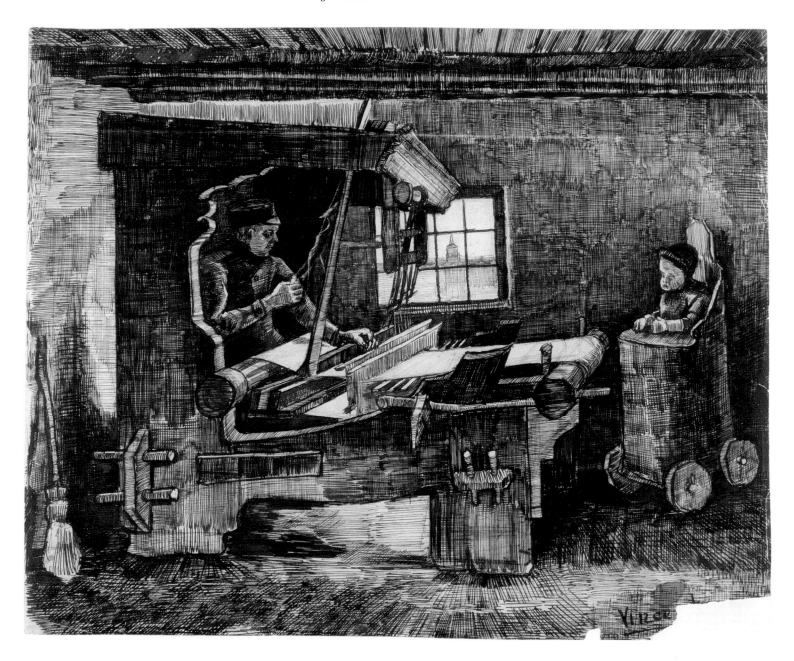

36
*Weaver, with a baby
in a high chair*
end January–
beginning February 1884
32 x 40 cm
Van Gogh Museum,
Amsterdam

studio in Courrières, he had passed through weavers' villages and had been impressed by the absorbed expression on the faces of the workpeople. Once he had settled in Nuenen, he quickly took up this subject again, anticipating that it would also be commercially rewarding: from the period between December 1883 and August 1884 we know of sixteen fully developed drawings in pen or watercolour showing weavers, as well as ten paintings (which in several cases were used as models for the drawings).

These sixteen drawings show clearly that Van Gogh had gained in confidence and had become more ambitious. Most of them were fairly large in format (around 30 x 40 cm), technically highly worked, and signed: features that point to the fact that they were prepared for sale. The drawings show a weaver at work, either behind his loom or engaged upon other activities of his craft, such as ordering the threads. One of the pen-and-ink

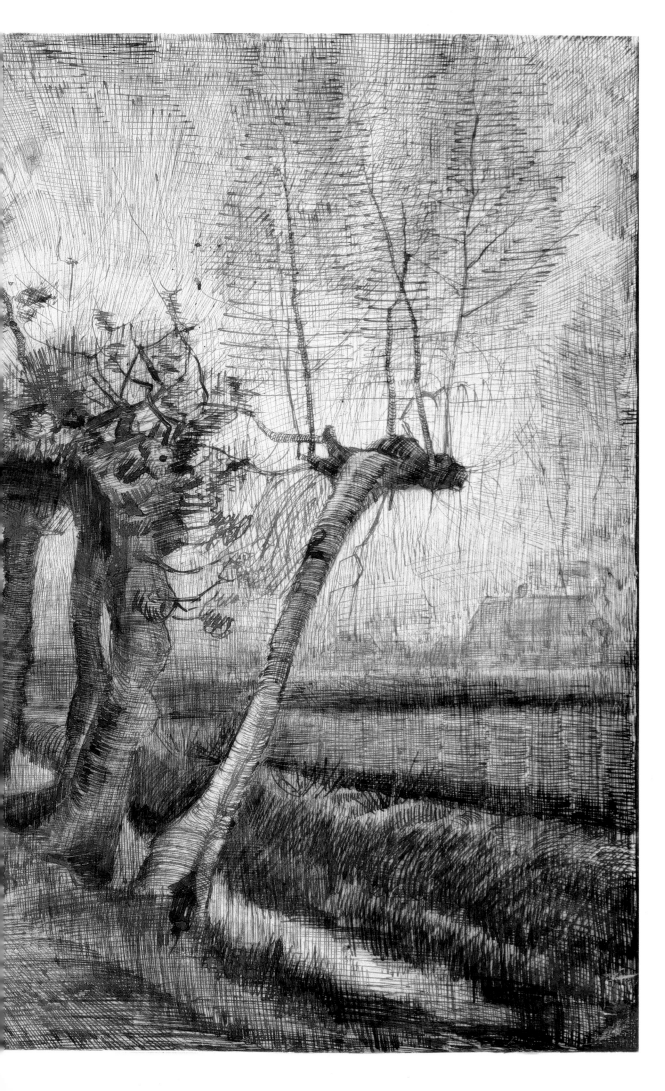

37
Behind the hedgerows
March 1884
40 x 53 cm
Rijksmuseum,
Amsterdam

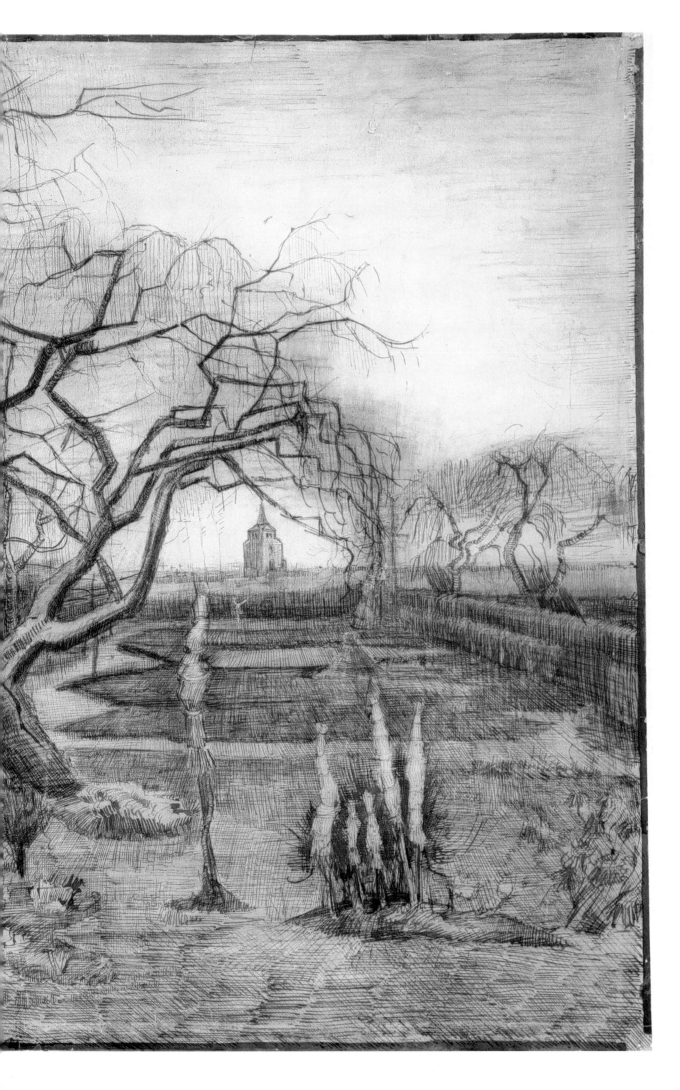

38
Garden in winter
March 1884
40 x 55 cm
Van Gogh Museum,
Amsterdam

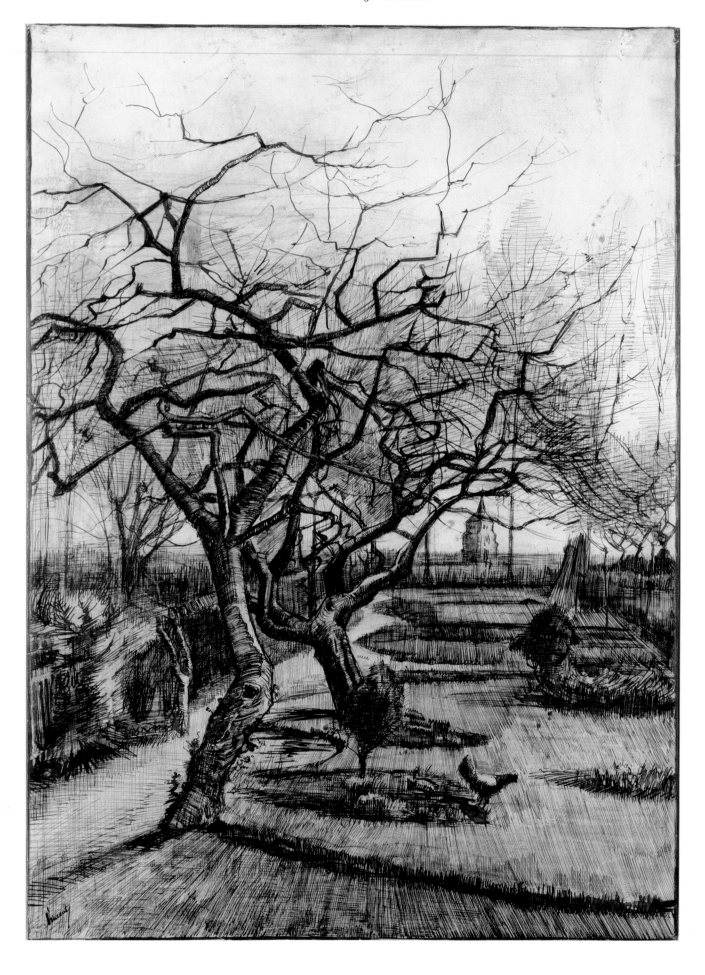

drawings, made after a painting, shows a homely scene, where in addition to the man working the artist also included a baby in a high chair (ill. 36). As so often before, Van Gogh found his inspiration in a book, in this case George Eliot's novel *Silas Marner,* in which the unfortunate weaver Marner only finds happiness after a child comes into his life. However, in general, Van Gogh had to revise his romantic view of weavers, because in reality they were poor, hardworking artisans. He thought they often had 'something agitated and restless about them' [482/392], a more melancholy view that is reflected in most of the drawings. There they have a certain, partly intentional, gloominess, but this is also determined by the overwhelming presence of the looms, enclosing the weavers like massive cages.

In March and April 1884, Van Gogh started to concentrate on landscape once again. This led to an imposing series of seven pen-and-ink drawings (one of which is lost), which display a quality that is exceptional in his Dutch oeuvre. The promise of his earlier pen-and-ink landscape drawings is

< 39
Garden in winter
March 1884
51 x 38 cm
Szépmüvészeti Museum,
Budapest

40
Pollard birches
March 1884
39 x 54 cm
Van Gogh Museum,
Amsterdam

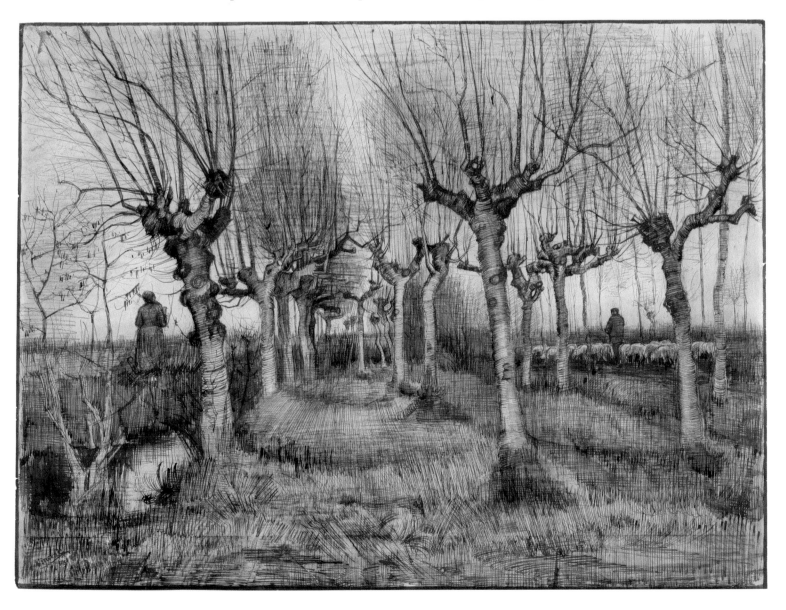

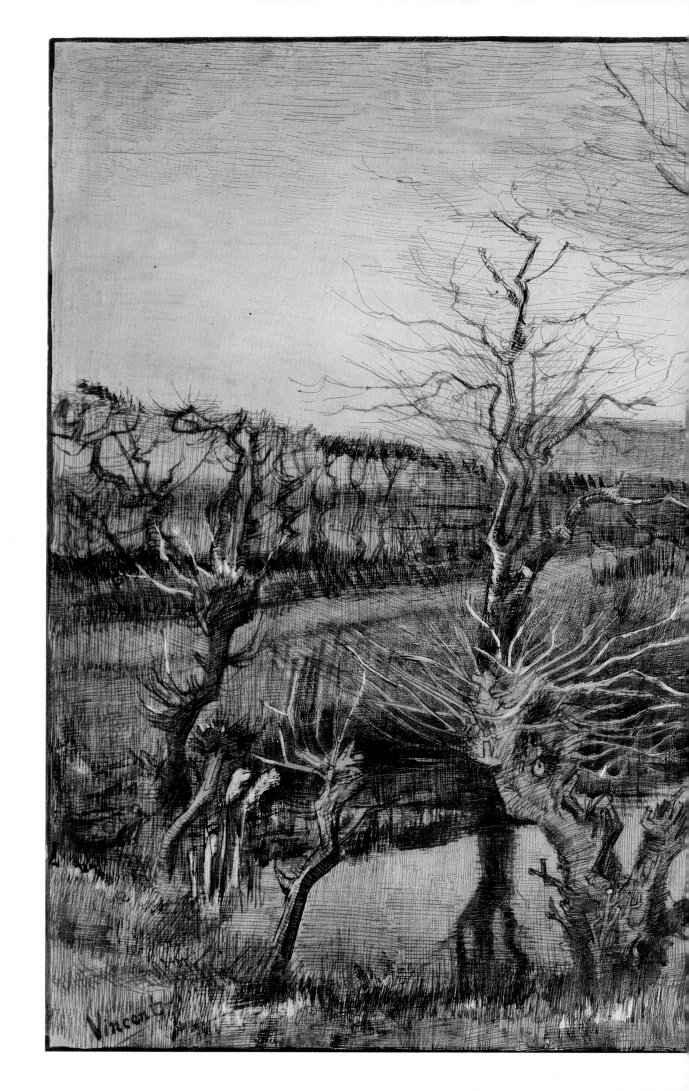

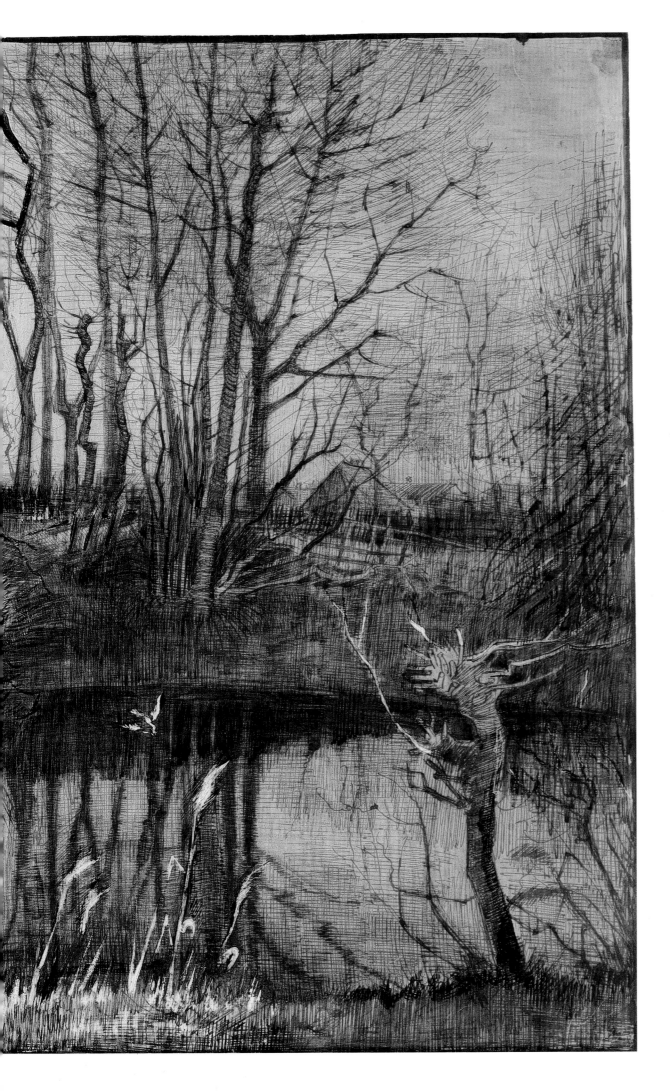

41
The kingfisher
March 1884
40 x 54 cm
Van Gogh Museum,
Amsterdam

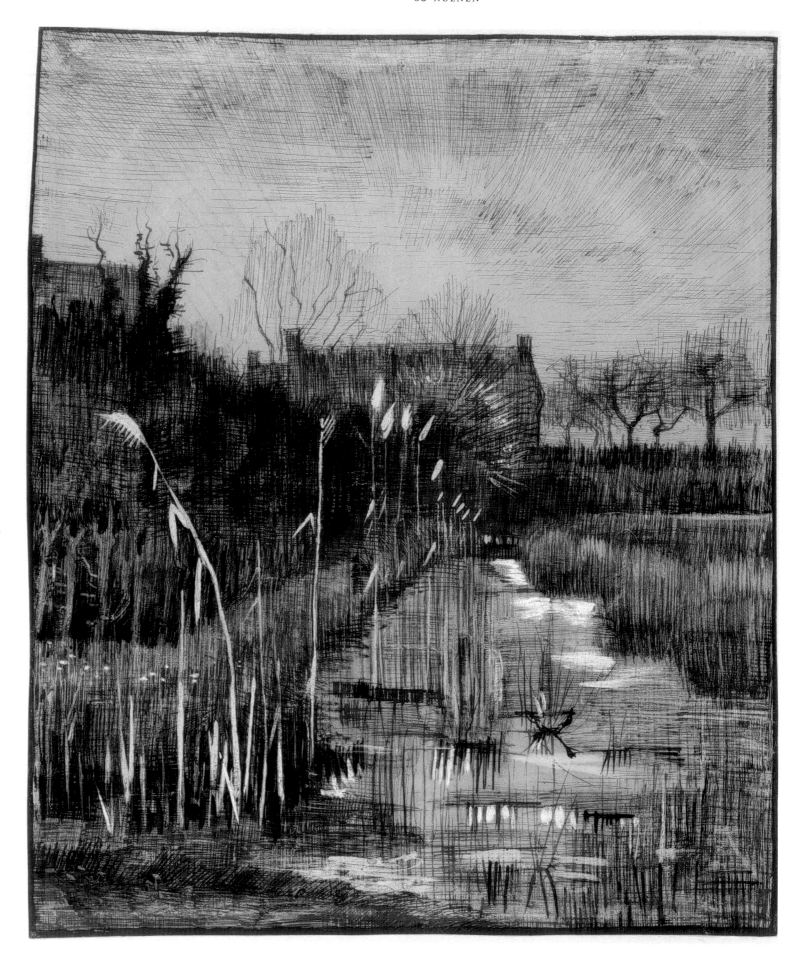

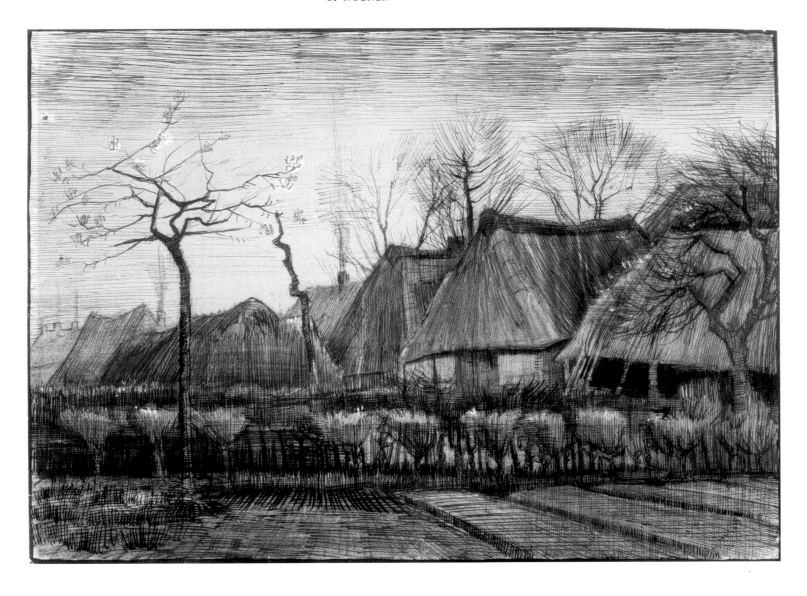

fulfilled in these sheets of drawings, which render a poetic and personal view of the southern Dutch landscape. Almost all the drawings (apart from one of an avenue of poplars, which is somewhat stiff) demonstrate his inventiveness in composition and his powerful drawing style. One of them shows the narrow path that ran behind the vicarage garden (ill. 37), while two are devoted to this barren, winter garden (ill. 38, 39). *Pollard birches* is one of the best examples of the soulful character Van Gogh was capable of injecting into his landscapes (ill. 40); he felt a great sympathy for these pruned trees with their striking, somewhat melancholy appearance. In The Hague he had felt impelled to depict a pollard willow as a living being [174/152], and somewhat later he compared a row of these trees to a 'procession of almshouse men' [282/242]. A similar kind of anthropomorphism can also be found in the monumental topped birches, and the same sentiment emanates from the affecting, gloomy look of the vegetation in the last drawing of the series, *The kingfisher* (ill. 41). The autumnal atmosphere of that piece was deeply inspired by a poem by Jules Breton, *Automne (Autumn)*.

< 42
Ditch
April 1884
42 x 34 cm
Van Gogh Museum,
Amsterdam

43
*Houses with
thatched roofs*
1884
30 x 45 cm
Tate, London

Van Gogh was well aware that this group of works was quite exceptional, and he sent a number of the drawings to Theo in the hope of a commercial success. When this proved not to be the case, he tried to market them through contacts of his friend Van Rappard. Despite his friend's enthusiasm, however, this initiative also failed.

Van Gogh made a few more drawings in April, including an attractive landscape showing a canal, in which wispy tufts of reeds dominate the foreground (ill. 42), and a powerful view of a group of cottages (ill. 43). He must have been disappointed by the lack of response to his series of landscapes; in any case, he never again embarked upon such ambitious drawings while he was in the Netherlands.

Pen and pencil In the Nuenen landscape drawings there is a feature that can be found in many of Van Gogh's pen-and-ink drawings, both in his townscapes of The Hague and the great landscapes of southern France: the important use of pencil. He employed it not only for the preliminary drawing, but also for essential parts of the composition that were not later gone over in pen. It was extremely unusual for artists to combine the two materials in such a striking way, and this technique may have been a consequence of the experiments Van Gogh made when he was 'painting in black' in The Hague. He originally used black ink for his landscapes, and the combination with the silvery-grey graphite resulted in a whole range of blackish-grey shades. Over time, the ink has become discoloured and turned brown, so that the original intention has been lost – although without the drawings really being robbed of their strength.

STUDIES OF HEADS AND HANDS In Nuenen Van Gogh's principal aim was to master the techniques of painting, and for some time this was his almost exclusive concern; he usually painted on canvas with weavers, landscapes and still lifes as subjects. It was not until December 1884 that a new burst of activity led to his making a great number of drawings once again; this provides a good example of the disciplined way in which Van Gogh tried to channel his development. He now started on a large series of painted and drawn heads of peasants, in imitation of a series from *The Graphic* entitled *Heads of the people* (ill. 25). At the same time, he was following in the footsteps of Jean-François Millet, whose vision of the lives of country people he greatly admired and used as a model for his own point of view. His ideas were not, however, particularly sophisticated: Van Gogh saw peasants as rough and uncouth, but these were precisely the characteristics that allowed them to be at one with nature in such an enviable way. It was 'a way of life quite different from ours, from that of civilized people' and 'in many respects one so much better than the civilized world.' [501/404] His belief in physiognomy – a nineteenth-century 'science' based on the premise that a person's nature was reflected in their facial features, and in which people were frequently compared to animals – prompted him to search for the most strongly defined features. His friends from the time, who also knew the peasant community well, were outspoken about this when reminiscing about the painter. He always chose 'the ugliest ones to model for him' was Willem van de Wakker's comment, and Anton Kerssemakers in his description of Van Gogh's studio said: 'You were taken aback to see how full it was, paintings all over the walls and stacked on the floor, draw-

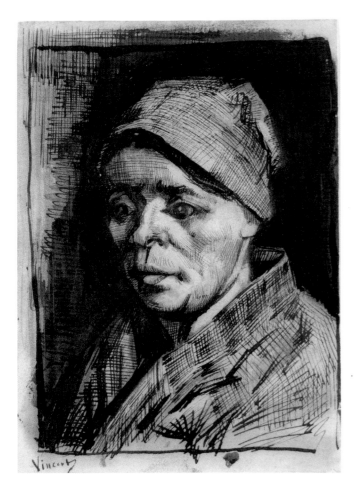

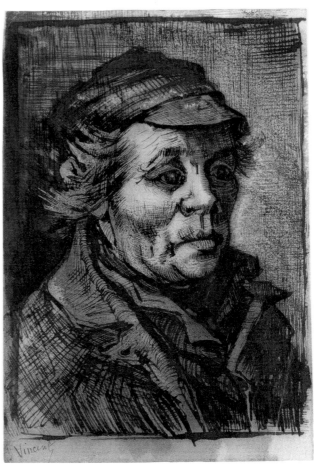

ings in watercolour and crayon, heads of men and women, accentuating the boorish snub noses, jutting cheekbones and big ears.'

Almost all these works, drawings as well as paintings, were studies for the great figure painting he was planning, *The potato eaters* of 1885. The heads on many of the sheets of drawings are good likenesses, but only a few drawings are of outstanding quality, such as the one showing the careworn face of a peasant woman (ill. 46). With her inward look she seems to stand as a symbol for the rigour of peasant life.

There is also a striking series of small pen-and-ink drawings, twenty of which Van Gogh sent to Theo between December 1884 and January 1885 (fifteen still survive). Their importance and quality varies: some are little more than pencil sketches touched up in pen, whereas others are very elaborate. A group of five, including the two that are illustrated here, were done with a serious purpose: the drawing of the heads is careful and detailed, and all of them were signed by Van Gogh (ill. 44, 45). Considering their size, the careful way they were drawn and the fact that they were sent to Theo, Van Gogh must have had serious hopes for these drawings; he may have expected that they could be used as illustrations in a periodical.

In order to prepare for a complex figure painting, he needed to study hands and arms in a systematic way. None of these drawings was meant to

44
Head of a woman
December 1884–January 1885
14 x 10 cm
Van Gogh Museum,
Amsterdam

45
Head of a man
December 1884–January 1885
14 x 10 cm
Van Gogh Museum,
Amsterdam

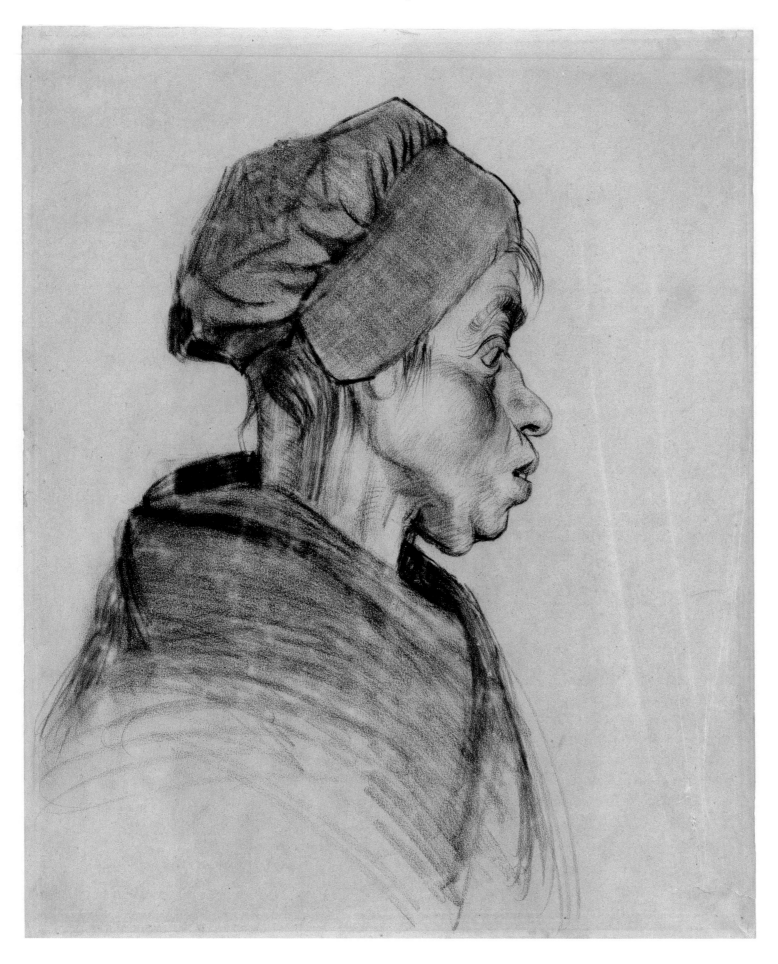

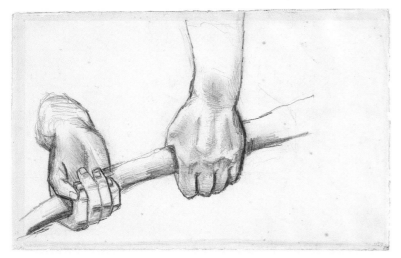

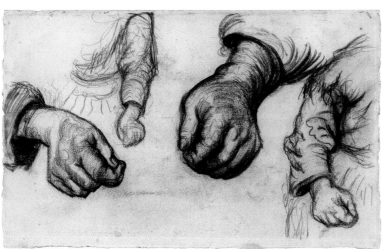

be more than part of a learning process. It is interesting that the sketches made between December 1884 and May 1885 show two clearly distinct approaches. In one group of drawings Van Gogh tried to show the accurate anatomy of the parts of the body, and for these he used pencil, because it allows for more precision (ill. 47). The other group of drawings – mostly of rugged peasants' fists – are done in black crayon: in these he concentrated on expressiveness (ill. 48). As a development from the studies of heads and hands, there are a few portrayals of seated women, in which Van Gogh put together his more detailed observations (ill. 49).

While working towards *The potato eaters*, Van Gogh also made studies of specific details that might play a role in the painting. In addition, he made drawings of women carrying out household chores, in which he paid special attention to light effects and backlighting. In April, after completing the second version of his large figure painting, he made a lithograph of the group of peasants eating (ill. 50). He wanted to use this to inform his colleagues and friends about a work that he himself considered to be the first major test of his craft. He found their reactions difficult to accept; he was deeply shocked by a letter from his colleague Van Rappard, whose

< 46
Head of a woman
December 1884–May 1885
40 x 33 cm
Van Gogh Museum,
Amsterdam

47
Two hands with a stick
December 1884–May 1885
21 x 34 cm
Van Gogh Museum,
Amsterdam

48
Two hands and two arms
December 1884–May 1885
21 x 34 cm
Van Gogh Museum,
Amsterdam

49
Seated woman
February–May 1885
34 x 21 cm
Van Gogh Museum,
Amsterdam

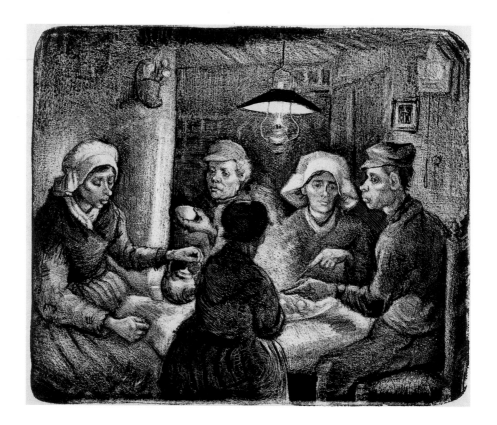

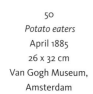

criticisms of the figures in the print were so merciless that their friendship was seriously affected. In reaction to Theo's presumably milder criticism (the letter has been lost, but the content can be inferred from Vincent's reaction to it), Van Gogh went on the defensive about his choice of technique: 'What you say of the figures is true, that as figure studies they are not what the heads are. That's why I've thought of trying it in quite a different way, for instance, starting with the torsos instead of the heads. But then it would have become something altogether different.' [505/408] In spite of all this, he realized that the criticism was not unfounded. On the whole his figures lacked volume, and his realization of this ushered in a new period of study from the model, which was to last until August.

THE OLD TOWER However, before he was able to devote himself to this, a new subject caught his attention. To his dismay, the old tower in the Nuenen fields was to be pulled down, and before it disappeared for good he wanted to record the various stages of its demolition. The large canvas he painted of this imposing building with its churchyard is now considered to be one of the most important works of his Dutch period (ill. 51). In the painting the top of the tower has already been demolished; the public sale of the scrap was the subject of a watercolour drawing (ill. 52). Van Gogh prepared this final drawing by doing sketches, in which various parts of the final composition can be seen. One of them, for example, shows a small study of a head, that of the village constable Johannes Biemans, who can be seen on the left of the

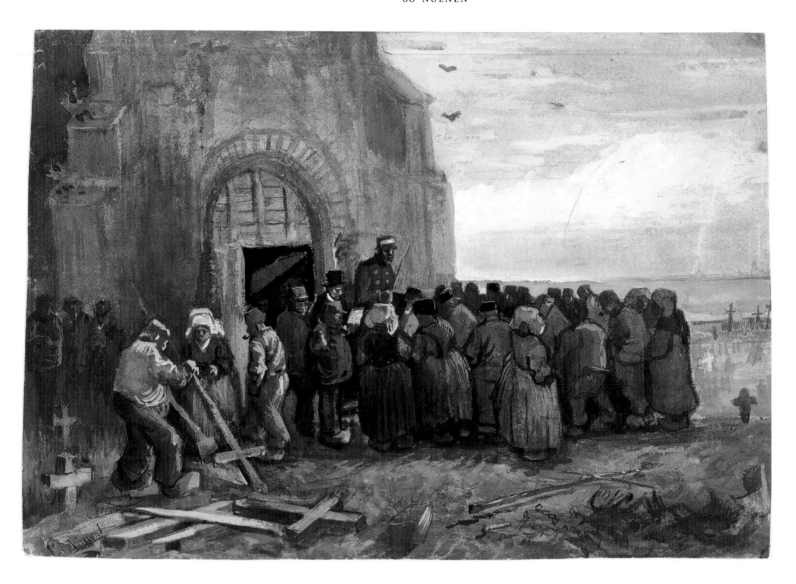

watercolour, standing on a mound of earth, keeping an eye on the throng of villagers (ill. 53). If one compares this drawing with *The poor and money* (ill. 24), done eighteen months previously, one can see that Van Gogh had now learnt to portray a group of people with far more subtlety. The stiffness has disappeared; he shows the crowd as a tight-knit unit and gives life to the scene by depicting three figures in action on the left, a man walking and a man and a woman looking at a cross. This group of three is made more conspicuous by being painted in brighter colours than the figures in the main crowd.

IN THE MANNER OF DELACROIX: NEW FIGURE STUDIES Van Gogh was dissatisfied with his figures, because he thought they were too 'flat'. As he had done many times before, he tried to find a solution to this artistic problem by looking for a model to follow; in this case he chose Eugène Delacroix (1798–1863), whose methods had been described in great detail in the reminiscences of the French painter Jean Gigoux, *Causeries sur les artistes de mon temps*, published in 1885. Van Gogh learnt from this that he

ought not to think in terms of lines and contours but should identify the essential mass of a figure and depict it by using large, rounded forms: egg-shapes or ellipses. He started off cautiously with small figures but soon took a liking to this system. In the summer of 1885 this led to a series of more than fifty quite sizeable pieces of work; the largest sheets measured about 58 x 45 cm. These drawings demonstrate without a shadow of a doubt that this new method worked for Van Gogh. They depict almost statuesque labourers, toiling hard at various kinds of agricultural work, in particular planting and harvesting crops. Several of the drawings bear French titles specifying the activity and the month in which it would be carried out. A profile view of a man digging with a spade is inscribed '*Bêcheur dans un champ de pommes de terre, février*' (Digger in a potato field, February) (ill. 54). This would suggest that Van Gogh was thinking in terms of a series showing the months of the year, thus making his own version of the much-admired series by Léon Lhermitte (1844–1925) (ill. 56). The association with the *Travaux des champs* (Labours of the fields) by Millet must have been even stronger, as he had copied these ten scenes early on in his career and they had continued to inspire him (ill. 57).

< 54
Digger in a potato field,
February
July–September 1885
54 x 42 cm
Van Gogh Museum,
Amsterdam

55
Peasant woman gleaning
1885
51 x 41 cm
Museum Folkwang,
Essen

56
Léon Lhermitte
The woodcutters
from *Le monde illustré* 1457 (1885)

57
after Jean-François Millet
Les travaux des champs
1853 (series of ten prints)
Van Gogh Museum,
Amsterdam

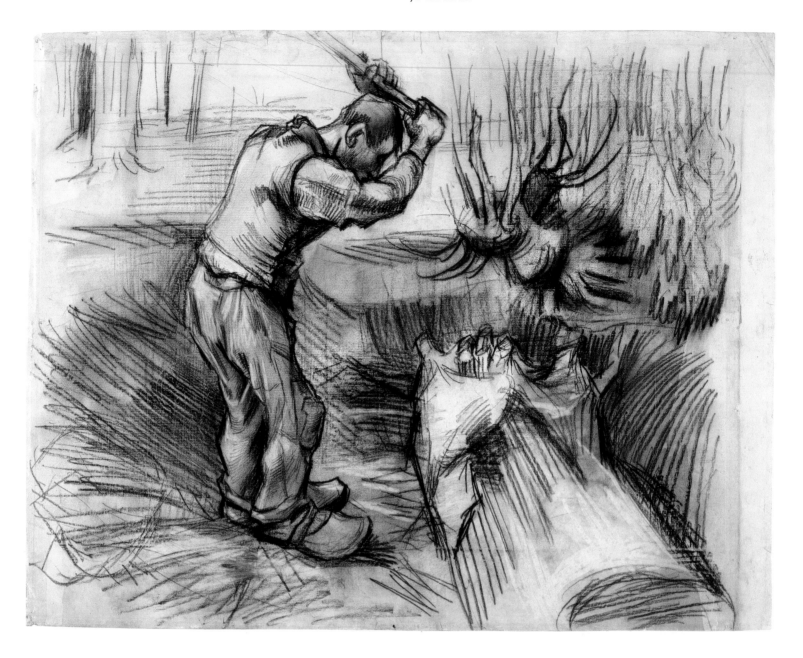

Although drawings of this kind were no more than exercises, used as a form of training so that he would later be able to make paintings with groups of figures, the quality of the peasant series is impressive; a few of them, like the *Peasant woman gleaning* and the *Woodcutter* (one of the few subjects not showing work in the fields), stand out among all Van Gogh's figure compositions (ill. 55, 58). The woodcutter was placed in a simple setting, but Van Gogh went a step further in six other drawings of the period. Here the labourers were placed in a specific environment, either with landscape elements or against the background of a peasant cottage (ill. 59, 60).

In September 1885, Van Gogh's practice of drawing from life came to an unexpected end. He was accused – quite falsely – of getting one of his models pregnant. The Nuenen Catholic clergy turned against him, and one of the parish priests personally advised his parishioners to stop posing for

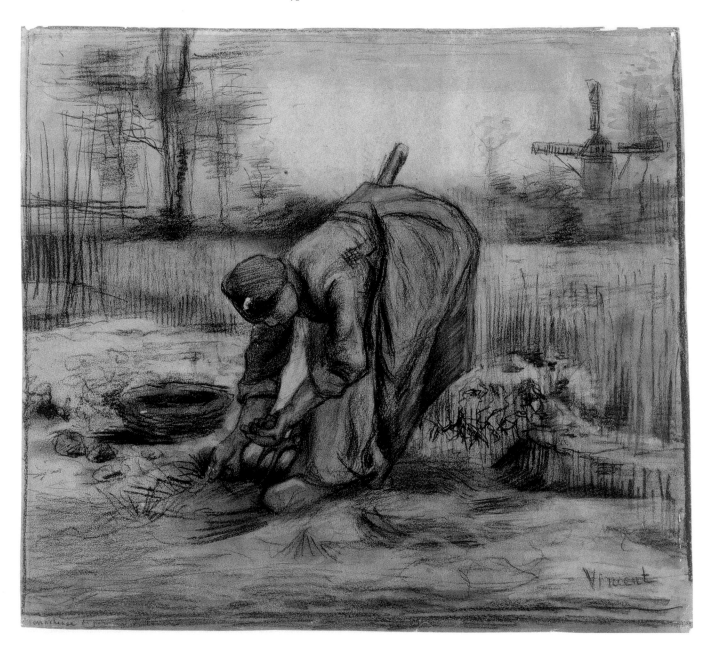

59
*Peasant woman
lifting potatoes*
August 1885
40 x 45 cm
Van Gogh Museum,
Amsterdam

the artist. Van Gogh had to find a new subject for his work. In August he had already drawn a number of scenes featuring the harvested wheat standing in sheaves (ill. 61). It is striking that the human figures is absent from these, or plays only a subsidiary role. Nevertheless, this type of composition was to become typical of the pictures that he would continue to make until the end of his career, in which only the wheat itself attests to the splendour of country life. After the villagers had been prohibited from posing for him, he concentrated more on painting still lifes and landscapes. However, he realized that this would seriously hamper his work, knowing well that he still had much to learn about the accurate depiction of the human anatomy. So in November 1885 he put into action a long cherished plan: he went to Antwerp.

60
Peasant working
August–September 1885
44 x 33 cm
Kröller-Müller Museum,
Otterlo

> 61
Wheatsheaves and a windmill
August 1885
44 x 56 cm
Van Gogh Museum,
Amsterdam

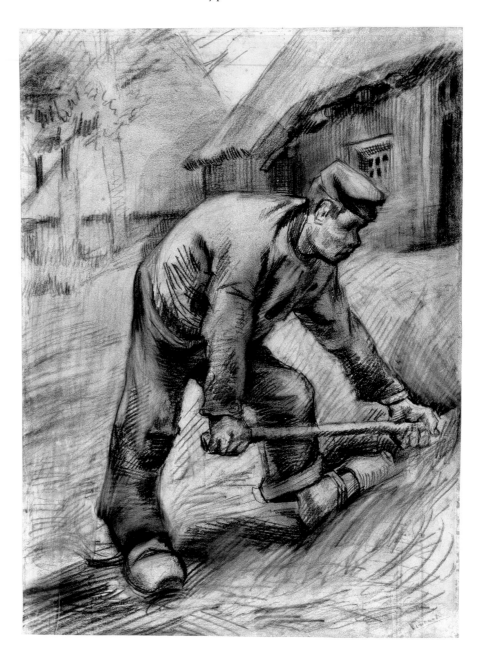

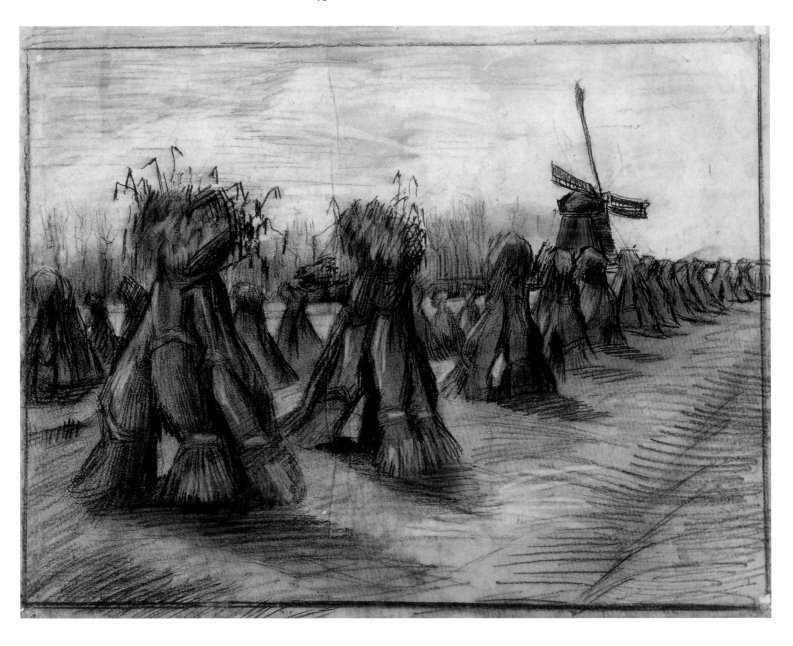

Drawing from life Van Gogh's drawings of peasants create the impression that he observed and drew them while they were carrying out their tasks in the fields. This is deceptive, because Van Gogh could not have depicted them at work: they would have been moving too quickly and would have had better things to do during their working day than pose for him for any length of time. In actual fact, the figures were not studied in the countryside but in Van Gogh's studio. From the start of his career as an artist he had collected typical belongings and items of clothing, such as the sou'wester that he was to use in The Hague to create figures of fishermen. In his Nuenen studio it was no different, as can be gathered from the description by his friend Anton Kerssemakers, who noted 'a spool, a spinning-wheel, a bed warmer, all sorts of rural implements, old caps and hats, filthy women's bonnets, clogs etc. etc.' Thanks to this 'pile of stuff' (as Kerssemaker described it), Van Gogh was able to get his models to take on a great many roles when they posed for him.

1885–1888

Antwerp and Paris

Opportunities in Antwerp

VAN GOGH HAD ALREADY THOUGHT about going to Antwerp in the spring of 1884, mainly to see if he could sell some of his work there, and he mentioned the town several times in later letters. Although he cherished a great love of the countryside, from time to time Van Gogh felt a profound need for the cultural (and commercial) possibilities of an urban environment. This desire was reinforced at the beginning of October 1885 by a visit he made to the Rijksmuseum in Amsterdam.

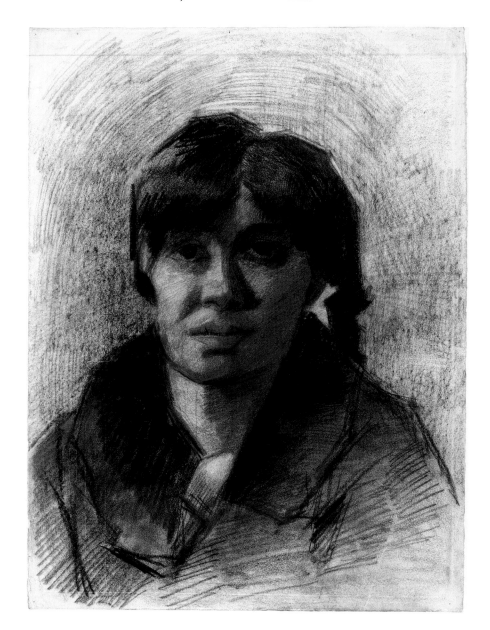

62
Portrait of a woman
end December 1885
51 x 39 cm
Van Gogh Museum,
Amsterdam

At the end of November 1885 he settled in Antwerp. He explored the town in December, visiting museums and churches, and he approached a number of art dealers to gain an impression of the local art market. He hoped that he would be able to earn some money by doing townscapes, but he got no further than a few faltering attempts. However, on his visit to the Rijksmuseum he had studied portraits (mainly from the seventeenth century) and had developed a great interest in this genre, particularly because it it might also be saleable. He painted and drew several portraits, including one of an inward-looking woman with plaited hair (ill. 62).

In the first half of January 1886 Van Gogh enrolled at the Koninklijke Academie voor Schone Kunsten (The Royal Academy of Fine Arts). Here he embarked upon drawing from plaster casts with some enthusiasm, even though he did not agree with the theoretical approach of his teachers. They emphasized the importance of contours in life drawing, whereas Van Gogh

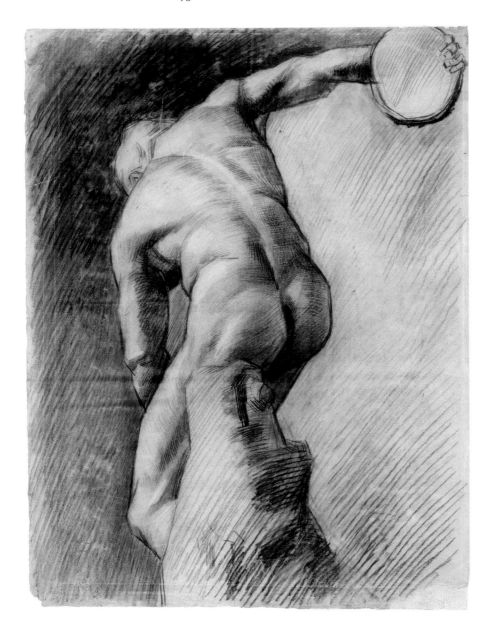

63
The discus thrower
first half February 1886
56 x 44 cm
Van Gogh Museum,
Amsterdam

had trained himself very successfully during his time in Nuenen to construct a figure by concentrating on its volumes. These divergent artistic principles were wholly incompatible, and his study at the academy was doomed to failure from the very start. Since students spent an average of three to four days making a drawing from a plaster cast, and Van Gogh stayed for about six weeks, he must have produced about a dozen of these drawings while he was there. However, only one drawing has been preserved, *The discus thrower* (ill. 63), and it is no accident that this study is rather unpolished, bearing a strong resemblance to Van Gogh's studies of Nuenen peasants from the summer of 1885.

As a newcomer to the art academy Van Gogh was not permitted to draw after living models, so he joined two drawing clubs, where he could draw after nude and clothed models in the evenings. There were no teachers present during these sessions, and the studies he made there are characterized by

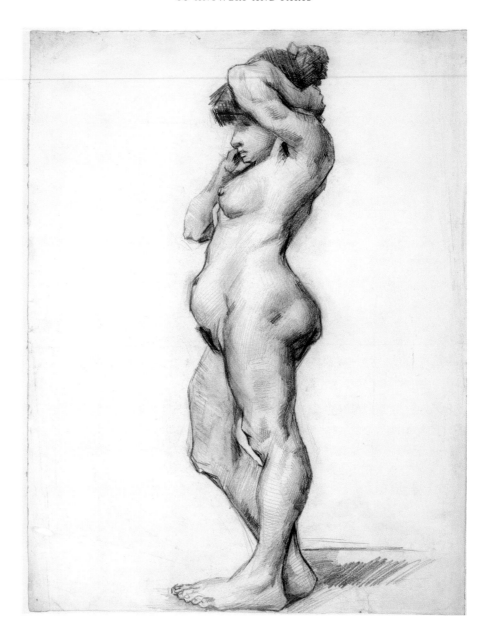

64
Standing female nude,
seen from the side
end January–
end February 1886
50 x 39 cm
Van Gogh Museum,
Amsterdam

his own, easily recognizable, solid, angular style (ill. 64). As so often in the past, he preferred realistic expression to anatomical accuracy, as the somewhat awkwardly drawn right leg indicates.

The long working days, which stretched from early in the morning to late at night, starting at the art academy and ending at the artists' clubs, sapped Van Gogh's strength. He did his best, but he was still dissatisfied with the tuition he received, particularly the classes at the art academy. He therefore decided to broaden his horizons and move to Paris, where the opportunities for artistic tuition were considerably better.

NEW PRIORITIES As far as Van Gogh's drawings are concerned, his time in Paris started with a period of relative calm, which was to last almost a year. He drew from nude models, but principally from plaster casts, in the studio of the well-known French painter and teacher Fernand Cormon

65
Seated girl and Venus
October 1886–January 1887
47 x 62 cm
Van Gogh Museum,
Amsterdam

66
Charles Blanc
*Grammaire des Arts
du Dessin*, Paris 1867

(1845–1926). In addition, he made studies from plaster casts at his brother Theo's apartment, although these were fairly unambitious. The occasional drawing does stand out, although the artist was not consciously striving to excel (ill. 65).

Van Gogh's decision to move to Paris was mainly motivated by his need to make more advanced studies of the figure. Given this, the relatively small number of drawings and paintings he devoted to that purpose seems at first sight to be rather strange. He complained that it was difficult to find models, but this is not very plausible; he could have fallen back on the wide circle of acquaintances he had assembled in Paris, and he was, after all, living and working in the lively neighbourhood of Montmartre, which had plenty of practising artists and no lack of professional models.

The real explanation for the small number of figure drawings is that he had simply underestimated his own abilities and artistic maturity and failed to see what progress he had already made. In Antwerp he had had no use for the theoretical points of view of his teachers, and it was no different with Cormon. Although the history painter seems not to have been a very dogmatic tutor, he also placed emphasis on the need to use contours and the search for correct proportions as the basis for drawing. Even in Arles, Van Gogh felt the need to repeat how much he disagreed with Cormon's belief that everything should be measured [687/539].

There was, however, another factor that played an important role in Van Gogh's underestimation of his own work: his professional isolation. In Nuenen, where his work had made great progress, Van Rappard was the only professional painter with whom Van Gogh had any contact, and even that

was infrequent. His artistic standards were, therefore, based primarily on his own collection of graphics, in which he could study the work of very capable draughtsmen such as Herkomer and Honoré Daumier (1808–1879), and of course on the books he read. In his favourite book, Charles Blanc's *Grammaire des Arts du Dessin*, he would have been able to find illustrations of works by great masters such as Raphael, Rembrandt and Michelangelo (ill. 66). His constant exposure to masterpieces and his isolation from other artists had led Van Gogh to underrate his own capacities. When he went to Antwerp and Paris and came into contact with work by lesser divinities, such as his tutors and fellow-students, he realized that he had made more progress than he could ever have imagined.

However, the most important reason for Van Gogh's declining interest in figure studies was his discovery in Paris that his style of painting was hopelessly dark and old-fashioned and in dire need of change. As figure composition is much less suitable for the study of colour than still life, it was

67
A guinguette
February–March 1887
39 x 52 cm
Van Gogh Museum,
Amsterdam

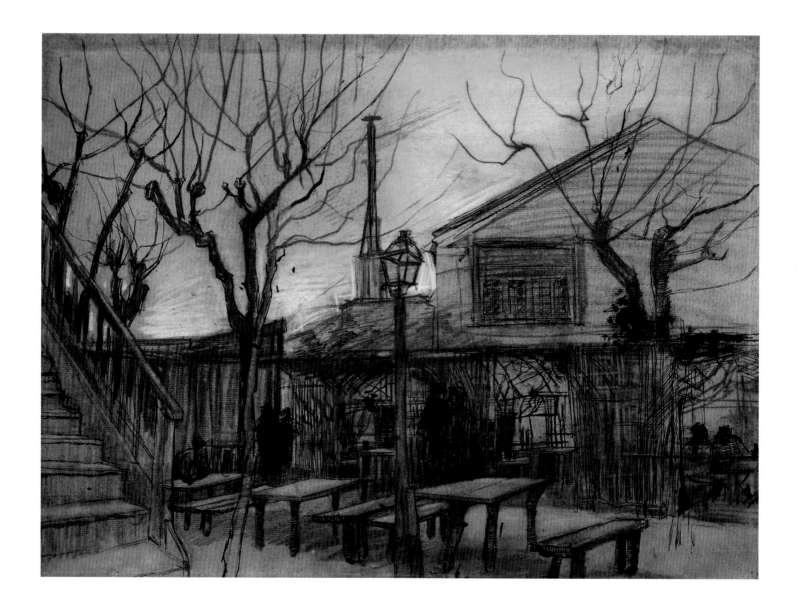

Disappearing colours; the simultaneous contrast Every work of art changes over the years, and Van Gogh's drawings and paintings are no exception; they no longer look the same today as they did a century ago. Usually the changes are not intrusive, as, for example, when black ink turns to shades of brown. Sometimes, however, real changes in appearance take place. For instance, *A guinguette* was drawn on blue paper that faded to a shade of light brown, causing it to lose a lot of its freshness; this can be seen quite clearly in a reconstruction (ill. 67, 68). In spite of this, it is still a delightful drawing. Other works in which a number of colours were used lost all their balance when the colour started to fade from the paper. This also led to the disappearance of interesting experiments. Van Gogh often worked with colour contrasts, including the simultaneous contrast, in which colours close to one another in the colour circle, like blue and greenish blue, are juxtaposed. This effect was also employed in several drawings executed on coloured paper, but when the background colour of the paper faded, the contrast disappeared.

68
A guinguette
digital reconstruction
with original paper colour

on still life that Van Gogh focused his attention. His decision to explore colour also meant that during the time he was in Paris painting would take precedence over drawing.

TOWNSCAPES AND PARISIAN UKIYO-E He began to make more ambitious drawings once again in February–March 1887, when his experiments with modern painting methods began to bear fruit, and he no longer had to concentrate exclusively on technical matters. It is noteworthy that in many of his drawings done in 1887 colour also played a pivotal role. However, there was no new development from the detailed pen-and-ink drawings he had done in Nuenen; when Van Gogh now worked with a pen (without using colour), he did this in a more fluent style (ill. 67). A few colour drawings from the early months of 1887 were done in crayon. He also experimented using a combination of crayon and pen, but this proved to be rather unsuccessful: the fine pen and the much coarser crayon did not make for a successful partnership.

In the summer of 1887 Van Gogh made two series of townscapes in watercolour, and these show innovations both in the technique and style of his drawing. A few of them are carefully executed works on a modest scale (ill. 69, 71, 72), while others are larger and drawn in a looser style (ill. 73). While Van Gogh's development was certainly less pronounced in his drawings than in his paintings, where his artistic past was a much heavier burden, there are great differences between his watercolour drawings of 1887 and those done in his years in the Netherlands: the latter are subdued and rather murky in colour, whereas the Paris drawings are translucent and bright. Obviously this was related to his choice of colours, but there was a technical explanation as well. In the Netherlands Van Gogh had almost invariably worked with gouache, sometimes highly diluted. In Paris he worked for the first time as a true watercolourist, which intensified the brightness and the attractive contrasts of complementary colours.

69
Gate in the Paris ramparts
June–September 1887
24 x 32 cm
Van Gogh Museum,
Amsterdam

70
Hiroshige
*A hundred views of
famous places in Edo:
View of the theatre street
Saruwakacho by night*
1856–1859
34 x 22 cm
Van Gogh Museum,
Amsterdam

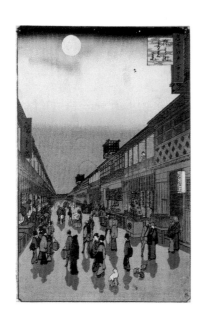

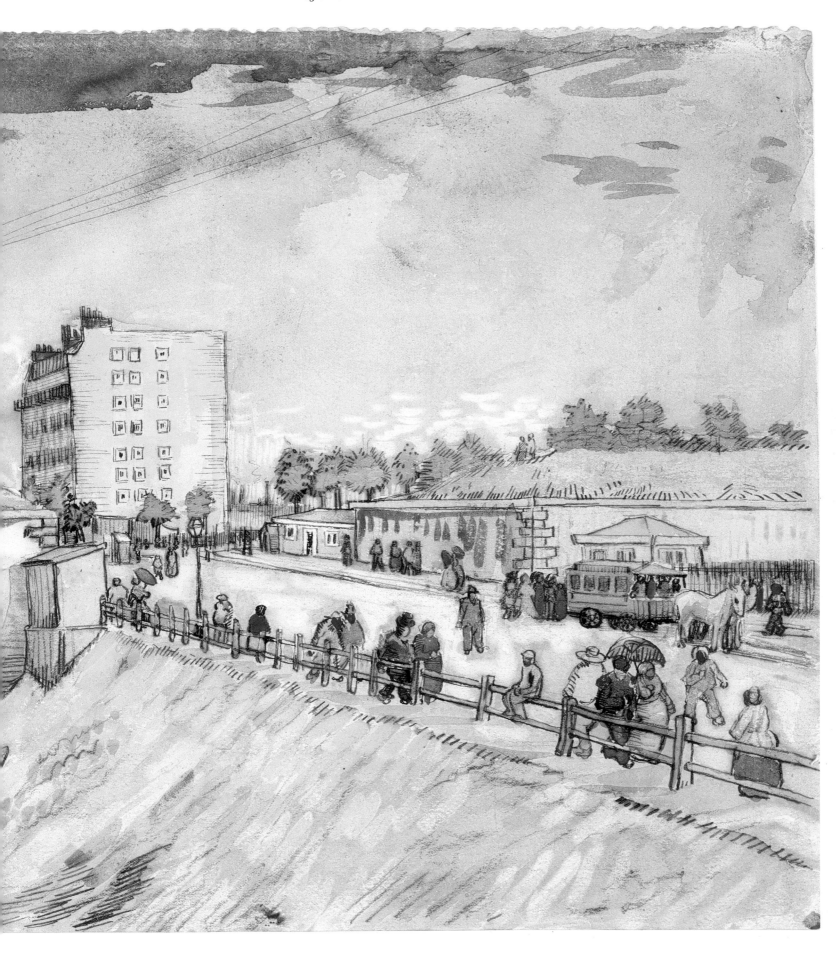

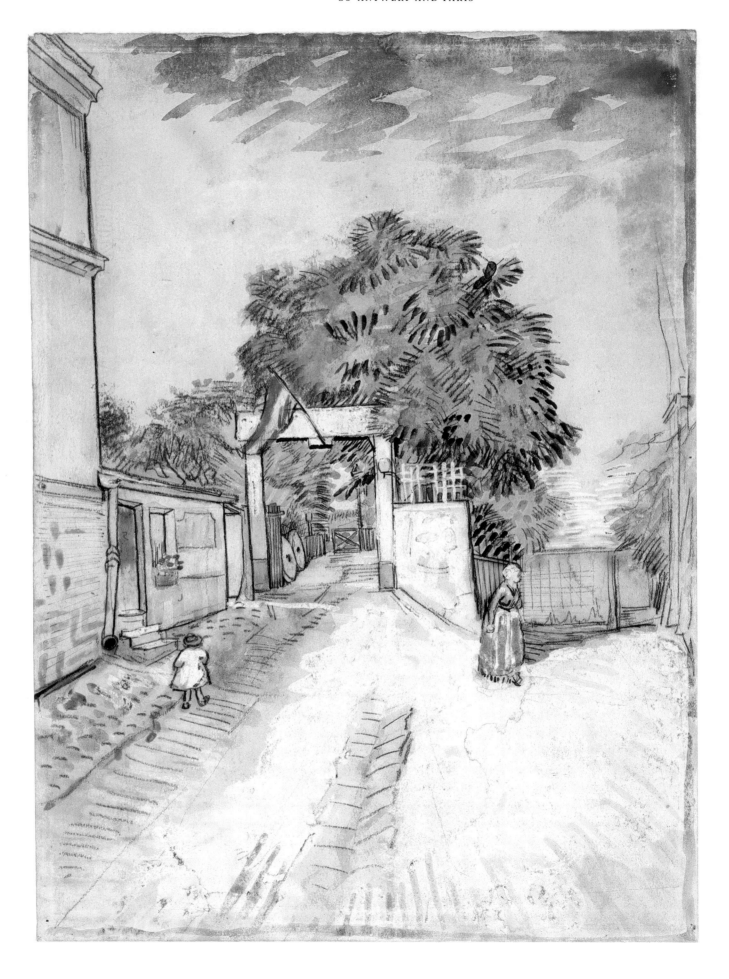

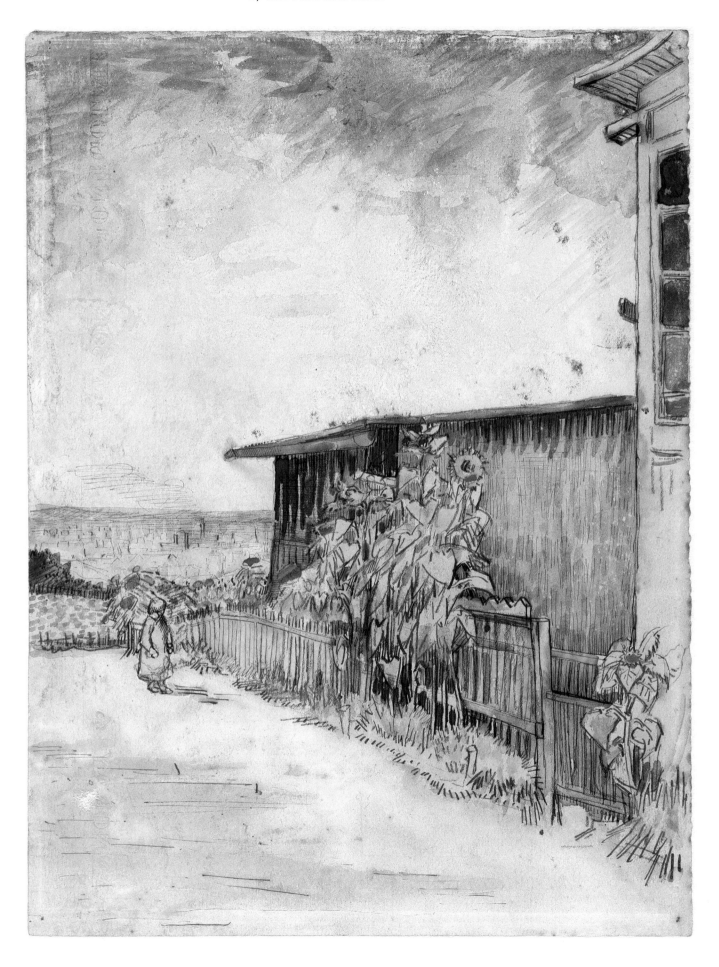

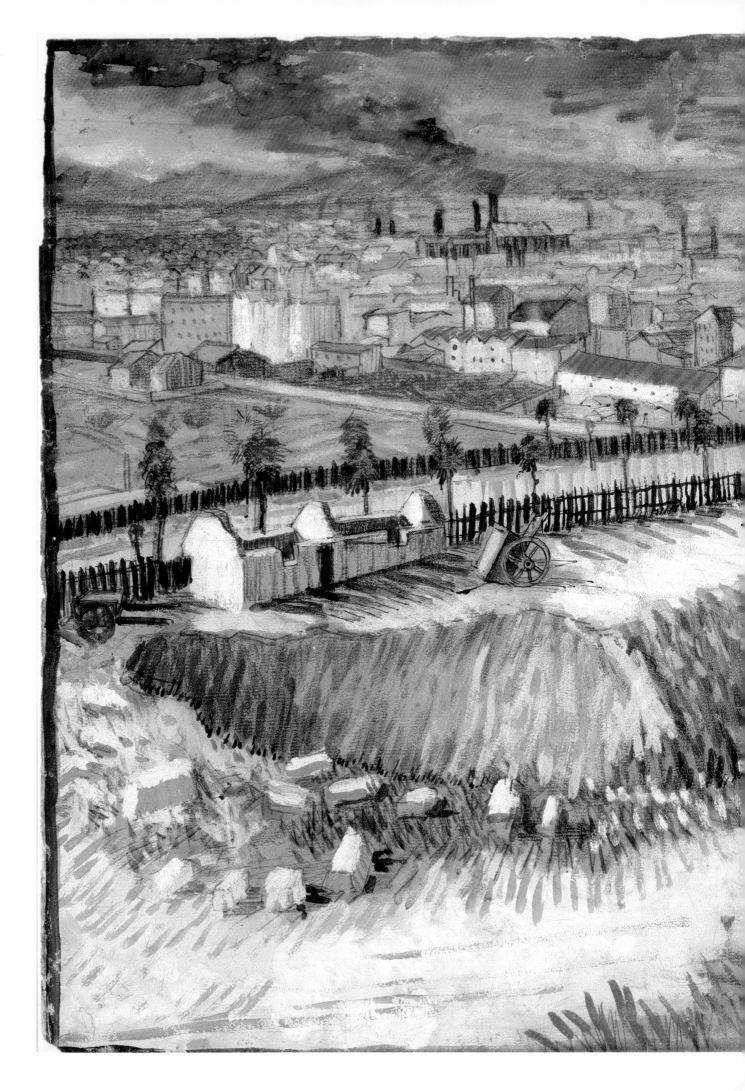

<< 71
*Entrance to
the Moulin de la Galette*
June–September 1887
32 x 24 cm
Van Gogh Museum,
Amsterdam

<< 72
Shed with sunflowers
August–September 1887
32 x 24 cm
Van Gogh Museum,
Amsterdam

73
*Suburb of Paris,
seen from Montmartre*
1887
39 x 53 cm
Stedelijk Museum,
Amsterdam

He was greatly influenced, particularly in his small views of Monmartre, by *ukiyo-e* prints (depictions of everyday life in Japan, which were usually in the same fairly small size). Van Gogh was deliberately following in the footsteps of the Japanese masters he had come to admire so much, and whose graphic work he had started to collect–a collection now preserved in the Van Gogh Museum. He bought the prints mainly from the gallery run by the art dealer Siegfried Bing (1838–1905), where he also came across other Japanese works of art. By comparing Van Gogh's drawings–for example, *Gate in the Paris ramparts* (ill. 69)–with these Japanese prints (ill. 70), it is easy to see how he learned from them. There are striking similarities: the use of bright colours, the characteristic compositions, daring perspectives and tiny figures populating the scene. In addition, these drawings correspond in size to their Japanese models. In his painted work Van Gogh was greatly influenced by impressionists such as Claude Monet (1840–1926) and younger artists such as Paul Signac (1863–1935) and Henri de Toulouse-Lautrec (1864–1901). However, in his drawings made in the summer of 1887 the Japanese models set the tone.

The complementary contrast When reading his textbooks back in Nuenen, Van Gogh had already discovered the complementary contrast. Here, once again, the ideas of Eugène Delacroix were of great importance. A complementary contrast is created when utterly contrary colours are placed next to one another: red and green, orange and blue or yellow and purple. As they are on opposite sides of the colour circle, when you mix them together they neutralize one another and blend into a shade of murky grey; but if you place these colours next to each other, the results can be very powerful and expressive. Van Gogh was constantly searching for contrasts of this kind.

There are few highlights to be found among the drawings done in Paris, as Van Gogh was concentrating on painting. After doing the townscapes, he made only a few more drawings. There is a small, but successful, severe-looking self-portrait (ill. 74); apart from this, the studies that are known are usually modest, sometimes experimental, and generally very sketchy. Van Gogh was well aware that his artistic prospects had dramatically improved in Paris. He was full of confidence when he moved to Arles, a town in Provence, in February 1888, and it was there that his draughtsmanship was to achieve greatness.

< 74
Self-portraits
January–June 1887
31 x 24 cm
Van Gogh Museum,
Amsterdam

1888–1889

Arles

The inspired line

ON 20 FEBRUARY 1888 Van Gogh reached Arles. He had left Paris because he was longing to spend some time in the unspoilt countryside, and he was also keen to escape the cold. He was therefore very disappointed when he arrived to find Arles beneath a thick layer of snow. To make matters worse, this prevented him from working out of doors.

In March he did his first drawings, as is indicated by one dated work (ill. 75), but he did not refer in his letters to another drawing until 9 April. Working on the assumption that the colourful Paris townscapes were done no later than September 1887, it would have been six months since Van Gogh had made any serious attempt at drawing, so he could hardly have effected any significant changes to his drawing style or technique in the meantime. This makes the Arles drawings all the more surprising. It was here that Van Gogh discovered the reed pen, and the drawings he made with it seem at first sight to mark an abrupt change of course in his oeuvre. However, a comparison with his Paris paintings and with Japanese prints offers surprising insights. Paintings as different as the still life with two sunflowers (ill. 76), the still life with cabbages and onions (ill. 77) and a self-portrait (ill. 78) show an analogous need for strong and controlled variation in his brushstroke, which finds an echo in the lines, coils and dots of the pen-and-ink drawings done in Arles.

Van Gogh had already worked with a reed pen in Etten, but he recalls 'I hadn't such good reeds there as here.' [602/478] Indeed, in all the work he

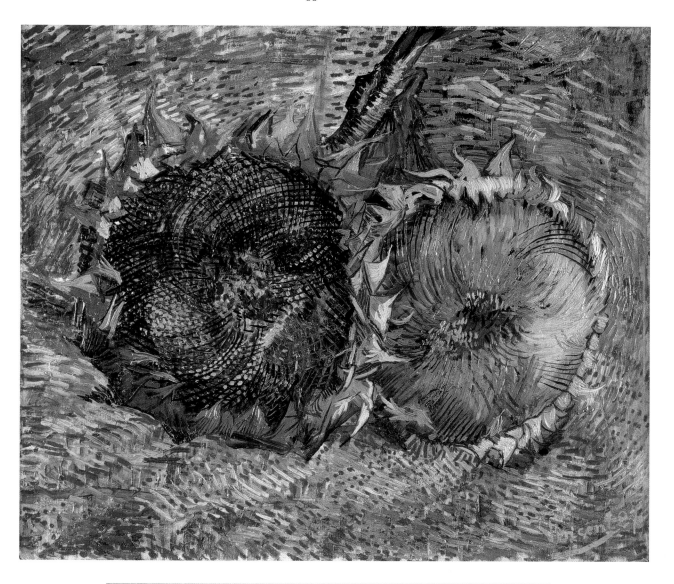

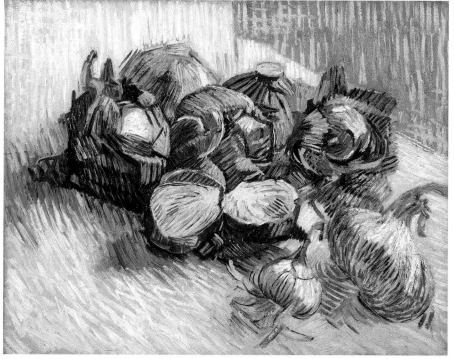

76
Sunflowers
1887
50 x 60 cm
Kunstmuseum Bern,
Bern

77
Still life with
cabbages and onions
autumn 1887
40 x 65 cm
Van Gogh Museum,
Amsterdam

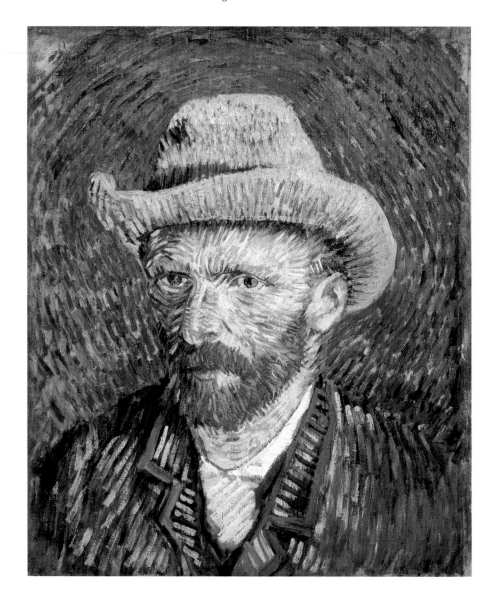

78
Self-portrait
1887–1888
44 x 38 cm
Van Gogh Museum,
Amsterdam

did in the Netherlands there is nothing that resembles the fluid style of
drawing that characterized his work done in Arles. For all that, it is doubt-
ful whether the quality of French reeds was in fact so much better than the
type of reed to be found in the Netherlands, or whether it was not simply
that Van Gogh as a mature artist had developed a skill that, at this point,
enabled him to take full advantage of the characteristic qualities of this pen.

VAN GOGH AND JAPAN In the Provençal landscape around Arles Van
Gogh found much that reminded him of Japan, a country that he knew only
through art and literature. Four weeks after his arrival, he gave a glowing
description of the surrounding area to Emile Bernard (1868–1941), whom
he had met at Cormon's studio: 'Having promised to write, I want to begin
by telling you that the country struck me as being as beautiful as Japan for
the limpidity of the atmosphere and gay colour effects. The water makes
patches of a beautiful emerald and a rich blue in the landscapes, such as we
see in crepons [Japanese prints].' [590/B2] Given his enthusiasm, it is not

surprising that *ukiyo-e* prints continued to influence Van Gogh's work. Just as he had done in Paris, he chose to make drawings in smaller formats, which were approximately the same size as Japanese woodcuts (around 25 x 35 cm), and he divided his compositions into large flat areas. In his paintings these areas were coloured with a regular brushstroke, while in the drawings he often chose to fill in an area with a particular kind of penstroke (for example, stippling when depicting the sky). In his harvest drawings, executed in the summer of 1888, he tried a combination of pen and patches of colour, inspired by Japanese models. Nevertheless, he still generally reserved colour for his paintings. In order to give Theo an idea of the canvases he was working on, he made a few watercolours after paintings, which he sent him. The Japanese atmosphere was also dominant in these drawings, particularly in the strong, bright colours to be seen in *The Langlois bridge* of April 1888 (ill. 80).

79
Provençal orchard
30 March–17 April 1888
39 x 54 cm
Van Gogh Museum,
Amsterdam

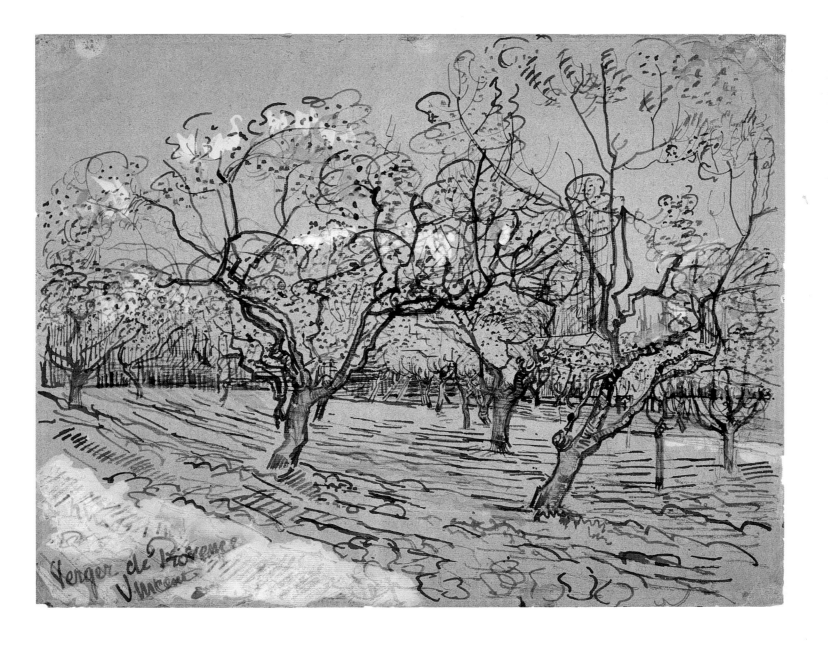

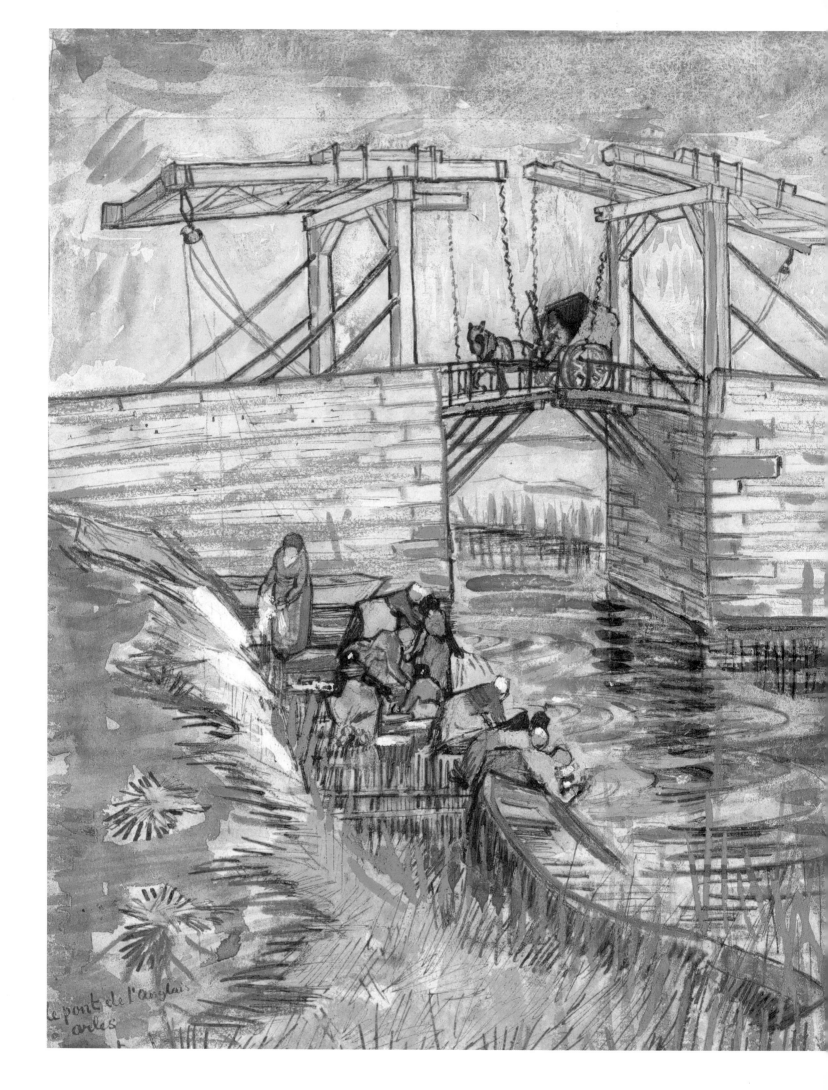

le pont de l'anglais
a rles

Laid and wove paper Van Gogh worked with many sorts of paper. In addition to the heavy watercolour paper he liked to draw on in his early years, the types of paper he used can be divided into two groups: laid and wove paper. Laid paper is a dipped paper in which the pattern of the sieve is easily recognizable: long wires a few centimetres apart intersect with finer, closer-knit wires. This paper has a visible surface structure. Wove paper is dipped using a sieve with a much finer structure, and this gives it a far smoother, more even surface than laid paper. Both types may have watermarks, made by inserting a wire into the sieve in the form of a name or a symbol. Where the wire is inserted the paper is thinner, so that the watermark becomes visible if held up to the light.

In the early spring of that year, drawing was set aside for a short time, as Van Gogh made a large series of paintings of orchards, in which he concentrated on capturing their colours on canvas. But in the second week of April he once again announced to Theo that he would have to do a '*tremendous* lot' of drawing, 'because I want to make drawings in the manner of Japanese prints.' [596/474] Although he made two larger drawings at the time (ill. 79), he decided to confine himself mainly to smaller-sized sheets, of which he wanted to make a series. He soon completed this, and on 1 May he wrote to Theo that he had just sent 'a roll of small pen-and-ink drawings, a dozen I think.' [604/480] More drawings were soon to follow, seventeen in all. Van Gogh also worked up a number of the subjects in his paintings, sometimes using the drawings as models (ill. 75, 83). Not all the works can be firmly dated: a view of the road to Tarascon may be from this period, but considering how leafy the trees are, it could have been done in the summer (ill. 81).

MONTMAJOUR – THE FIRST SERIES Soon after he arrived, Van Gogh explored Arles and the surrounding area and discovered Montmajour, a hill some five kilometres to the north-east of the town with an impressive ruin of a medieval Benedictine abbey. This hill was featured in two series of drawings, the first of which was done in May 1888.

80
The Langlois bridge
April 1888
30 x 30 cm
Private collection

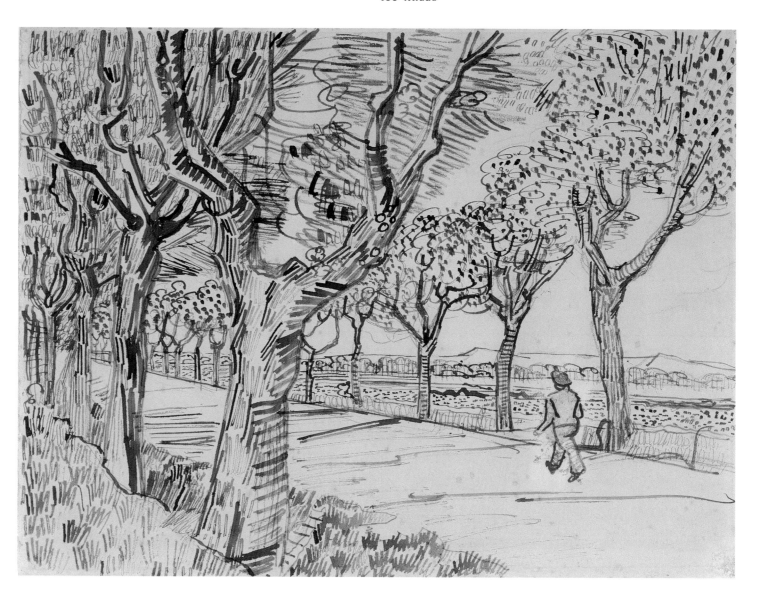

81
*The road to Tarascon
with a man walking*
spring/summer 1888
25 x 34 cm
Kunsthaus Zürich,
Zürich

82
The ruins of Montmajour
reproduction in the
1928 catalogue raisonné

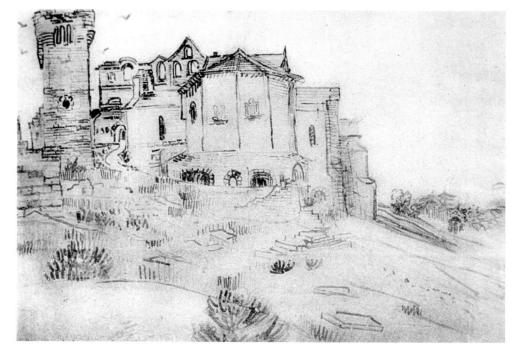

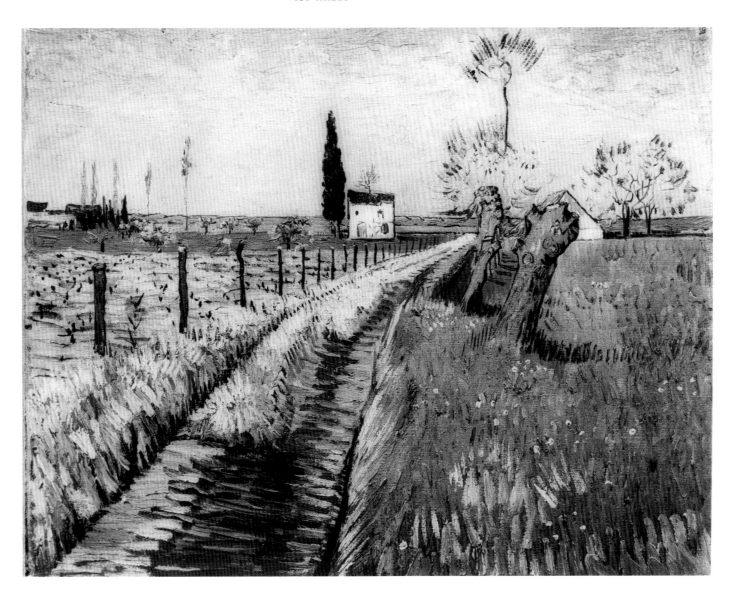

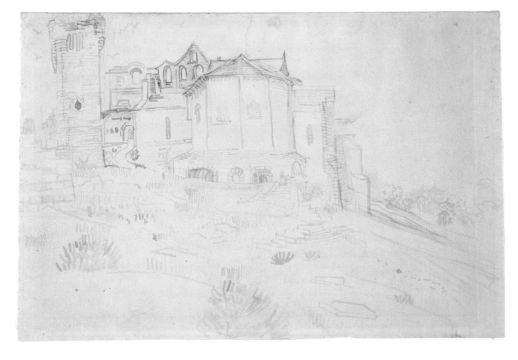

83
*Landscape with path
and pollard willows*
April 1888
31 x 39 cm
Private collection

84
The ruins of Montmajour
May 1888
31 x 48 cm
Van Gogh Museum,
Amsterdam

The first Montmajour series consisted of seven drawings. Van Gogh drew in pencil and reed pen using aniline ink on laid paper, and each drawing was done on a half-sheet. Aniline ink comes in a variety of colours, but it is light-sensitive, and unfortunately the ink has faded in all the drawings, sometimes to a dull shade of brown (ill. 84). Comparison with an old reproduction, which is still almost in its original state, shows the dramatic deterioration of this once magnificent picture of the abbey ruins (ill. 82). Of the whole series, only a panoramic prospect of Montmajour seen from the plain of La Crau is in a reasonably satisfactory state (ill. 85).

Some of these works show Van Gogh's characteristically balanced combination of pencil and ink, in which the pencil plays a remarkably important part (an effect that the fading of the ink has heightened). The original shade of the ink cannot always be determined with any certainty; in a few works, where the mount has protected the ink from light, traces of purple ink have been preserved, and there are also descriptions of some of the works stating

that they were actually done in purple. However, it is also quite possible that purple is the colour that occurs at a certain stage as aniline ink decomposes, and that it was not therefore the original colour. There is even a possibility that the drawings were done in more than one colour.

Japan was constantly in Van Gogh's thoughts while he was making this series. He suggested to Theo that these sheets would be very suitable to 'make sketchbooks with 6 or 10 or 12 like those books of original Japanese drawings. *I very much want* to make such a book for Gauguin, and one for Bernard.' [617/492] A telling sketch in the letter with four recognizable drawings illustrates his plans (ill. 87).

A SEASIDE VILLAGE: LES SAINTES-MARIES-DE-LA-MER At the end of May 1888 Van Gogh travelled by diligence to spend a few days at Les Saintes-Maries-de-la-Mer, a Mediterranean fishing village on the edge of the Camargue. There he found southern variants of subjects he had already

tackled in Scheveningen: boats on the beach (ill. 86) and at sea (ill. 88), picturesque fisherman's cottages (ill. 89–92) and a view of the village with its typical fortified church (ill. 93).

For his trip to Les Saintes-Maries Van Gogh took 'especially whatever I need for drawing'. The strength of his Provençal subjects had already been praised by Theo, and he wanted to develop these further: 'I must draw a great deal, for the very reason you spoke of in your last letter. Things here have so much style. And I want to get my drawings more deliberate, more exaggerated.' [620/495] He returned to Arles at the beginning of June with nine drawings and three paintings and wrote elatedly to Emile Bernard around 7 June: 'At last I have seen the Mediterranean.' [625/B6] His letters indicate unmistakably the marked increase in his self-confidence.

In several of the landscapes he made in Arles from March to May there are traces of lines that point to his use of a perspective frame. However, he boasted that he had done the drawings of the boats on the beach without

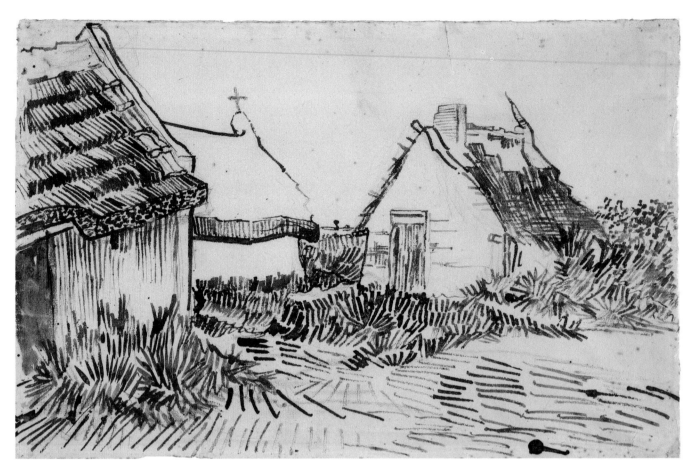

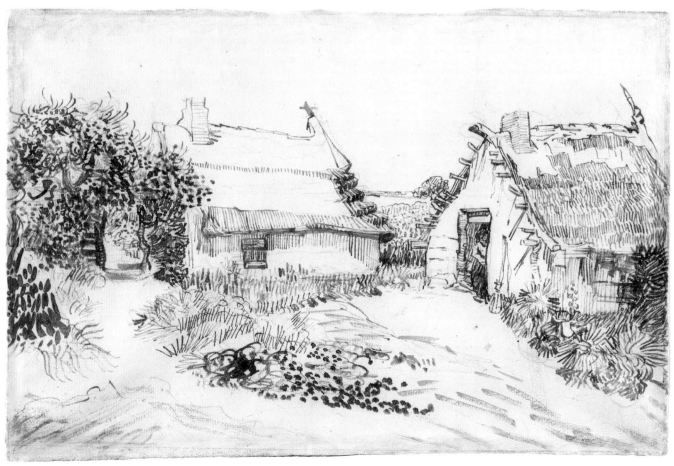

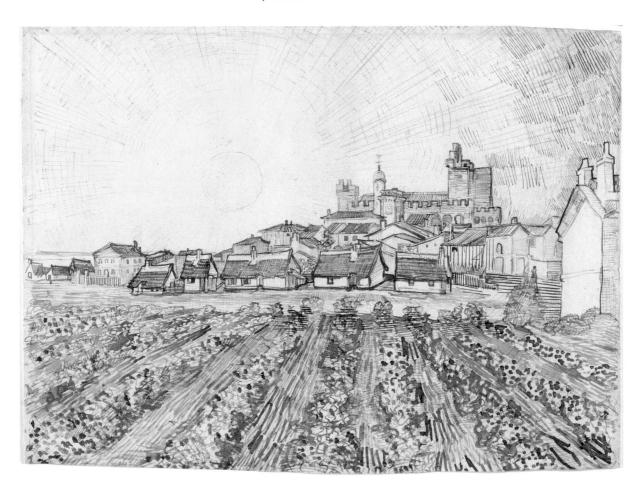

any sort of aid, thanks to the inward harmony he had found in Arles. In this way he was once again emulating Japanese artists: 'I am convinced that I shall set my individuality free simply by staying on here. The Japanese draw quickly, very quickly, like a lightning flash, because their nerves are finer, their feeling simpler. I have only been here a few months, but tell me this – could I, in Paris, have done the drawing of the boats *in an hour*? Not even with the perspective frame, and this one is done without measuring, just by letting my pen go.' [623/500]

The boats on the beach and the view of the village are large drawings, executed fairly carefully. Using smaller-sized paper, Van Gogh also experimented in a few of his pictures of the fishermen's cottages with the 'more spontaneous, more exaggerated' style of drawing he had already heralded in his letter to Theo: a fluent, spontaneous style in which he also used a brush, applying the ink thickly and ignoring proportions in favour of effective expression (ill. 90, 91).

In his studio in Arles Van Gogh made paintings after the three drawings executed in Les Saintes-Maries, including the picture of the boats (ill. 86, 95).

< 91
Three cottages,
Saintes-Maries-de-la-Mer
end May–beginning June 1888
30 x 47 cm
Van Gogh Museum,
Amsterdam

< 92
Two cottages,
Saintes-Maries-de-la-Mer
end May–beginning June 1888
30 x 47 cm
Pierpont Morgan Library,
New York

93
View of
Les Saintes-Maries-de-la-Mer
end May–beginning June 1888
43 x 60 cm
Sammlung Oskar Reinhart am
Römerholz, Winterthur

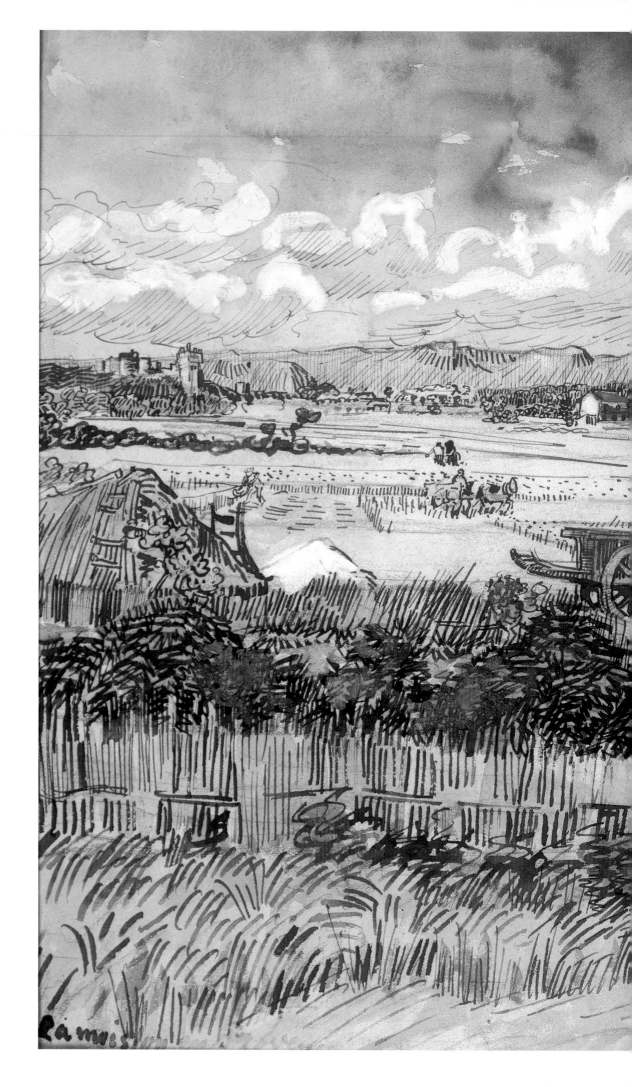

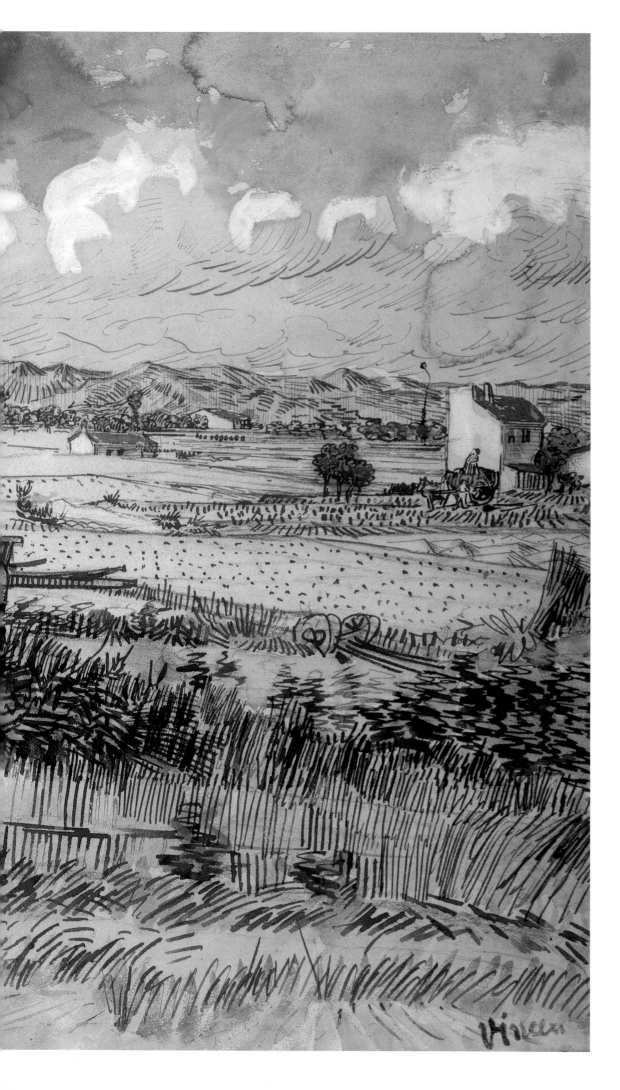

94
The harvest
June 1888
48 x 60 cm
Private collection

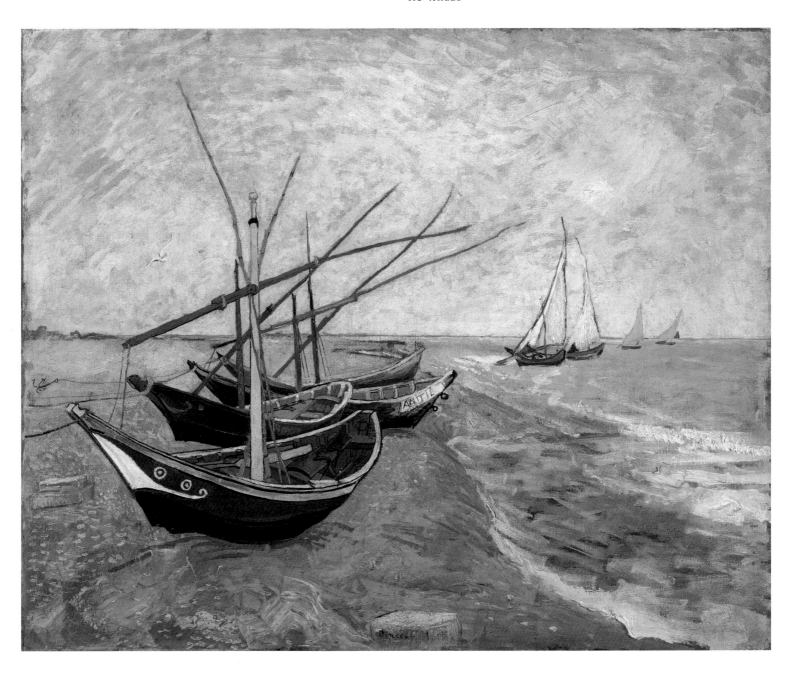

95
Fishing boats on the beach at
Les Saintes-Maries-de-la-Mer
June 1888
65 x 82 cm
Van Gogh Museum,
Amsterdam

THE HARVEST In June, as the wheat was just about to be harvested, Van Gogh saw an opportunity for a new series of paintings and drawings. He considered that this subject and that of the sower were the most powerful expressions of country life, and, as they had in Nuenen, they soon captured his attention. The earliest version of *The harvest* (ill. 96) was his first attempt at a new working method inspired by Japanese prints. He had asked Theo to send him some watercolours because he was planning to make pen-and-ink drawings that he would also colour in – just like Japanese woodcuts

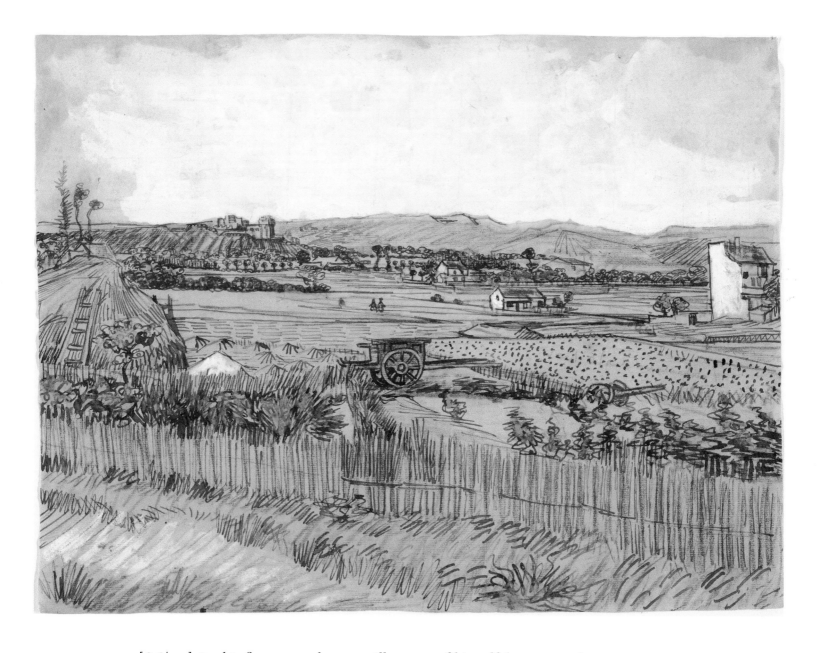

[616/491]. In this first group, he was still unsure of himself, but a second attempt produced a spectacular result (ill. 94). After doing the preliminary design in pencil, he made a complete pen-and-ink drawing, which was then coloured in using gouache – in perfect harmony with his 'Japanese' inspiration. Van Gogh was clearly satisfied: he signed the drawing, gave it a title, and also made a large painting of the same subject (ill. 97). After this, the harvest was mainly the subject of paintings; and these served some time later as models for drawings.

96
The harvest
June 1888
39 x 52 cm
Fogg Art Museum,
Harvard University,
Cambridge

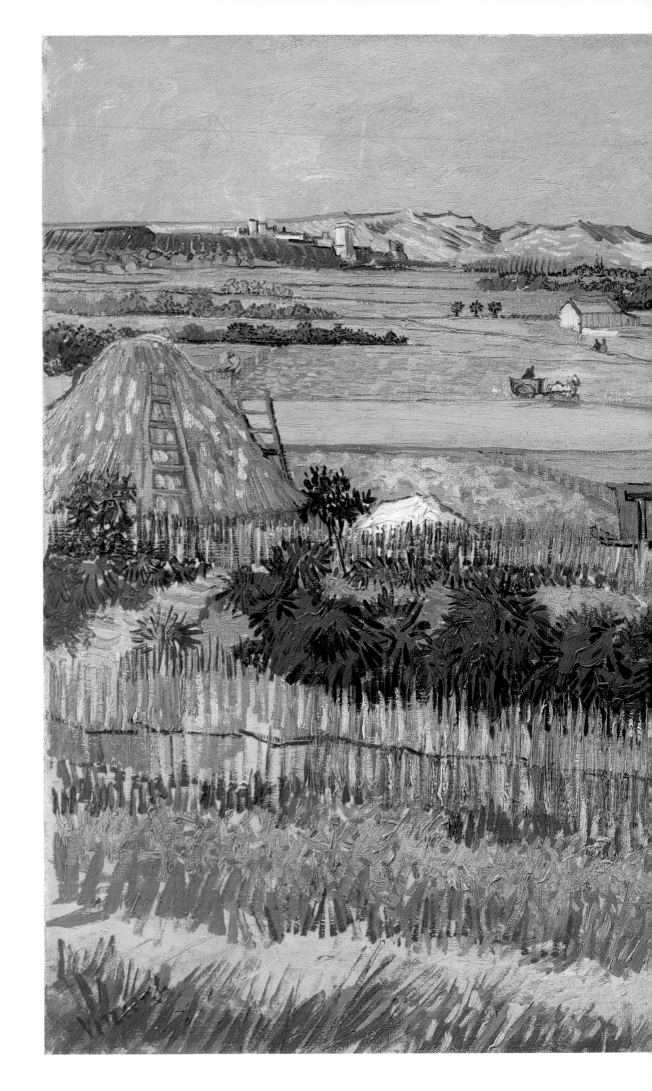

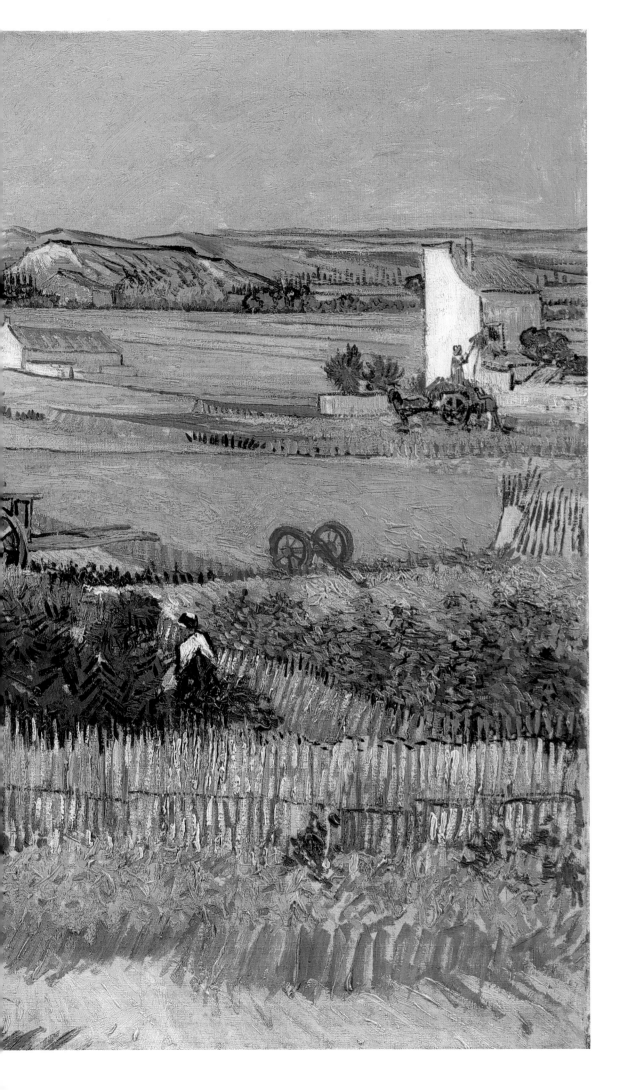

97
The harvest
June 1888
73 x 92 cm
Van Gogh Museum,
Amsterdam

98
The Zouave
June 1888
65 x 54 cm
Van Gogh Museum,
Amsterdam

99
The Zouave, seated
20–25 June 1888
49 x 61 cm
Van Gogh Museum,
Amsterdam

FIGURES AND HEADS Although for a few months Van Gogh had worked with some success mainly on landscapes, he had not lost sight of his great passion: depicting the human figure. However, before he could devote himself completely to the figure, he wanted first to regain his strength, because life in Paris had thoroughly exhausted him, as he told the Dutch painter Arnold Koning (1860–1945): 'This is what I am aiming at, only it seemed to me that walking and working in the open air would be better for my health, and I did not want to start on the figure before feeling stronger.' [621/498a] Van Gogh had, in fact, an important goal:

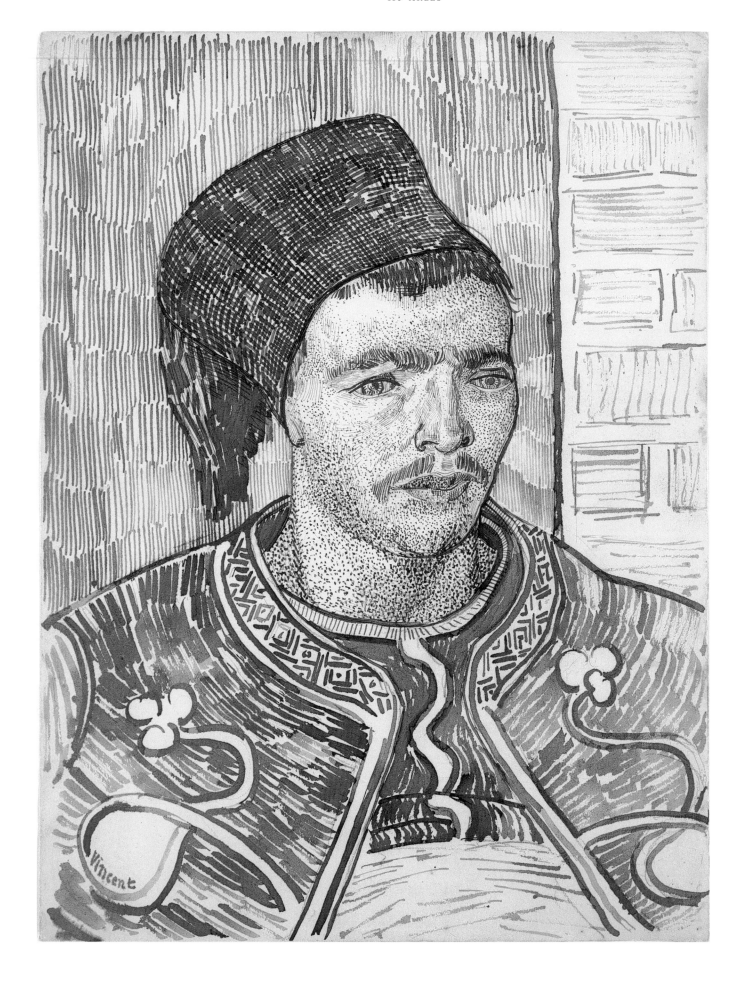

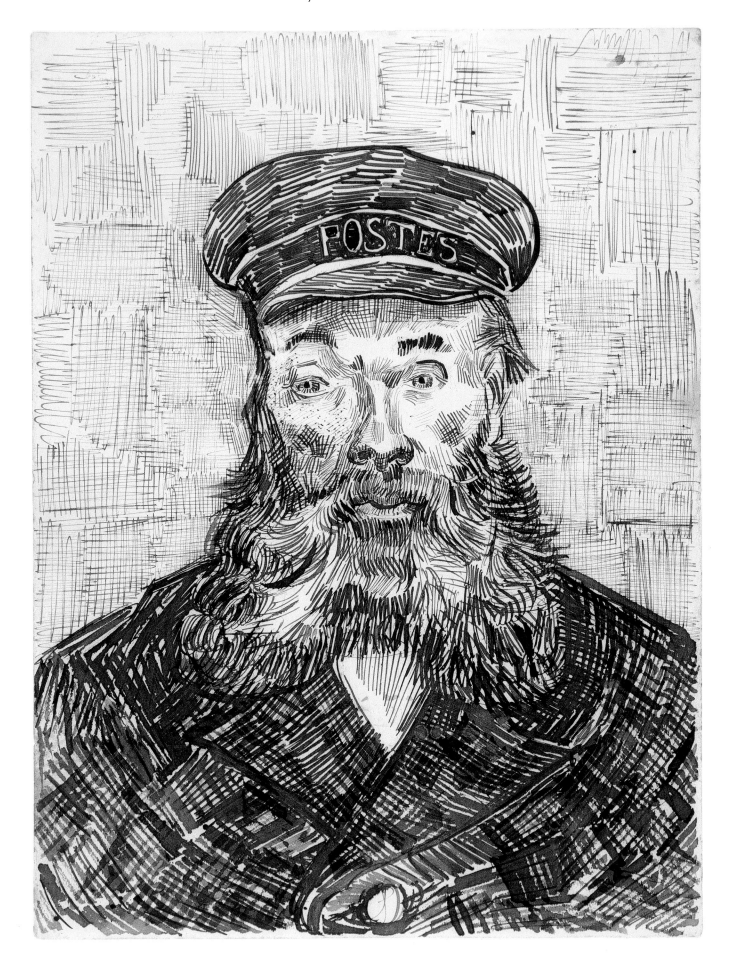

he wanted to make a contribution to modern art specifically with figure paintings, and he wanted to do this by painting his own version of Millet's *Sower* with a modern colour scheme.

This goal did not affect his drawings, as colour was not of such importance to them. Nevertheless, he still focused on the figure in his works on paper, if in a more restrained way. The first opportunity was offered when he met a Zouave. Van Gogh was immediately enthusiastic about this tough-looking young soldier in his striking apparel. He described him to Theo as 'a boy with a small face, a bull neck, and the eye of a tiger.' [631/501] Using him as a model he made two paintings, one of the Zouave sitting up against a wall, the other a half-length portrait (ill. 98). In addition to this, he made a large pen-and-ink drawing from life (ill. 99). In this drawing, Van Gogh clearly attempted to do justice to the tough, manly character of the Zouave, who looks challengingly at the spectator, his hands placed firmly on his thighs. However, the proportions of the figure are not very satisfactory, and the work as a whole is not entirely successful.

Shortly afterwards, Van Gogh made two drawings after the half-length portrait, one in watercolour, the other in pen. The latter is one of the most successfully drawn portraits he was ever to make (ill. 100). The man's head is rendered with a fine pen in a detailed, delicate manner, making an attractive contrast with the rest of the picture, which was drawn quickly using a reed pen. A comparable procedure was used in two other portrait drawings that were also made after paintings: that of his friend, the postman Joseph Roulin (ill. 101), and one of a girl from Arles, to which he gave the Japanese title *La mousmé* (ill. 102).

MONTMAJOUR – THE SECOND SERIES In the first half of July, Van Gogh was attracted once again to the plain of La Crau and Montmajour, and he drew a second series of landscapes there. This consisted of five drawings, but he wrote to Theo that another sheet he had already sent at the end of May should be considered as part of the series [643/509] (ill. 103). He took up drawing again because it was cheaper than painting – and because he had recently found it impossible to continue working on a fairly large canvas while he was being buffeted by the mistral. Taken together, the six drawings are unquestionably a high point in his career as a draughtsman. Not only do they show Van Gogh's maturity in the medium, they also demonstrate his versatility. *View of Arles from Montmajour* clearly indicates that as early as the end of May he was experimenting with a more fluent and powerful style of drawing, which he also used in a few of the views he did in Les Saintes-Maries. This style of drawing culminated in *The rock of Montmajour with pine trees* (ill. 105); here Van Gogh was working with pencil and a fine pen, but mostly with a reed pen and brush, using grey and black ink. In no

<< 100
The Zouave
end July–begining August 1888
32 x 24 cm
Solomon R. Guggenheim
Museum, New York

<< 101
Portrait of Joseph Roulin
end July–beginning August 1888
32 x 24 cm
Getty Center,
Los Angeles

> 102
La mousmé
end July–beginning August 1888
31 x 24 cm
Thomas Gibson Fine Art Ltd,
London

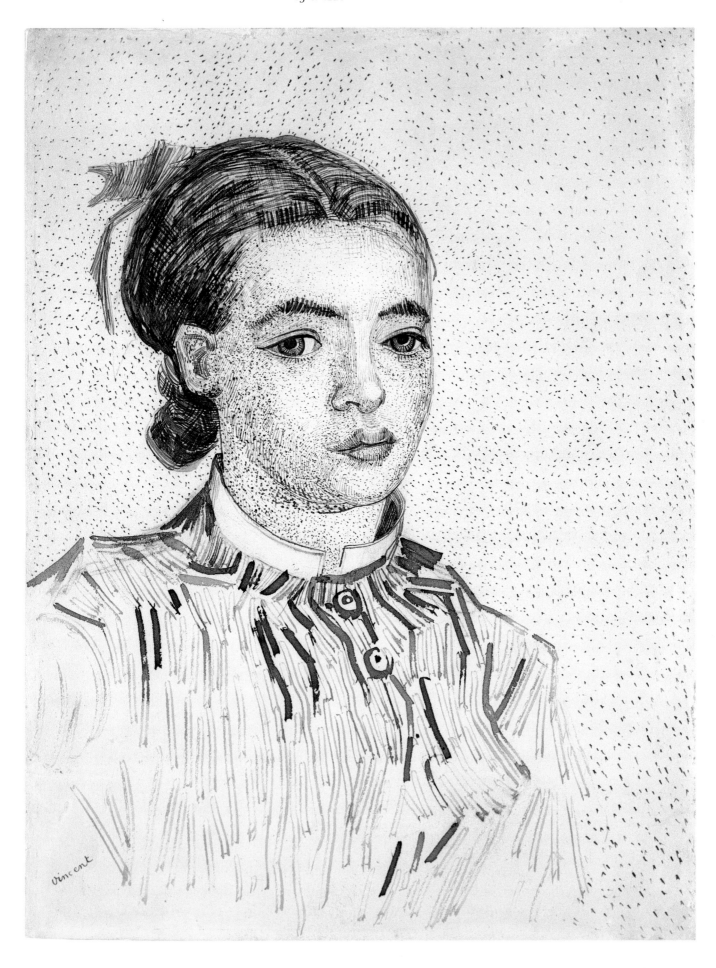

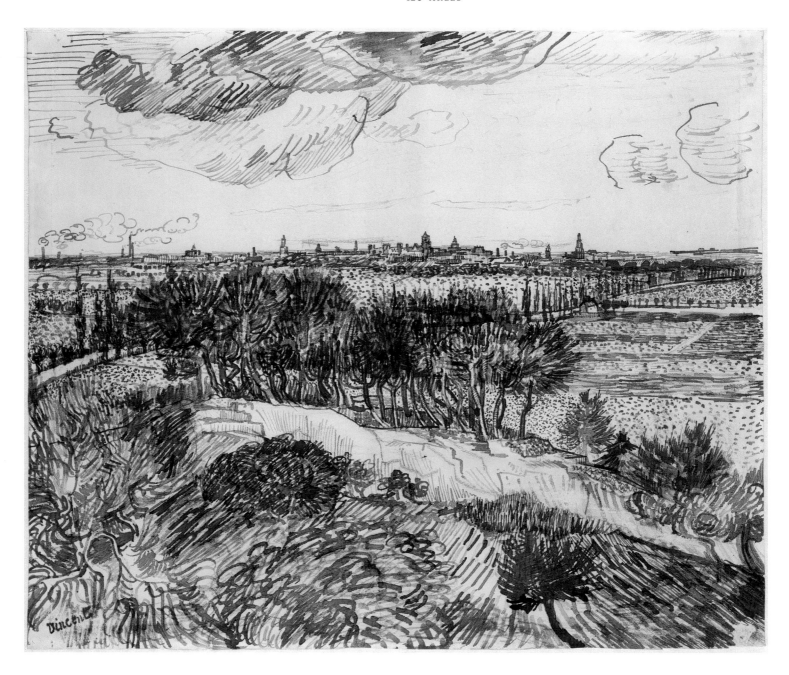

103
*View of Arles
from Montmajour*
May 1888
48 x 59 cm
Nasjonalgalleriet,
Oslo

other drawing was he to get so close to the character of a Japanese pen-and-ink drawing. Another view in the series of trees and rocks is more delicate, because he did it without using pencil, although it also seems to have been produced using this method of drawing (ill. 104).

The other three drawings are more carefully worked out and more balanced, though with no loss in their expressive spontaneity (ill. 106, 107, 109). The two panoramic landscapes – in which Van Gogh recalled Dutch seventeenth-century landscape paintings – display a particularly wide variety of penstrokes. The artist used smaller and finer strokes towards the horizon – one of the techniques he employed to give these landscapes their surprising depth. The compositions show a wealth of detail, such as groups of trees,

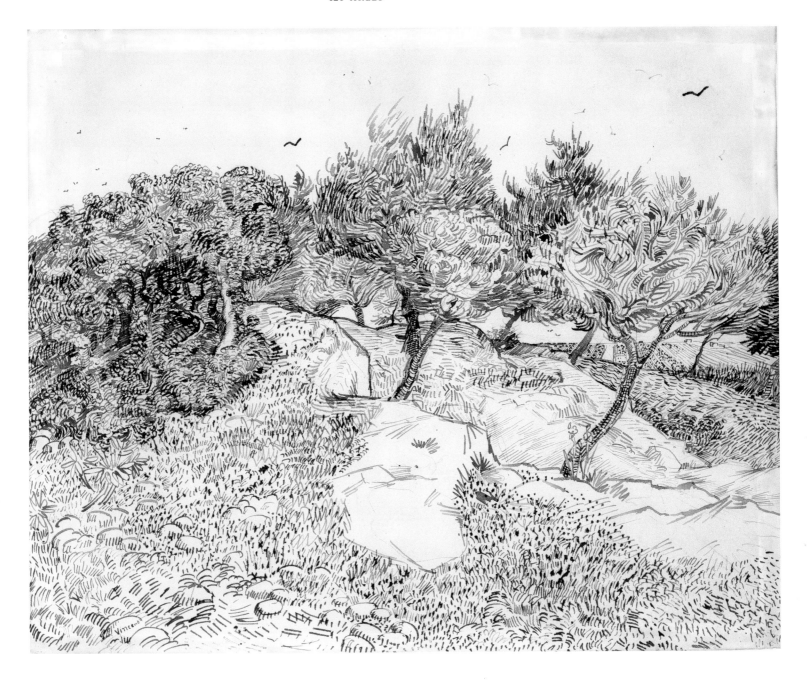

104
Olive trees: Montmajour
July 1888
48 x 60 cm
Musée des Beaux-Arts
de Tournai

walkers and a train, but these features are included so casually and un-obtrusively that one notices them almost by accident. For Van Gogh it was this subtlety that lay at the heart of the Japanese character of the works, as he wrote to Bernard: 'a microscopic figure of a ploughman, a little train running across the wheatfield – this is all the animation there is in it.' [645/B10] The precision of these details was, however, something that was very deliberate, as can be seen from Van Gogh's comparison of these two drawings to a 'map, a strategic plan as far as the *execution* goes' [643/509]. The same exactness can be seen in the way that he described the locations on the drawings, a quite unusual addition to his work.

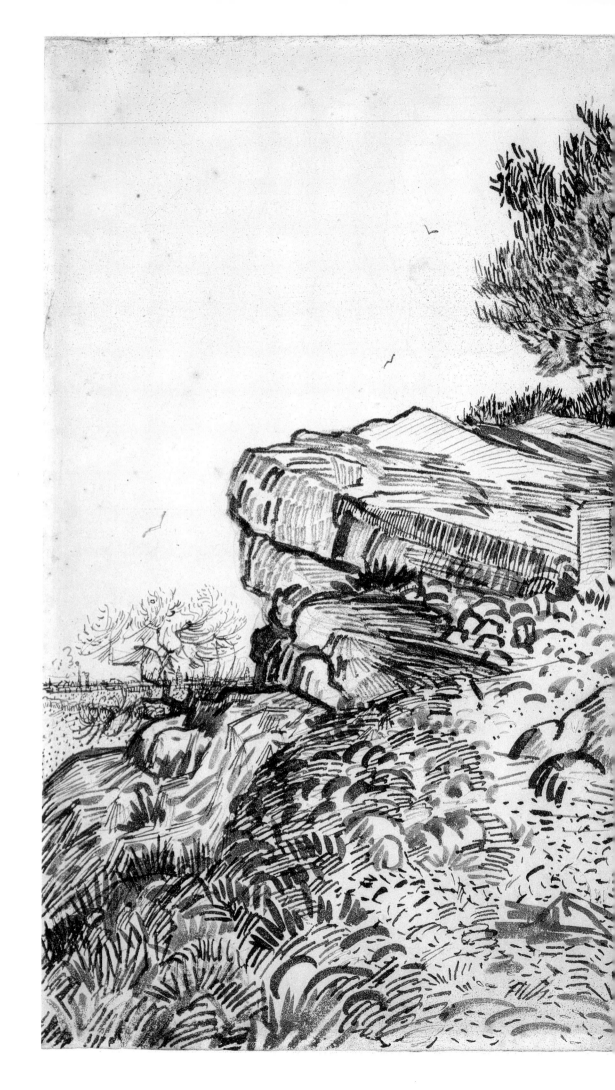

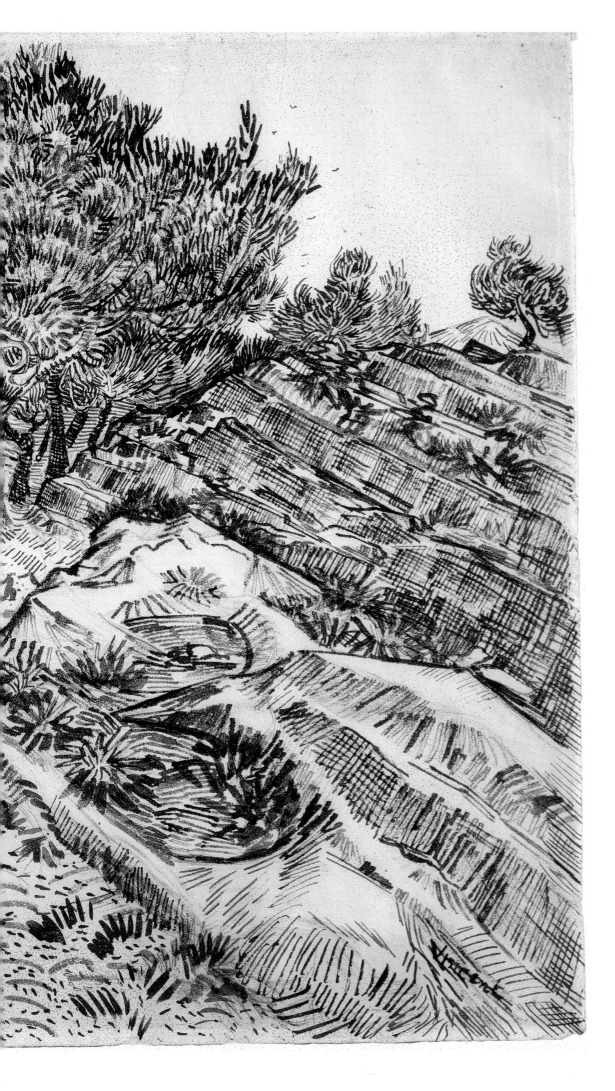

105
*The rock of Montmajour
with pine trees*
first half July 1888
49 x 61 cm
Van Gogh Museum,
Amsterdam

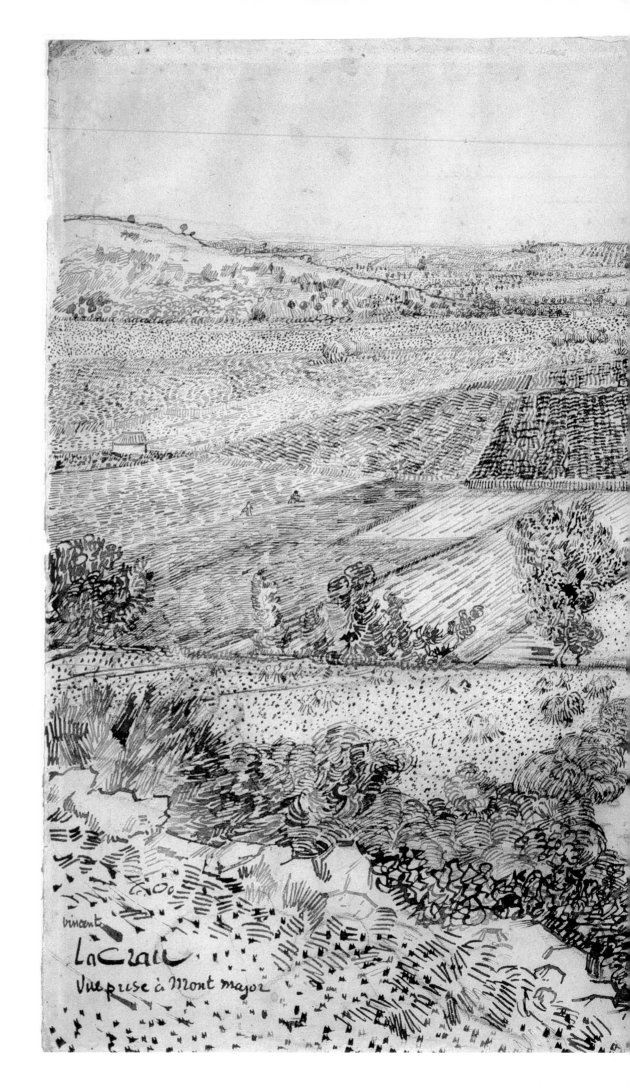

vincent

LaCrau

Vue prise à Mont major

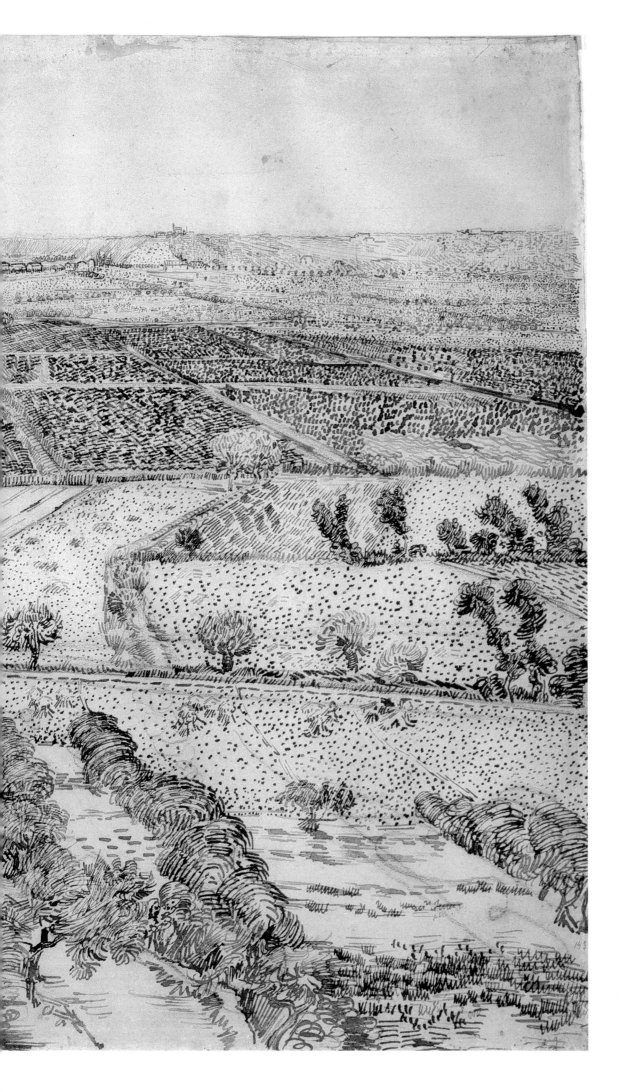

106
*La Crau seen
from Montmajour*
first half July 1888
49 x 61 cm
Van Gogh Museum,
Amsterdam

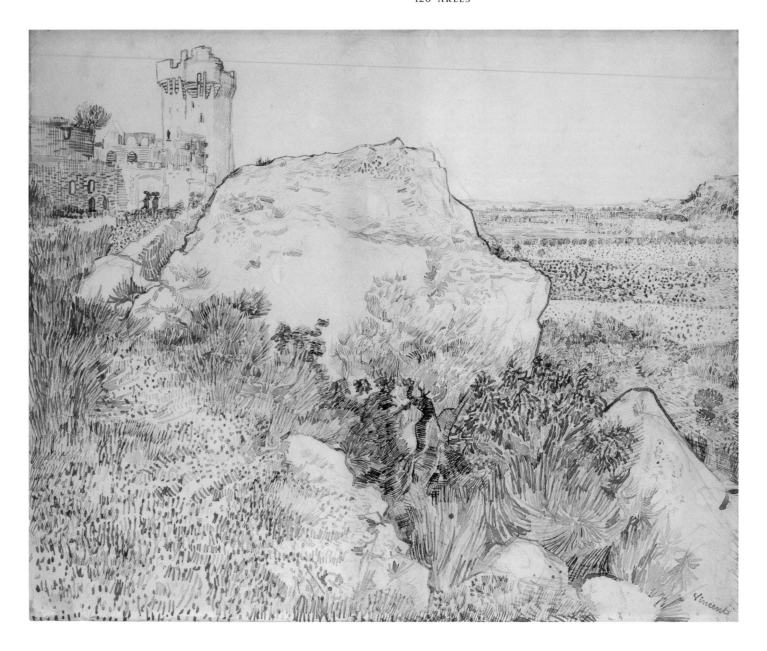

107
*Ruins of the abbey
of Montmajour*
July 1888
48 x 59 cm
Rijksmuseum,
Amsterdam

From the point of view of technique, it is worth noting that pencil plays a much lesser role than in the first Montmajour series, particularly in the two drawings with the trees and boulders (ill. 104, 105), which points to the fact that he was searching for greater clarity of line. This is also borne out by the works done over the succeeding months. In the drawings he did in Saint-Rémy, it was also exceptional for him to use pencil except as a reinforcement.

The drawings reveal a self-assured artist working almost effortlessly: 'So many leaves of Whatman, so many drawings,' he noted, referring to the type of paper he used [642/506].

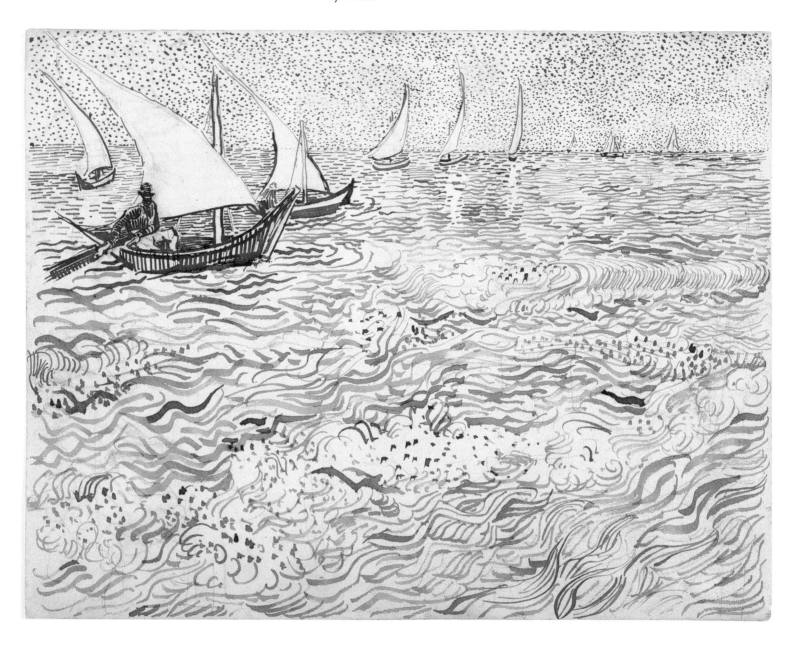

DRAWINGS AFTER PAINTINGS In the second half of July 1888 Van Gogh embarked on three series of drawings after paintings he had done in Arles. The first series of fifteen was intended for Emile Bernard, who gave him some drawings in return. Twelve drawings were made as a gift for John Russell (1858–1931), an Australian painter with whom Van Gogh had become friendly when he was in Paris, in order to persuade him to buy one of Paul Gauguin's canvases from Theo. Finally, his brother was supposed to receive a dozen drawings, but as far as is known he received only five.

Even though they were not exact copies, the drawings were of course intended to give the recipients an idea of the kind of paintings he had made. He was not satisfied with all of his canvases: the brushwork sometimes left

108
Boats on the sea,
Les Saintes-Maries-de-la-Mer
end July–beginning August 1888
24 x 32 cm
Solomon R. Guggenheim
Museum, New York

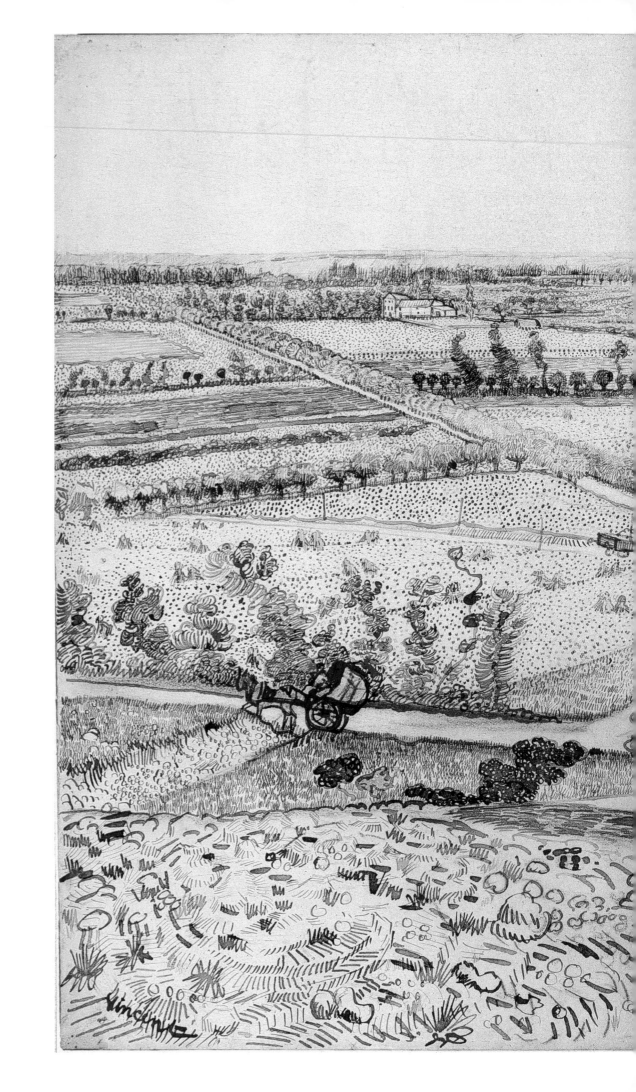

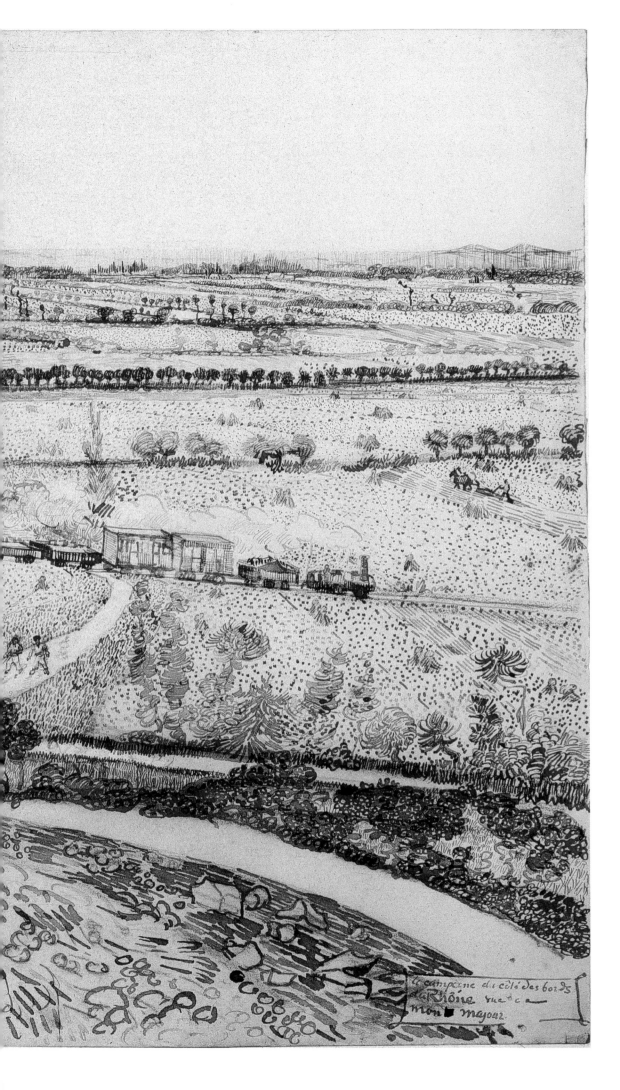

109
*Landscape near
Montmajour with train*
July 1888
49 x 61 cm
The British Museum,
London

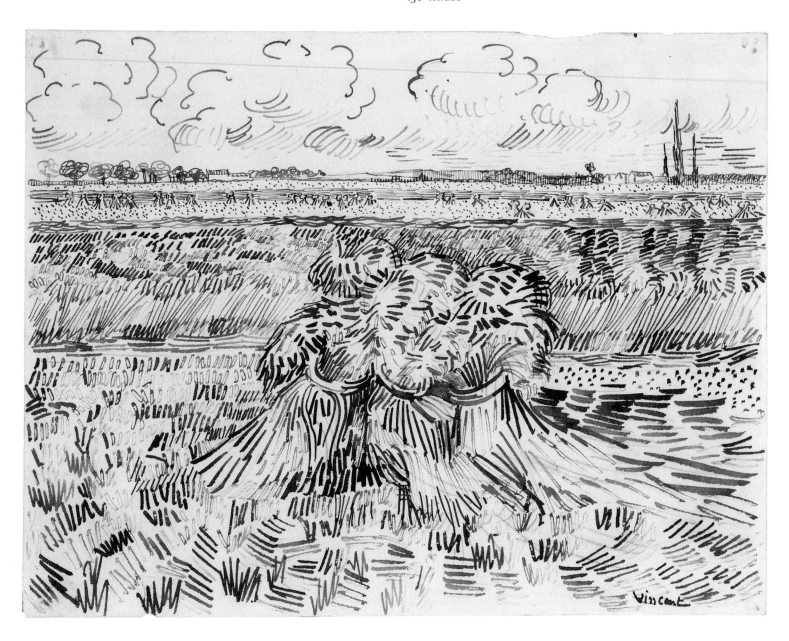

110
Wheatsheaves
June 1888
24 x 32 cm
Staatliche Museen zu Berlin,
Kupferstichkabinett, Berlin

a lot to be desired, He also wanted to achieve a greater degree of precision in the drawings. This artistic process – moving back and forth between paintings and drawings, allowing him to scrutinize the rhythm and cohesion in the composition by comparing the contrasting media – is much in evidence in the work Van Gogh executed in Arles.

Bernard received his drawings in two batches around the middle of July. Van Gogh had included works from Les Saintes-Maries (ill. 92, 108) among the paintings he copied for him, but the emphasis was on the seven drawings after harvest scenes that he had painted in the summer (ill. 110, 111). The painted version of *The sower* (ill. 112) was also part of this group. When he was painting this, he was constantly trying to produce strong colours, to develop a consistent brushstroke and to create a convincing, powerful figure. The effort of this struggle clearly shows in the painting, which in the end left Van Gogh dissatisfied. In his drawing of *Sower with setting sun* (ill. 113) the

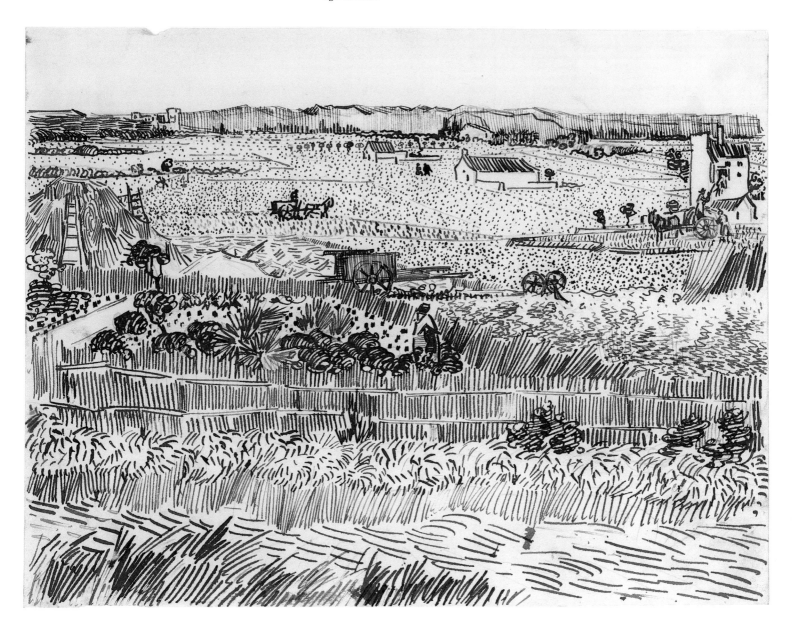

111
Harvest in Provence
July 1888
24 x 32 cm
Staatliche Museen zu Berlin,
Kupferstichkabinett, Berlin

colour is absent, but the picture is varied and lively, with the small figure of the sower taking resolute strides across his field. This fluent, effective style of draughtsmanship is typical of the drawings he sent to Bernard (ill. 114).

The drawings for Russell were more delicate and include, for example, stippled areas, and there was less emphasis on harvest scenes (ill. 115, 117). Russell received no less than three portraits – the pen-and-ink drawing of the Zouave mentioned above, the postman Roulin and *La mousmé* (ill. 100, 101, 102) – and a small group of other subjects (ill. 116, 118).

The five works for Theo include a view of a garden (ill. 119), a seascape (ill. 120), a harvest scene (ill. 121) and a version of *The sower* (ill. 122). In the execution of these drawings the handling of the pen is careful, even, in the case of *The sower,* elegant. There is a sense of joy in the way in which the field, the corn and the sky have been drawn, while, for a peasant, the sower is working in an unusually graceful way.

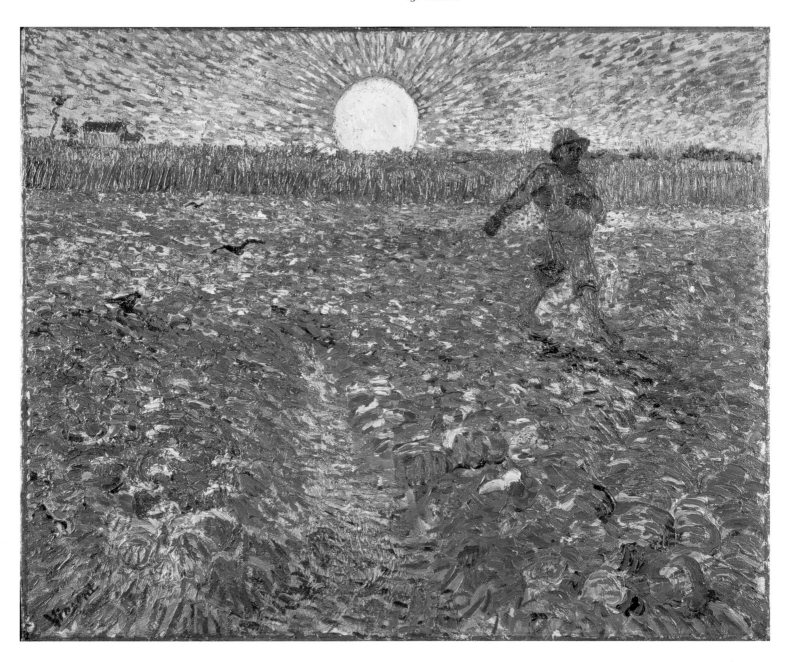

112
The sower
c. 17–28 June 1888
64 x 80 cm
Kröller-Müller Museum,
Otterlo

PARKS AND GARDENS Theo also received three large independent draw-ings featuring gardens as their main subject. The small areas of planned nature to be found in villages and towns greatly attracted Van Gogh. Wher-ever he worked, he made pictures of gardens and parks, and in Arles they were one of his favourite subjects (ill. 123). He cherished strongly poetic feelings towards these places and introduced loving couples into many of the scenes, as he had done in a large painting made a few years earlier in Paris (ill. 124).

Up until July 1888, whenever he was working out of doors, Van Gogh had chosen mainly to depict the landscape around Arles, inspired by his yearning for the unspoilt countryside he had missed so much in Paris.

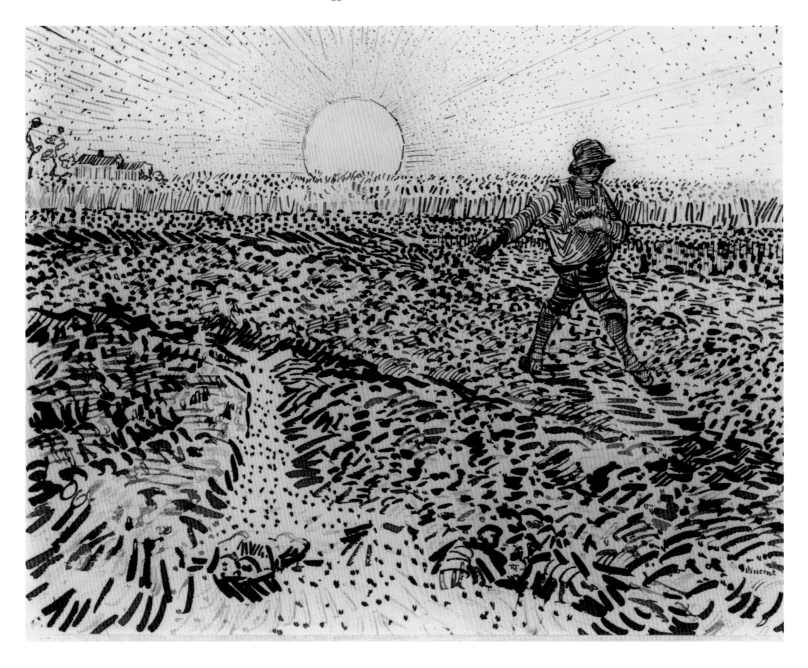

113
Sower with setting sun
July 1888
24 x 31 cm
Private collection

However, from August until October of that year, he also found suitable subjects in town. His series of parks and gardens starts with the impressive summer views of gardens that he sent to his brother in August (ill. 125, 126). The lush vegetation, depicted with a broad range of penstrokes, makes the summer heat seem almost palpable in these scenes.

In September Van Gogh often worked in the park near his house and studio, better known as the 'Yellow House', on Place Lamartine (ill. 127). At that time he started to make a literal association between parks and poets such as Petrarch and Boccaccio, underlining the poetic character of scenes of this kind in his oeuvre. The drawings bear silent witness to this connection.

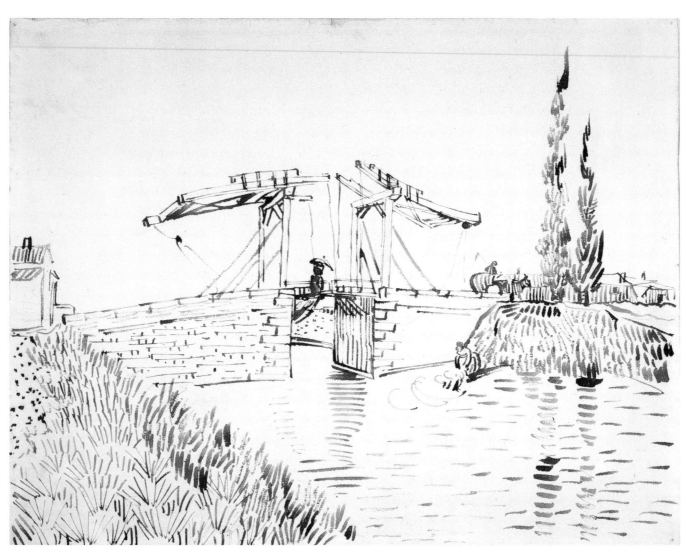

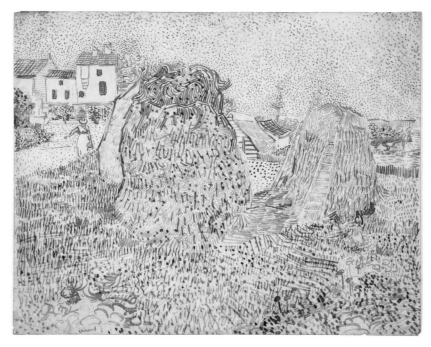

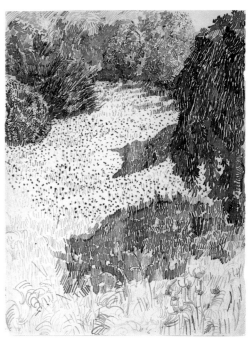

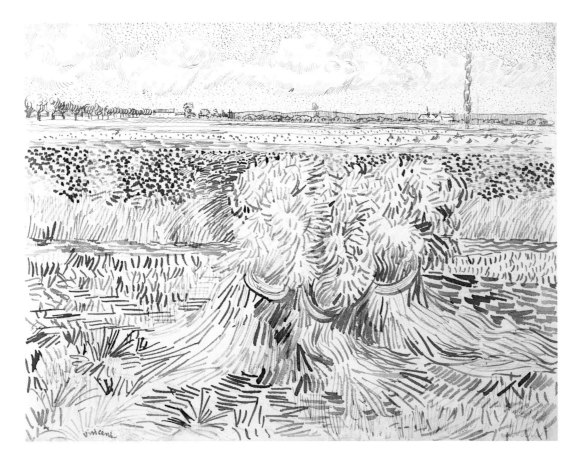

< 114
The Langlois bridge
July 1888
24 x 32 cm
Los Angeles County Museum
of Art, Los Angeles

< 115
Hayricks near a farm
end July–beginning August 1888
24 x 31 cm
Philadelphia Museum of Art,
Philadelphia

< 116
*A corner of a garden
in Place Lamartine*
end July–beginning August 1888
31 x 24 cm
Private collection

117
Wheatfield with sheaves
July–August 1888
24 x 32 cm
Private collection

118
*Street in
Les Saintes-Maries-de-la-Mer*
July 1888
24 x 32 cm
The Metropolitan Museum
of Art, New York

119
*A corner of a garden
in Place Lamartine*
August 1888
24 x 32 cm
Menil Collection,
Houston

120
*Boats on the sea,
Les Saintes-Maries-de-la-Mer*
August 1888
24 x 32 cm
Musées royaux des Beaux-Arts
de Belgique, Brussels

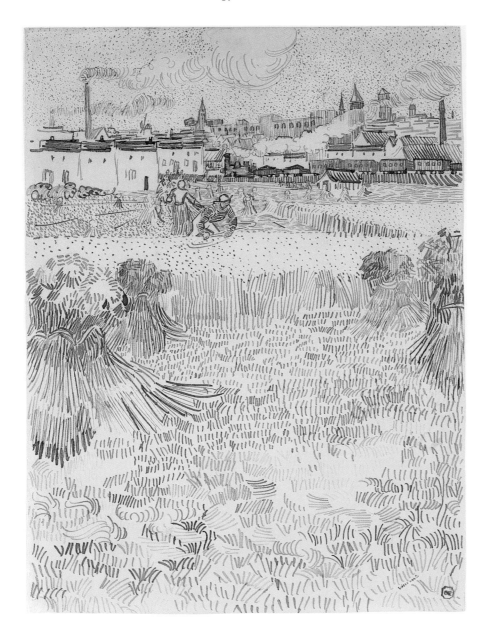

121
Wheatfields with Arles
in the background
August 1888
31 x 24 cm
J. Paul Getty Museum,
Los Angeles

THE YELLOW HOUSE AND OTHER TOWNSCAPES The term townscape is not always well chosen for the type of representation to be found in Van Gogh's French work, because his main interest was to explore particular aspects of the life of a town rather than to capture the beauty or picturesque qualities of the place. A drawing of April 1888 of the bank of the Rhône in Arles is both townscape and river view, but above all it gives an impression of the industry carried on in the small harbour (ill. 128). In August, Van Gogh focused more sharply on this aspect in a depiction of sand barges at the quayside (ill. 129).

In some cases there are both painted and drawn versions of compositions, as with the pavement café in the Place du Forum in the evening (ill. 130, 131). Van Gogh makes no mention of the drawing in his letters, so we cannot tell which of the two works was created first. In any case, neither seems to have been the model for the other: there are considerable differences, such as the

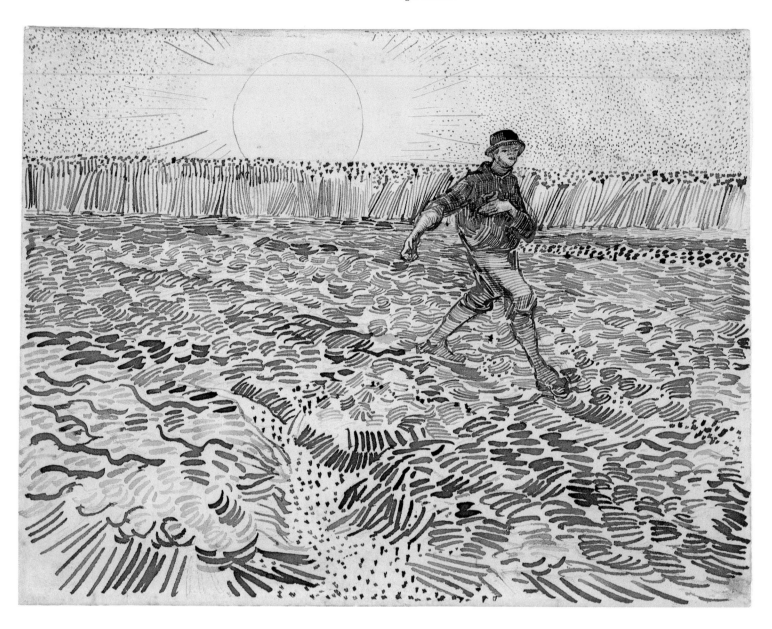

houses jutting out above the canopy on the left of the street. Once again, Van Gogh was exploring the possibilities of a subject with the use of two different techniques. In the case of the painting this yielded a charming evening scene, which has become one of the artist's most popular works. The drawing, with its quite forceful, uningratiating style, provides a more realist view.

Van Gogh took out the lease on his house on Place Lamartine in May 1888, and he often spoke of it in almost amorous terms. The Yellow House was where he hoped to realize the dream that had been one of his reasons for moving to the south: he wanted to establish an artists' colony or 'Studio of the South', where artists could live and work together. This ideal of his makes one understand why the house played such a significant role in his life. At the end of September 1888, he made a painting of it that is so affectionate that it is almost a portrait (ill. 132). He sent Theo a watercolour of the painting to give him an impression of what it was like (ill. 133). The differences

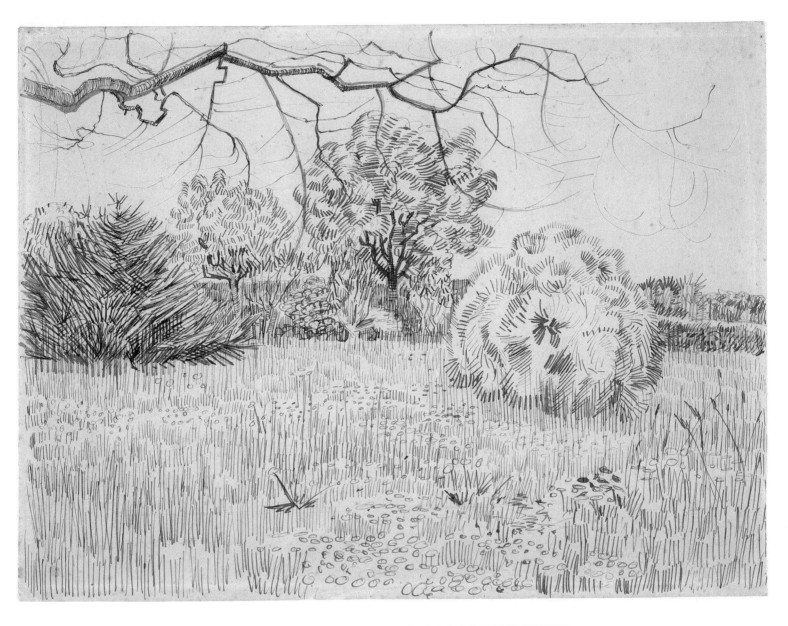

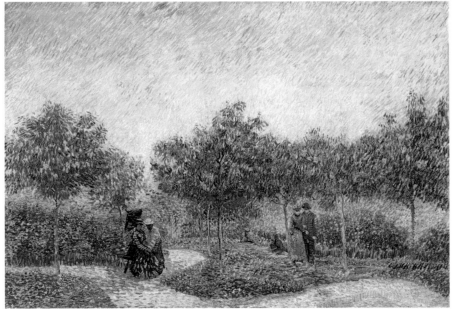

>> 125
Garden of a public baths
beginning August 1888
61 x 49 cm
Van Gogh Museum,
Amsterdam

>> 126
Cottage
August 1888
61 x 49 cm
Private collection

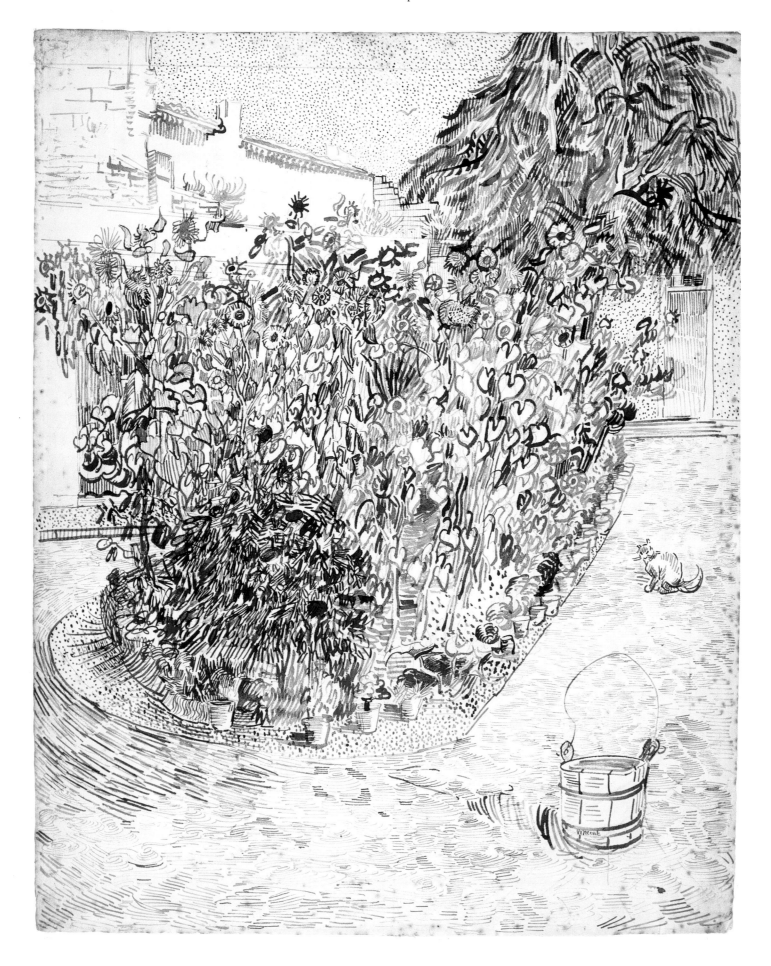

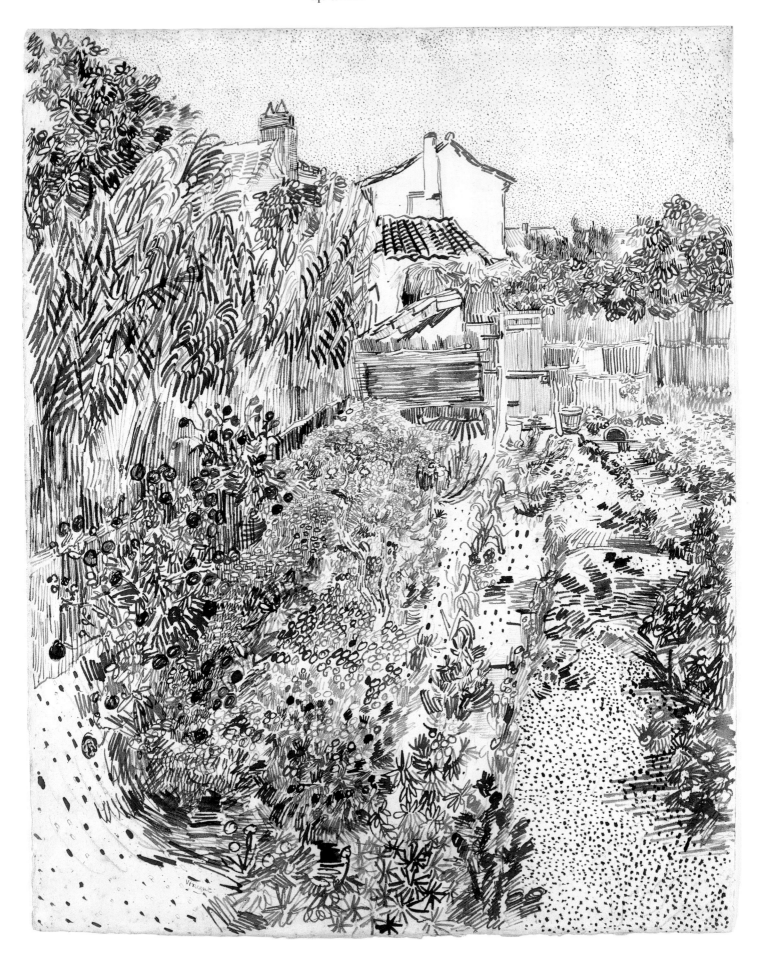

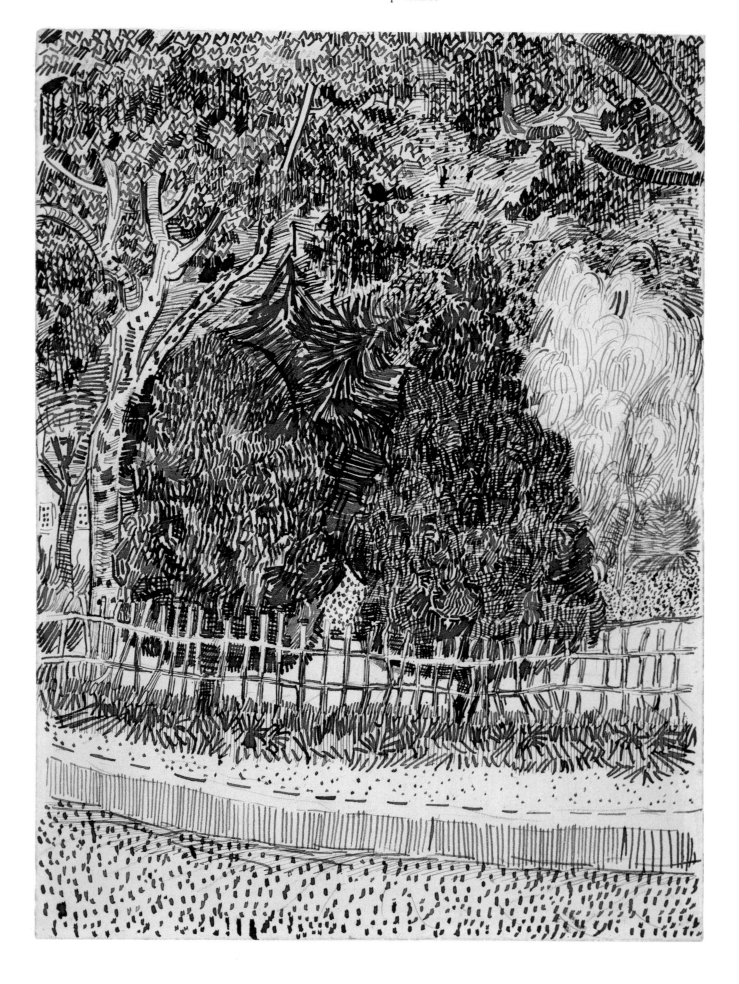

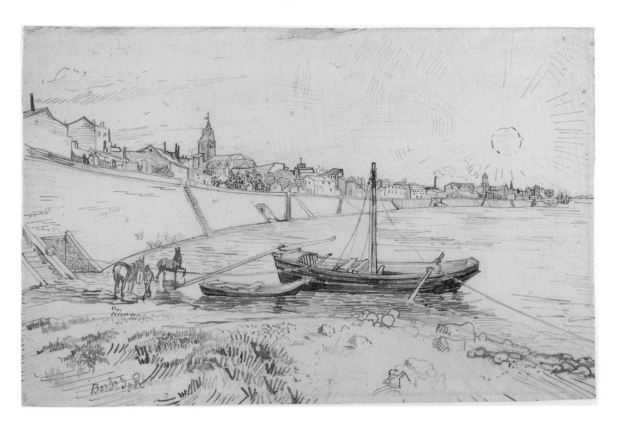

that are often found between his paintings and drawings of the same subject are absent here, although the two works are not identical, which shows that Van Gogh did not simply make a slavish copy of the canvas. Both are charming representations of the place where he intended the Studio of the South to be accommodated.

GAUGUIN IN ARLES : FOCUS ON PAINTING One of the artists Van Gogh believed to be an indispensable member of his Studio was his friend Paul Gauguin (1848–1903), whom he had got to know in Paris and whose work he had come to admire greatly. It took much patience and all his powers of persuasion to convince his colleague to come to the south, but on 23 October 1888 Gauguin finally arrived in Arles.

Since early September, Van Gogh had concentrated predominantly on painting, and after Gauguin's arrival he set aside drawing completely for quite some time. Gauguin was first and foremost a painter, so that the discussions between the two artists centred specifically on this area, covering subjects such as form and colour, the texture of canvases and the application of paint, and whether or not to work from memory (imagination). Painting was the most suitable medium for all this.

During the nine weeks that they spent together in the Yellow House the two artists produced a large and interesting group of paintings, but the conclusion was catastrophic. At the end of December, the strength of their artistic convictions, the conflict between their characters and their changeable

< 127
Park with fence
second half September 1888
32 x 24 cm
Van Gogh Museum,
Amsterdam

128
Bank of the Rhône
April 1888
38 x 60 cm
Museum Boijmans
van Beuningen,
Rotterdam

129
Sand barges on the Rhône
August 1888
48 x 62 cm
Cooper-Hewitt
National Design Museum,
New York

>> 130
*Café terrace at night
(Place du Forum)*
c. 16 September 1888
81 x 65 cm
Kröller-Müller Museum,
Otterlo

>> 131
*Café terrace on
the Place du Forum*
September 1888
62 x 47 cm
Dallas Museum of Art,
Dallas

132
The Yellow House ('The street')
September 1888
72 x 92 cm
Van Gogh Museum,
Amsterdam

moods led to such a furious argument that Van Gogh mutilated his own left ear, upon which Gauguin left Arles as quickly as he could. After this, the dream of the Studio of the South went up in smoke.

Van Gogh continued to concentrate on painting even after Gauguin had left, although he was plagued by illness – a form of epilepsy of which the crisis with Gauguin was the first manifestation and which continued to be an important factor in his life for the next eighteen months. He was twice admitted to the hospital in Arles and then, at the beginning of May 1889, went to receive treatment in a clinic in Saint-Rémy. Shortly beforehand, he did a final, impressive pen-and-ink drawing of the hospital courtyard in Arles (ill. 135). Neither the interval of some six months without drawing nor his illness had affected his ability: the energetic penstrokes and distinctly opti-

mistic character of the picture seem to be in sharp contrast with the difficult time Van Gogh was living through.

During this same period he also made a last drawing of a public garden in Arles, but here the freshness of his earlier views of parks is absent (ill. 134). It is probably the work Van Gogh was referring to in his last letter from Arles, when he reports that 'it has turned out very dark and rather melancholy for one of spring.' [771/590] With this, indeed bleak, work he was expressing the feelings that overcame him, knowing that his departure from Arles was inevitable.

The impressive number of drawings Van Gogh produced in Arles, including scores that are of an astonishingly high quality, shows beyond any doubt that his work in the medium of drawing had reached the same

133
The Yellow House
('The street')
October 1888
26 x 32 cm
Van Gogh Museum,
Amsterdam

134
*A garden in the Place Lamartine
(Weeping tree in the grass)*
May 1889
49 x 61 cm
The Art Institute
of Chicago, Chicago

> 135
*The courtyard
of the Hospital in Arles*
May 1889
47 x 60 cm
Van Gogh Museum,
Amsterdam

level as his painting. Nevertheless, after he had left Arles Van Gogh gave precedence to his painting. A few groups of large, independent drawings were yet to come, although the choice of medium was sometimes made when he had no materials for painting. In addition, he did a number of small studies, though these were little more than simple sketches.

1889–1890
Saint-Rémy

The garden in pen and colour

DURING THE FIRST MONTH of his voluntary confinement at the Saint-Paul-de-Mausole psychiatric clinic in Saint-Rémy, Van Gogh was not allowed to work outside the walls. Fortunately, this former monastery had a large, overgrown garden, which was a constant source of inspiration to him during the time he spent there.

< 136
*Fountain in the garden
of the clinic*
last week May–
first week June 1889
50 x 46 cm
Van Gogh Museum,
Amsterdam

137
*Pine trees in the garden
of the clinic*
end May–
beginning June 1889
62 x 48 cm
Tate, London

The first serious works he made were done with a reed pen and featured the walled garden. It was an impressive start, and these drawings are among the best he did that year. A view of the south-west corner of the garden shows traces of lines that seem to indicate that Van Gogh had once again used a perspective frame. In this drawing, with pine trees beside the perimeter wall, he was still making extensive use of pencil (ill. 137). In particular, the tops of the trees and the passage in the foreground are emphasized with pencil. The view between the trees and the large open sky create a feeling of space, but, in contrast, the two other pen-and-ink drawings are filled in with pen right up to the edges, and, in the case of the one with the fountain, also with the brush; there are hardly any open spaces (ill. 136, 139). When a drawing is worked in this way the composition can easily become too dense, but Van Gogh was able to avoid this danger. The compositions are overloaded but nevertheless pure and transparent.

138
Trees and shrubs
in the garden of the clinic
end May–beginning June 1889
47 x 62 cm
Van Gogh Museum,
Amsterdam

The same is true of a group of seven brush drawings from this period, executed in (very diluted) oil paint, using colours that can also be found in the earliest canvases he painted at Saint-Rémy. Presumably Van Gogh did these drawings with leftover paint that would have been insufficient for a whole painting (he was waiting for a new batch of painting materials at the time). The drawings are so novel in their technique and style that it is surprising there is no mention of them in the letters (ill. 138, 140). Van Gogh was not interested in creating depth in these compositions but was concentrating instead on rhythm, with swirling patterns of leaves and self-assured brushstrokes. The slightly abstract result almost resembles the character of a mosaic and looks extremely modern.

139
*Tree with ivy
in the garden of the clinic*
last week May–
first week June 1889
62 x 47 cm
Van Gogh Museum,
Amsterdam

THE WALLED FIELD From his room Van Gogh had a view of a walled wheatfield, which enabled him to follow the growth of the crop, the harvest, the new round of sowing and all the other activities in the field. Of course these subjects had a strong appeal for him, and this particular field became the subject of a large series of compositions. The most ambitious of these are the paintings, as was only natural, since colour played a prominent role in recording the growth of the wheat: from fresh green under a blue sky to deep yellow in the sweltering summer air (ill. 141).

Nevertheless, the walled field appears in drawings too, mostly in small pencil sketches (ill. 142), although in the drawing *Sun above the walled field* the subject is fully developed (ill. 143). Here too the depiction is densely

< 140
*Steps in the garden
of the clinic*
last week May–
first week June 1889
63 x 46 cm
Van Gogh Museum,
Amsterdam

141
Wheatfield with reaper
July 1889
73 x 92 cm
Van Gogh Museum,
Amsterdam

142
Walled field
May–June 1889
25 x 33 cm
Private collection

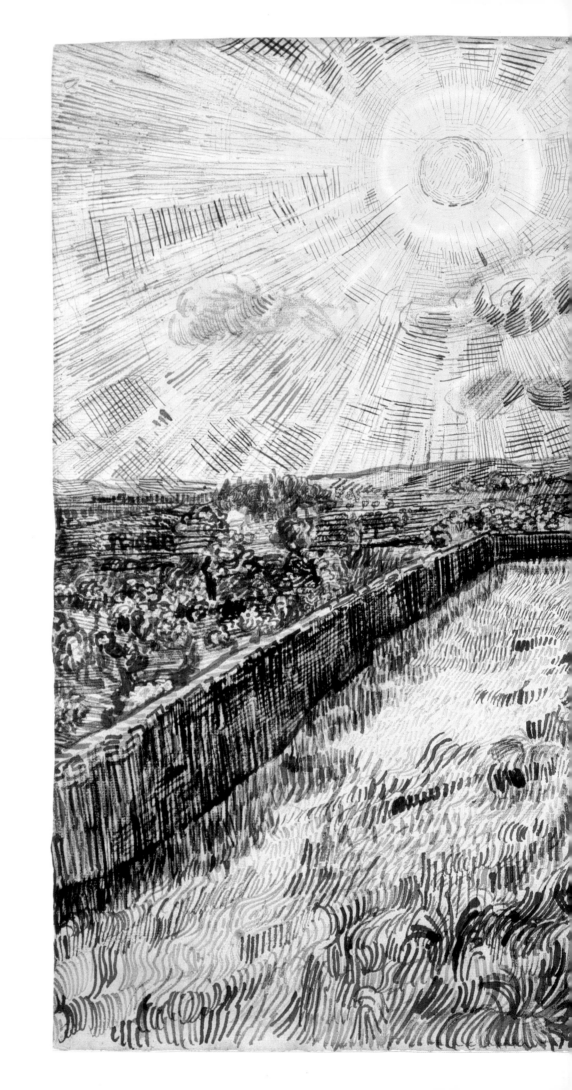

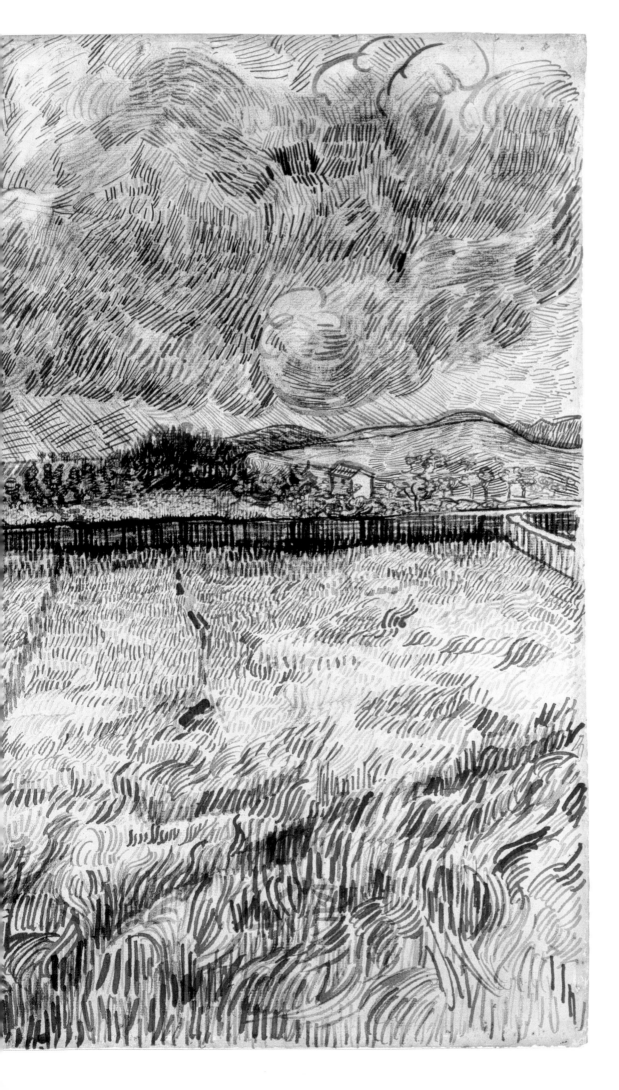

143
Sun above the walled field
end May–beginning June 1889
47 x 57 cm
Kröller-Müller Museum,
Otterlo

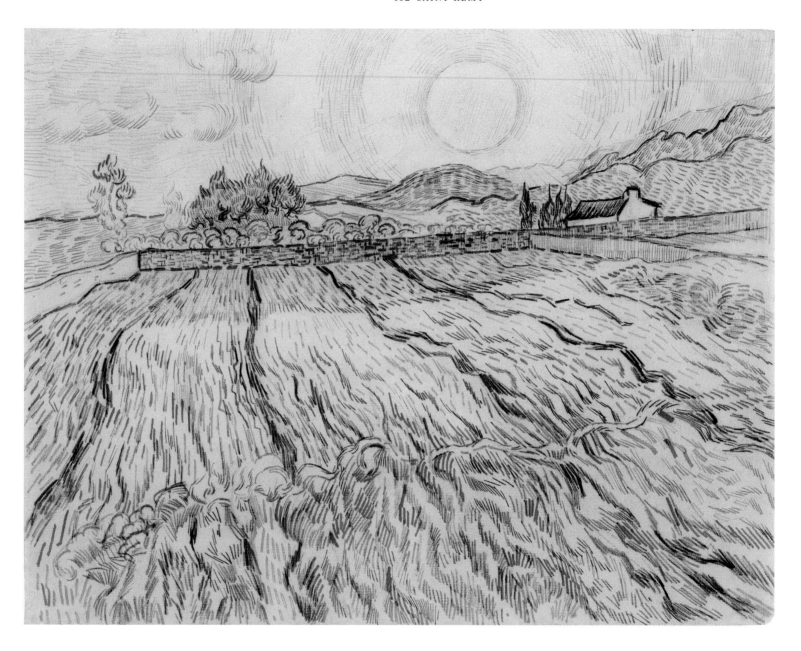

144
Walled wheatfield
with rising sun
mid-November–
mid-December 1889
47 x 62 cm
Staatliche Graphische
Sammlung, München

filled in with a great variety of penstrokes. In contrast with most of the pictures of the field – painted or drawn – the mood is somewhat menacing, with a fearsome cloud dominating the composition – and we are left in doubt as to whether it has just passed away from the sun or is about to cover it.

The wheatfield appeared once again in a large drawing done between the middle of November and the middle of December (ill.144). Unlike the previous drawing, this is closely linked with a painting (ill.145), although it is not clear which of the two works was done first.

COPIES AFTER PAINTINGS Once he had received painting materials at the beginning of June 1889, Van Gogh concentrated almost entirely on painting. By then, his health had improved sufficiently to allow him to work outside the clinic walls. He explored the countryside around Saint-

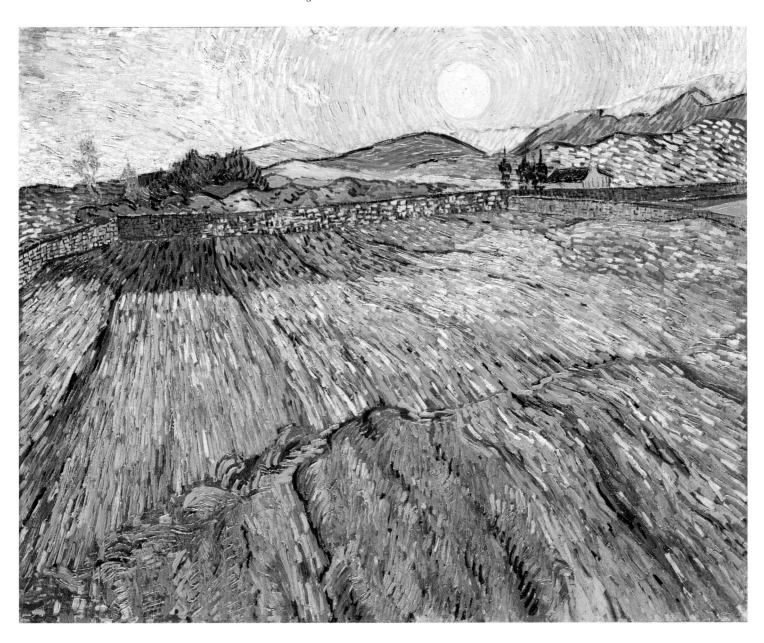

Rémy, which lies at the foot of the small mountain range of the Alpilles. It was a varied landscape, where, apart from wheatfields with cypresses, Van Gogh also found orchards of olive trees, quarries and other new features.

While Van Gogh was still working on this series of Provençal subjects, he started to make pen-and-ink drawings after the canvases, which he sent to Theo to give him an idea of his recent work, in which he had been trying to project a strong style. He did the drawings on quite smooth paper that is unique in his oeuvre. The texture of the paper allowed the pen to glide over it fluidly, sometimes perhaps too fluidly: Van Gogh was not pleased with the final results because in his opinion they lacked character and strength. Nevertheless the drawings are really impressive. *Cypresses* (ill. 146), for example, is no less monumental that its painted counterpart (ill. 147). Van Gogh was very

145
Walled field with young wheat and rising sun
1889
71 x 90 cm
Private collection

>> 146
Cypresses
June 1889
62 x 47 cm
The Brooklyn Museum,
New York

>> 147
Cypresses
1889
93 x 74 cm
The Metropolitan Museum
of Art, New York

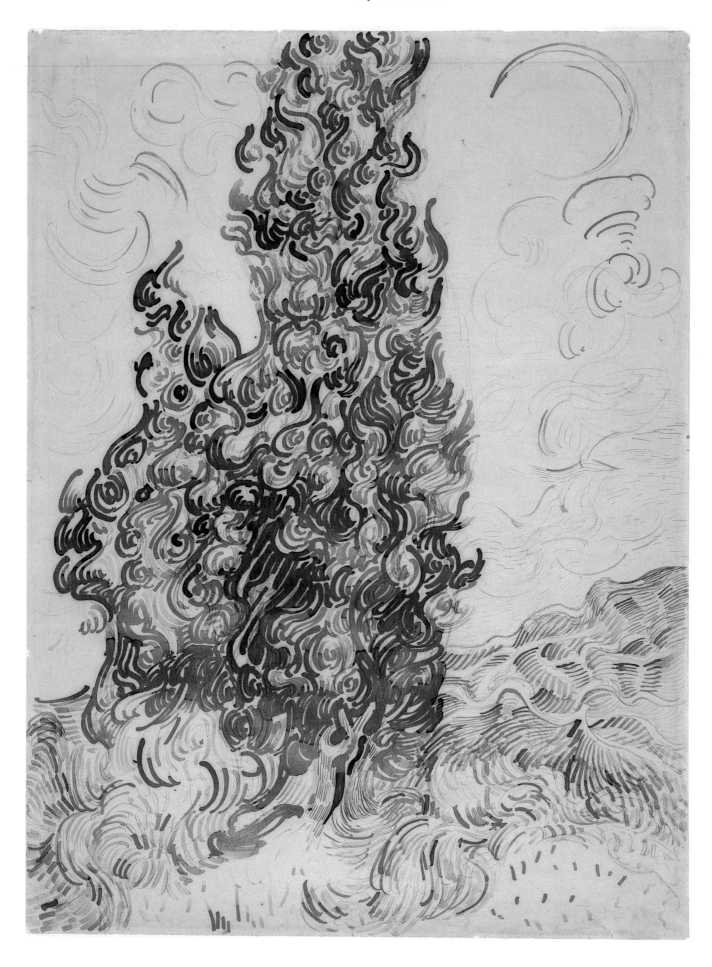

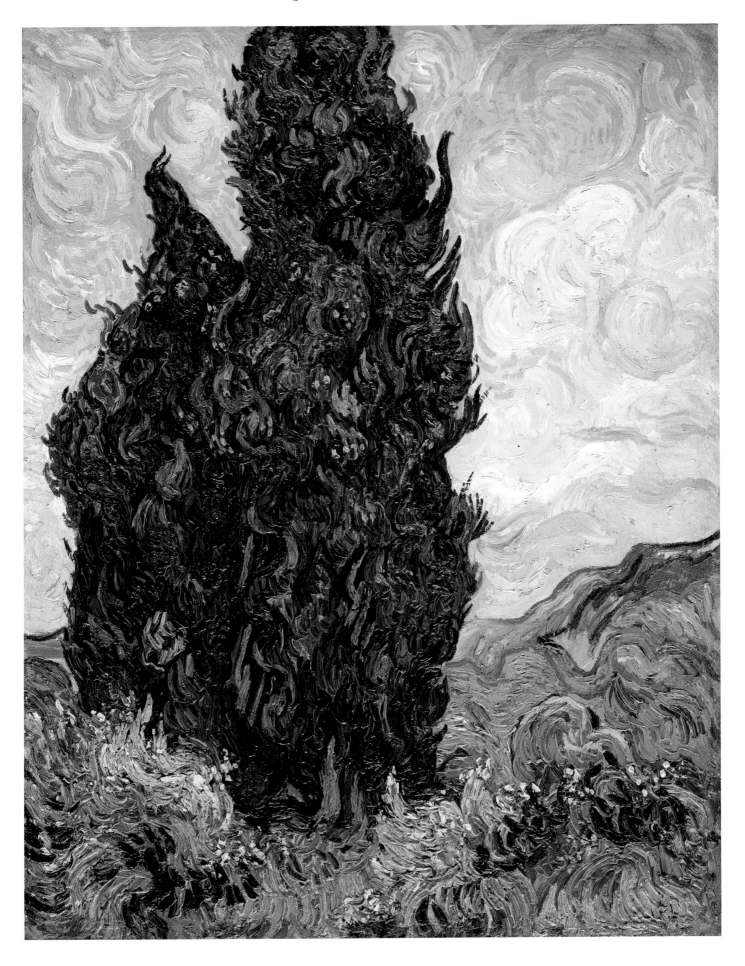

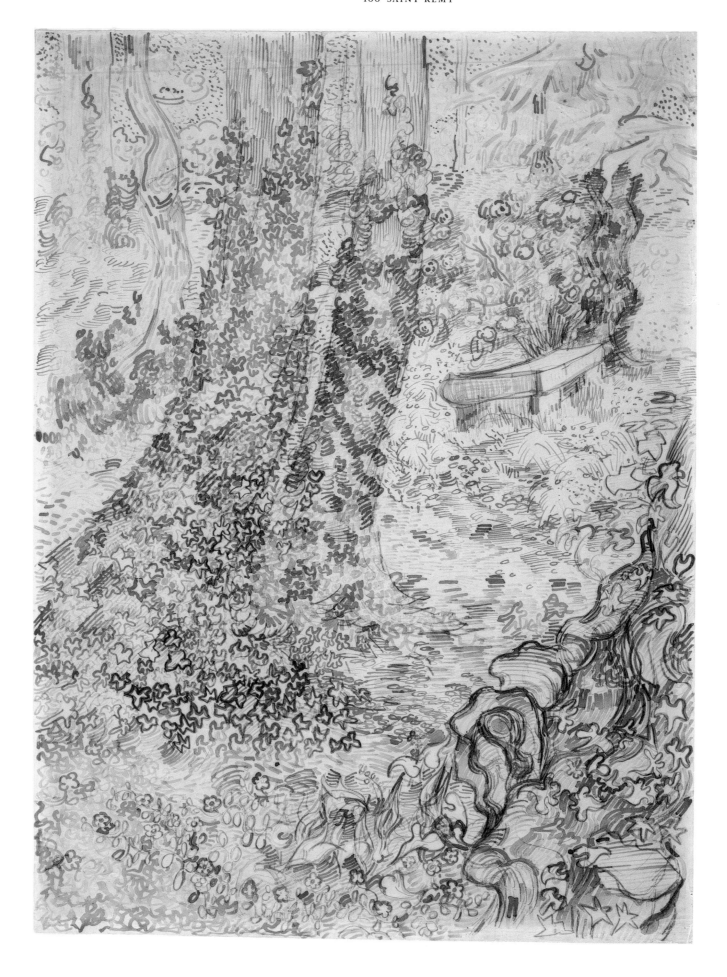

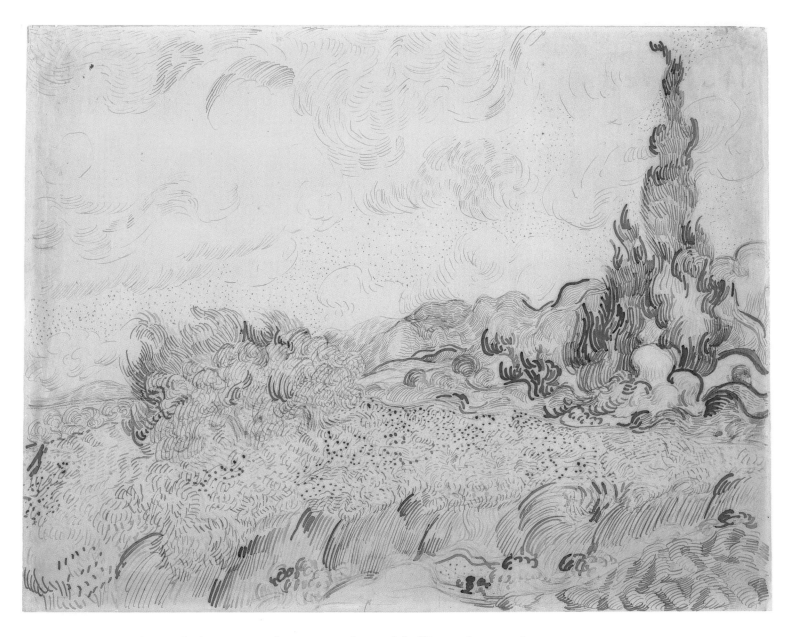

taken with this species of tree: 'It is as beautiful of line and proportion as an Egyptian obelisk. And the green has a quality of such distinction. It is a splash of *black* in a sunny landscape, but it is one of the most interesting black notes.' [785/596] He translated these impressions effectively in works of this kind.

Other examples of drawings after paintings are *Trees with ivy in the garden of the clinic* (ill. 148), *Wheatfield with cypresses* (ill. 149) and a drawing after the celebrated painting *Starry night* (ill. 150). All these drawings and paintings are evidence of Van Gogh's attempt 'to mass things by means of a drawing style which tries to express the interlocking of the masses.' [818/613] *Wild vegetation* (ill. 151), a drawing in which he depicts the wild flora of Provence in a breathtaking way, belongs with these works in terms of style and technique, even though there is no known painted version of it.

Van Gogh's new manner of drawing thus led to strongly stylized drawings very much along the same lines as their painted models. He wanted

‹ 148
*Trees with ivy in
the garden of the clinic*
mid-June–2 July 1889
62 x 47 cm
Van Gogh Museum,
Amsterdam

149
Wheatfield with cypresses
mid-June–2 July 1889
47 x 62 cm
Van Gogh Museum,
Amsterdam

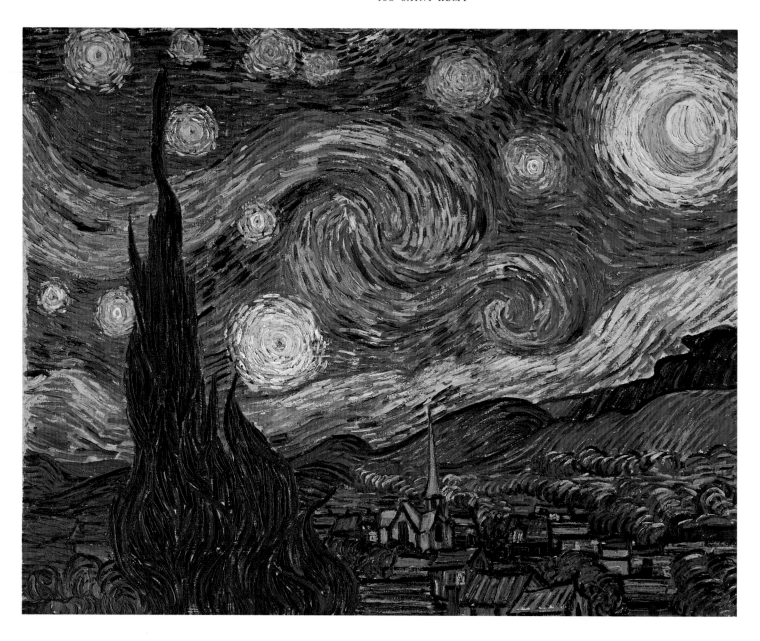

150
Starry night
1889
74 x 92 cm
The Museum of
Modern Art, New York

Theo to get an idea of these works, but his brother was not very impressed with the drawings; he thought that 'the search for some style is prejudicial to the true sentiment of things.' [815/T 19]

PAINTING ON PAPER From the middle of July to the end of August, Van Gogh was unable to work due to a bad bout of his illness, and when his health did improve a little he was so debilitated that he worked indoors for a while. He consoled himself by making painted copies after black-and-white prints by cherished models such as Millet, Delacroix and Rembrandt, an activity that he thought of as translating black-and-white into colours.

During the same period (September–October 1889), he is also thought to have made three pictures of the interior of the clinic: a view of the entrance hall (ill. 152), a corridor (ill. 153) and a window of his studio: an

empty room in Saint-Paul-de-Mausole that Van Gogh had appropriated (ill.154). All three were done in oils on pink laid paper. In the drawings he had done a few months earlier (ill.138, 140) Van Gogh had used oils in a very graphic way, but here he used them far more emphatically and filled whole surfaces with them. The character of these monumental compositions thus lies somewhere between the lightness of a drawing and the more solid character of a painting.

SKETCHES Around the beginning of October, Van Gogh resumed his work out of doors, doing among other things a considerable number of small sketches in the garden (ill.156). These are fairly unpretentious, but they often capture beautifully the gnarled trees around the clinic. From December onwards, his illness made it harder for him to work. In this difficult, cheerless time Van Gogh often thought of his homeland. This resulted, in the

151
Wild vegetation
mid-June–2 July 1889
47 x 62 cm
Van Gogh Museum,
Amsterdam

>> 152
Entrance hall of the clinic
September–October 1889
62 x 47 cm
Van Gogh Museum,
Amsterdam

>> 153
Corridor in the clinic
September–October 1889
65 x 49 cm
The Metropolitan Museum
of Art, New York

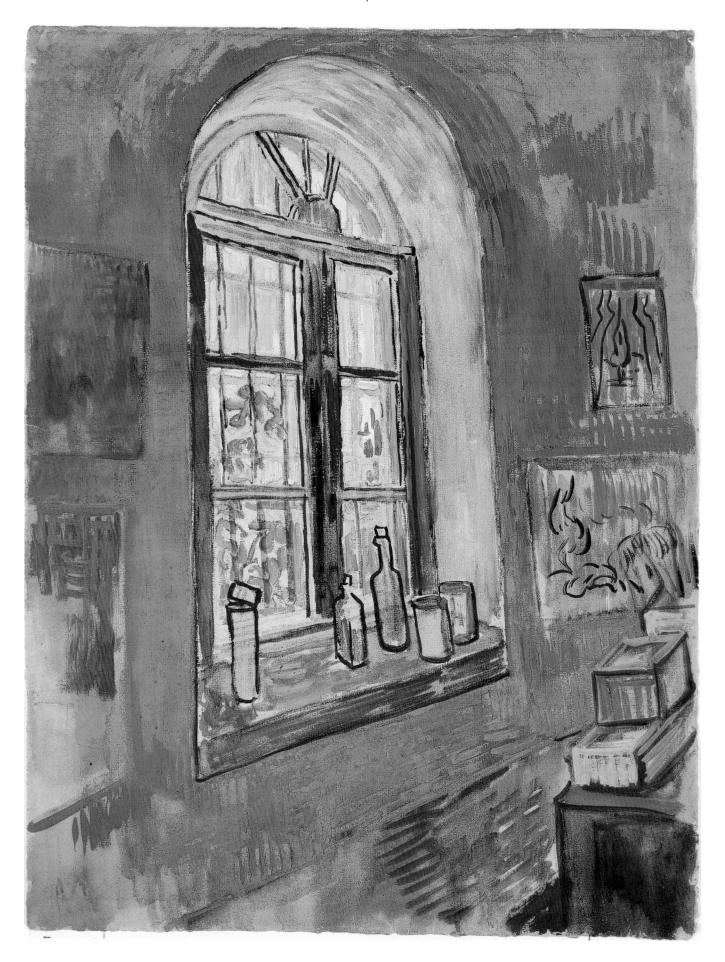

< 154
Window in the studio
September–October 1889
62 x 47 cm
Van Gogh Museum,
Amsterdam

155
*Interior with
people eating*
1890
33 x 50 cm
Van Gogh Museum,
Amsterdam

156
*Dead tree in the garden
of the clinic*
1889–1890
30 x 17 cm
Van Gogh Museum,
Amsterdam

spring of 1890, in works that he described in several letters as 'Memories of the North'. There are about fifty sketches that can be included in this group. The hesitant way in which they are drawn often gives an oppressive image of Van Gogh's pitiable frame of mind at the time. It was then that he was considering making a modern version of the masterpiece done in the early years of his artistic career, *The potato eaters*. Although he never realized this plan, he did make sketches as studies for the work (ill. 155). They were the last drawings he was to do in Saint-Rémy.

1890

Auvers-sur-Oise

Return to the north

VAN GOGH FELT that staying among the mentally ill in Saint-Rémy was doing him more harm than good, so in May 1890, after consulting his doctor, he decided to discharge himself from the clinic. He had written to his brother about this possibility and had indicated that he might settle in northern France. Camille Pissarro (1830–1903) had suggested to Theo that Auvers-sur-Oise might be just the place for Van Gogh. One of the important factors in selecting this place was that Pissarro had given Theo an introduction to a doctor, Paul Ferdinand Gachet (1828–1909), who was willing to keep an eye on his brother.

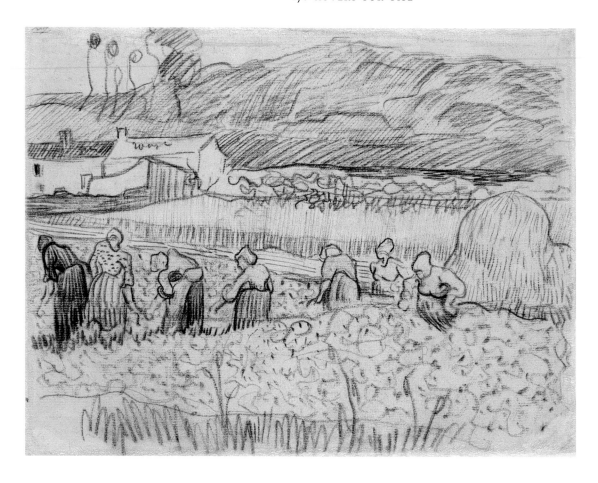

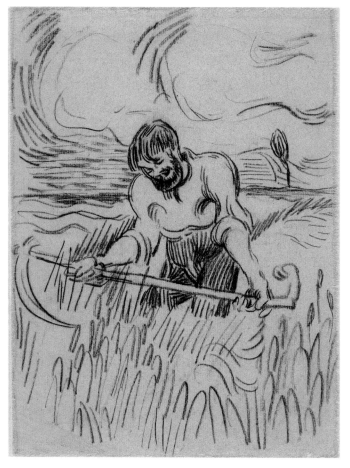

Van Gogh left Saint-Rémy on 16 May 1890. He first paid a visit to Theo and his family in Paris, where for the first time he saw Theo's wife, Jo van Gogh-Bonger, and his nephew of a few months, who had been named after him: Vincent Willem. On 20 May, he arrived in Auvers. The village's rural setting immediately appealed to him, and he was very taken with the many picturesque cottages and farms with their rustic thatched roofs. Many of the studies he drew show how he explored his surroundings and in so doing rediscovered old, familiar subjects (ill. 157, 158).

Painting, however, was his main occupation in Auvers. Even for the prolific Van Gogh, the number of canvases he produced while he was there was quite astounding: in less than two and a half months he made more than seventy paintings, including many that are considered among his masterpieces (ill. 159, 160). On the other hand, there are only a small number of large,

< 157
*Women working
in the fields*
1890
24 x 31 cm
Van Gogh Museum,
Amsterdam

< 158
*Man scything
in a field*
1890
31 x 24 cm
Van Gogh Museum,
Amsterdam

159
Portrait of Doctor Gachet
June 1890
67 x 57 cm
Whereabouts unknown

>> 160
Wheatfield with crows
July 1890
50 x 103 cm
Van Gogh Museum,
Amsterdam

ambitious drawings. In Saint-Rémy Van Gogh had experimented with a more restrained palette than he had used in Arles. His return to the north made it necessary for him to take a close look once again at his use of colour. In his last paintings he also undertook new experiments with his brushwork, replacing the wavy lines that typified his work done in Saint-Rémy with a more graphic working method. Once Van Gogh recognized the need to undertake something new and experimental, he acted immediately, and drawing was then pushed into the background.

Two works, one in watercolour the other in oils, done soon after he arrived in Auvers, show that he had once again started to tackle the old problem of the simultaneous contrast (ill. 161, 162). *Old vineyard with peasant woman* is painted predominantly in shades of blue, with a little complementary orange, which has turned brown due to discolouration, while *Landscape with cottages* is done entirely in shades of blue. The leaves, which are depicted with great subtlety, are worked in attractive, fluent brushstokes.

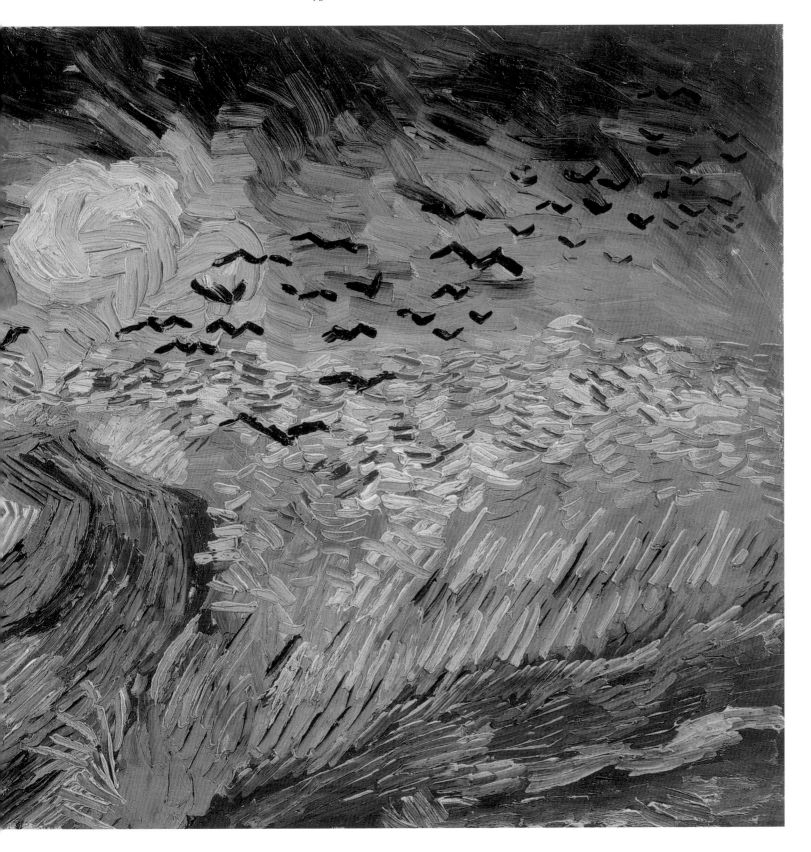

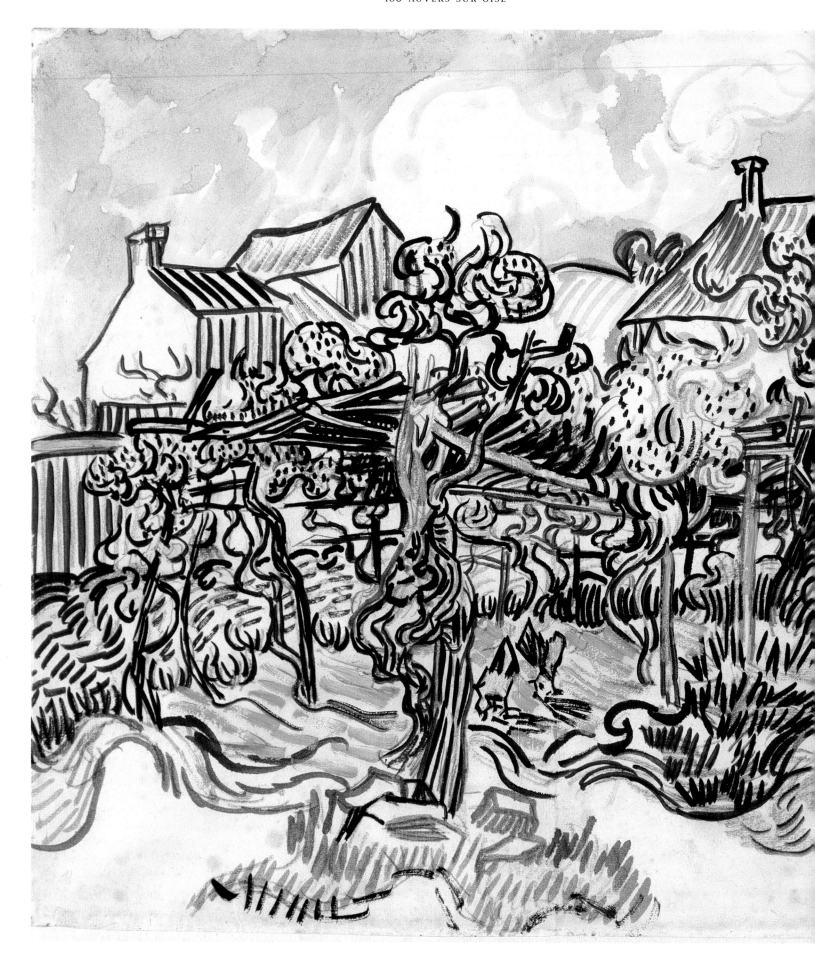

In *Landscape with bridge over the Oise* (ill.163) Van Gogh worked with both simultaneous and complementary contrasts. The two factories across the water, one of which is hidden behind the poplars, and the wrought-iron bridge on the right—which at that time had been in use for only six months—indicate the advance of the modern age, a development that both fascinated and troubled the artist.

TAKING STOCK The last drawings Van Gogh made in Auvers concluded a body of work that displayed a combination of enduring values and constant renewal. The fact that Van Gogh started his career with drawing and showed great perseverance in developing his talents in this field meant that he reached maturity as a draughtsman sooner than as a painter.

It is rare to find such a large quantity of drawings of such high quality as those produced by Van Gogh in a period of only ten years, and it was still more unusual at a time when most artists preferred painting, because it offered more scope for experimentation with colour. Only a handful of his contemporaries produced a substantial body of drawings, and none of them took the technique of pen-and-ink drawing to such a high level of skill. Acknowledged master draughtsmen such as Paul Cézanne and Edgar Degas worked for the most part in in watercolours and pastels respectively. Georges Seurat excelled in intimate works done in black crayon. Odilon Redon liked to work with black materials, as well as in pastels, and produced impressive work in both techniques. Henri de Toulouse-Lautrec recorded the human figure throughout his career in his realistic, fluent style of drawing, which often characterized his paintings as well. Of the young members of the avant-garde, Edouard Vuillard (1868–1940) was the leading artist who also devoted himself to drawing, but many young artists of the 1890s who were interested in working on paper turned to lithography.

The fact that Van Gogh considered his drawings to be fully complementary to his paintings was made clear on a number of occasions during his career, and his last, highly innovative, works leave us in no doubt of this fact. Van Gogh achieved a balance in his work that was matched by very few of his colleagues.

161
*Old vineyard
with peasant woman*
20–23 May 1890
44 x 54 cm
Van Gogh Museum,
Amsterdam

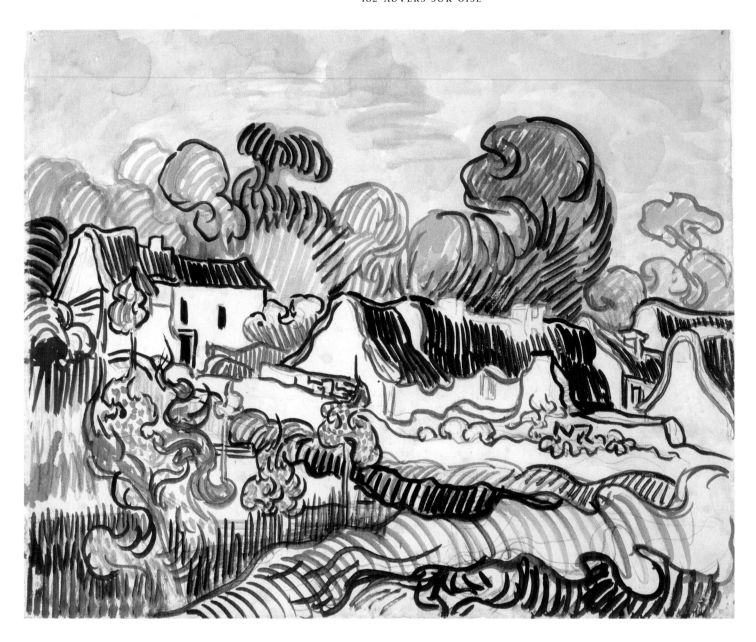

162
Landscape with cottages
c. 23 May 1890
44 x 54 cm
Van Gogh Museum,
Amsterdam

> 163
Landscape with bridge
over the Oise
end May–beginning
June 1890
47 x 63 cm
Tate, London

VAN GOGH'S DEATH Despite the vital, colourful character of his work done in Auvers and the apparent enthusiasm with which he once again explored old subjects, Van Gogh was pessimistic about the future. Theo had always provided financial support, but now his brother had a young family to maintain and, furthermore, was thinking about becoming an independent art dealer. Van Gogh was afraid that he would become too great a financial burden on Theo. On Sunday 27 July 1890 Van Gogh shot himself in the chest. Two days later, at the age of thirty-seven, he died with his brother at his side. The personal esteem in which he was held and his growing reputation as an artist were clearly expressed at his funeral, and among the condolences offered to Theo, the most striking were the simple words of Eugène Boch (1855–1941): 'A great artist is dead.'

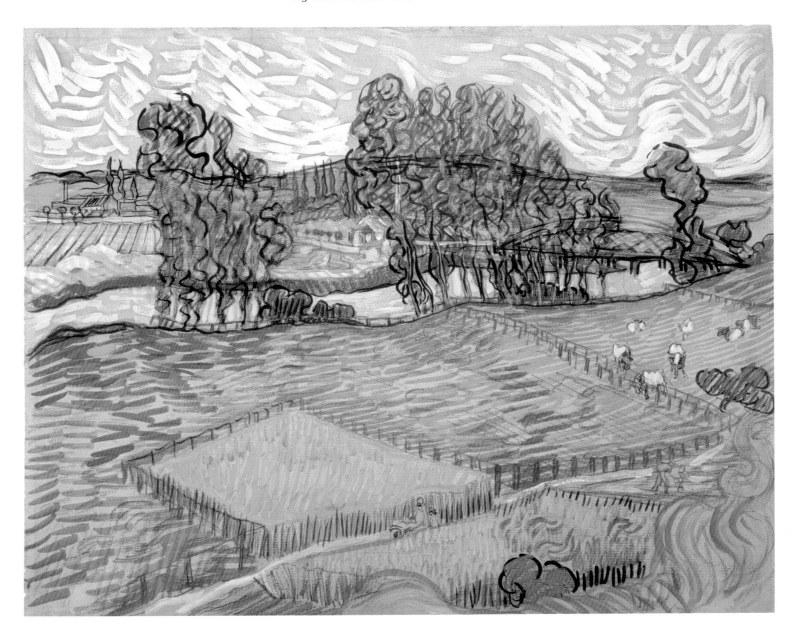

Suggestions for further reading

Sjraar van Heugten, *Vincent van Gogh: Drawings, Volume 1. The Early Years, 1880–1883*, Amsterdam (Van Gogh Museum), 1996
Sjraar van Heugten, *Vincent van Gogh: Drawings, Volume 2. Nuenen, 1883–1885*, Amsterdam (Van Gogh Museum), 1997
Marije Vellekoop and Sjraar van Heugten, *Vincent van Gogh: Drawings, Volume 3. Antwerp & Paris, 1885–1888*, Amsterdam (Van Gogh Museum), 2001
Marije Vellekoop and Roelie Zwikker, *Vincent van Gogh: Drawings, Volume 4. Arles, Saint-Rémy and Auvers-sur-Oise, 1888–1890*, Amsterdam (Van Gogh Museum), to be published in 2006.

Fuller information can be found in the exhibition catalogue:
Colta Ives, Susan Alyson Stein, Sjraar van Heugten, Marije Vellekoop, *Vincent van Gogh. The Drawings,* The Metropolitan Museum of Art, New York / Van Gogh Museum, Amsterdam, 2005

Note to the reader

All quotations from Van Gogh's letters appear with two reference numbers. The first of these refers to *De brieven van Vincent van Gogh,* ed. Han van Crimpen and Monique Berends-Albert, 4 vols., The Hague 1990; and the second to *The Complete Letters of Vincent van Gogh,* 3 vols., Greenwich (Conn.), 1958.

List of works

1 *Canal*
autumn 1872–spring 1873
pencil, pen and brown ink
on wove paper
25 x 26 cm
Van Gogh Museum, Amsterdam
Juv. xvi jh –

2 *Miners in the snow*
September 1880
pencil on wove paper
44 x 56 cm
Kröller-Müller Museum, Otterlo
F 831 jh Juv. 11

3 *The bearers of the burden*
beginning 1881
pencil and ink on laid paper
43 x 60 cm
Kröller-Müller Museum, Otterlo
F 832 jh –

4 *Man with a sack of wood*
autumn 1881
black crayon and pencil on laid
paper
61 x 42 cm
Van Gogh Museum, Amsterdam
F 895 jh 21

5 *Boy with a sickle*
end October –
beginning November 1881
black crayon, charcoal and gouache
on laid paper
47 x 61 cm
Kröller-Müller Museum, Otterlo
F 851 jh 61

6 *Old man putting dry twigs on the fire*
November 1881
pencil, crayon and gouache
on laid paper
56 x 45 cm
Kröller-Müller Museum, Otterlo
F 868 jh 80

7 *Woman sewing*
end 1881
black crayon and watercolour
on laid paper
62 x 47 cm
Kröller-Müller Museum, Otterlo
F 1221 jh 70

8 *Worn out*
summer 1881
pencil, ink and watercolour
on laid paper
23 x 31 cm
P. and N. de Boer Foundation,
Amsterdam
F 863 jh 34

9 *A marsh*
June 1881
pencil, pen and black ink
on laid paper
47 x 59 cm
National Gallery of Canada,
Ottawa
F 846 jh 8

10 *Windmills at Dordrecht*
August 1881
pencil, crayon, ink and watercolour
on laid paper
26 x 60 cm
Kröller-Müller Museum, Otterlo
F 850 jh 15

11 *Bridge and houses on the corner of
Herengracht and Prinsessegracht,
The Hague*
March 1882
pencil, pen and brush with brown
(originally black) ink and white
gouache with brown-grey wash
on laid paper
24 x 34 cm
Van Gogh Museum, Amsterdam
SD 1679 jh 121

12 *Entrance to the Pawn Bank,
The Hague*
March 1882
pencil, pen and brush with brown
(originally black) ink and white
gouache with grey wash on laid
paper
24 x 34 cm
Van Gogh Museum, Amsterdam
F – jh 126

13 *Nursery garden on the Schenkweg*
April 1882
black crayon, pencil, pen
and brush with black and
brown ink, heightened with white
on laid paper
30 x 58 cm
The Metropolitan Museum of Art,
New York. Bequest of Walter
C. Baker
F 930 jh 138

14 *Carpenter's yard*
April 1882
pencil, pen and ink, black crayon
and gouache with wash
on laid paper
28 x 47 cm
Kröller-Müller Museum, Otterlo
F 939 jh 150

15 *Allée d'arbres en perspective*
illustration from Armand
Cassagne, *Traité pratique de
perspective appliquée au dessin
artistique et industriel,* Paris 1879

16 *Country road*
March–April 1882
pencil, pen and brush with brown
(originally black) ink and white
gouache on laid paper
25 x 34 cm
Van Gogh Museum, Amsterdam
F 1089 jh 124

17 *Sketch in a letter to Theo of
5 August 1882* [254/222]
Van Gogh Museum, Amsterdam

18 Sketch in a letter to Theo of
5 August 1882 [255/223]
Van Gogh Museum, Amsterdam

19 *Old woman with a shawl*
March 1882
pencil, pen with brown
(originally black) ink
and light-green gouache
on wove paper
57 x 32 cm
Van Gogh Museum, Amsterdam
F 913 jh 109

20 *Sorrow*
April 1882
pencil, pen and ink on wove paper
44 x 27 cm
Walsall Museum & Art Gallery,
Walsall
F 929a jh 130

21 *Worn out*
November 1882
pencil on watercolour paper
50 x 32 cm
Van Gogh Museum, Amsterdam
F 997 jh 267

22 *Fish-drying shed at Scheveningen*
July 1882
pencil, watercolour and gouache
on wove paper
36 x 52 cm
Private collection
F 945 JH 160

23 *Roofs*
July 1882
watercolour and gouache
on paper
39 x 56 cm
Private collection
F 943 JH 156

24 *The poor and money*
September–October 1882
black crayon, gouache, pen
and black ink on wove paper
38 x 57 cm
Van Gogh Museum, Amsterdam
F 970 JH 222

25 Hubert Herkomer
*Heads of the people drawn
from life, II : The agricultural
labourer – Sunday*
from *The Graphic* 12 (9 October 1875)

26 Luke Fildes
Houseless and hungry
from *The Graphic*, Portfolio 1877

27 *Portrait of Jozef Blok*
November 1882
pencil, watercolour
and lithographic crayon
on wove paper
38 x 26 cm
Van Gogh Museum, Amsterdam
F 993 JH 254

28 *Sorrow*
November 1882
lithograph
39 x 29 cm
Van Gogh Museum, Amsterdam
F 1655 JH 259

29 *Worn out (At eternity's gate)*
26–27 November 1882
lithograph
40 x 34 cm
Van Gogh Museum, Amsterdam
F 1662 JH 268

30 *Old man with a top hat*
December 1882–January 1883
pencil, black lithographic crayon,
scraped, and pen and brush
with brown (originally black) ink
on watercolour paper
60 x 36 cm
Van Gogh Museum, Amsterdam
F 985 JH 286

31 *Weeping woman seated on a basket*
January–February 1883
black lithographic crayon,
scraped, grey wash and white
and grey gouache
on watercolour paper
47 x 29 cm
Kröller-Müller Museum, Otterlo
F 1060 JH 326

32 *Soup distribution
in a public soup kitchen*
March 1883
black mountain chalk, scraped,
brush and black paint and white
gouache on watercolour paper
57 x 44 cm
Van Gogh Museum, Amsterdam
F 1020a JH 330

33 *Landscape with a stack of peat
and farmhouses*
September–December 1883
gouache on wove paper
42 x 54 cm
Van Gogh Museum, Amsterdam
F 1099 JH 399

34 *Landscape in Drenthe*
second half September–
beginning October 1883
pencil, pen and brush
with brown ink and white gouache
on laid paper
31 x 42 cm
Van Gogh Museum, Amsterdam
F 1104 JH 424

35 *Melancholy*
December 1883
pencil, pen and brown ink
on wove paper
29 x 21 cm
Van Gogh Museum, Amsterdam
F 1127 JH 426

36 *Weaver, with a baby in a high chair*
end January–
beginning February 1884
pencil, pen and brown ink,
heightened with white
and pale pink gouache,
on wove paper
32 x 40 cm
Van Gogh Museum, Amsterdam
F 1118 JH 452

37 *Behind the hedgerows*
March 1884
pencil, pen and brown (originally
black) ink on wove paper
40 x 53 cm
Rijksmuseum, Amsterdam
F 1129 JH 461

38 *Garden in winter*
March 1884
pencil, pen and brown (originally
black) ink on wove paper
40 x 55 cm
Van Gogh Museum, Amsterdam
F 1128 JH 466

39 *Garden in winter*
March 1884
pencil, pen and brown (originally
black) ink on wove paper
51 x 38 cm
Szépmüvészeti Museum,
Budapest
F 1130 JH 465

40 *Pollard birches*
March 1884
pencil, pen and brown (originally
black) ink, heightened with white,
on wove paper
39 x 54 cm
Van Gogh Museum, Amsterdam
F 1240 JH 469

41 *The kingfisher*
March 1884
pencil, pen and brush with brown
(originally black) ink, heightened
with white, on wove paper
40 x 54 cm
Van Gogh Museum, Amsterdam
F 1135 JH 468

42 *Ditch*
April 1884
pencil, pen and ink, heightened
with white and green paint,
on wove paper
42 x 34 cm
Van Gogh Museum, Amsterdam
F 1243 JH 472

43 *Houses with thatched roofs*
1884
pen and brown ink, pencil and
watercolour on wove paper
30 x 45 cm
Tate, London
F 1242 JH 474

44 *Head of a woman*
December 1884–January 1885
pencil, pen and brush with brown
ink and brown wash on laid paper
14 x 10 cm
Van Gogh Museum, Amsterdam
F 1177 JH 609

45 *Head of a man*
December 1884–January 1885
pencil, pen, brush and quill brush(?)
with brown ink and brown wash
on laid paper
14 x 10 cm
Van Gogh Museum, Amsterdam
F 1198 JH 564

46 *Head of a woman*
December 1884–May 1885
black crayon on wove paper
40 x 33 cm
Van Gogh Museum, Amsterdam
F 1182 JH 590

47 *Two hands with a stick*
December 1884–May 1885
pencil on laid paper
21 x 34 cm
Van Gogh Museum, Amsterdam
F 1159r JH 614

48 *Two hands and two arms*
December 1884–May 1885
black crayon on laid paper
21 x 34 cm
Van Gogh Museum, Amsterdam
F 1155 JH 744

49 *Seated woman*
February–May 1885
pencil, pen and brown ink
on laid paper
34 x 21 cm
Van Gogh Museum, Amsterdam
F 1190 JH 676

50 *Potato eaters*
April 1885
lithograph
26 x 32 cm
Van Gogh Museum, Amsterdam
F 1661 JH 737

51 *The old church tower at Nuenen*
('*The peasants' churchyard*')
end May–beginning June 1885
oil on canvas
65 x 80 cm
Van Gogh Museum, Amsterdam
F 84 JH 772

52 *Demolition sale*
May 1885
black crayon or charcoal,
watercolour and gouache
on watercolour paper
38 x 55 cm
Van Gogh Museum, Amsterdam
F 1230 JH 770

53 *Demolition sale* (page of sketches)
May 1885
black crayon on laid paper
34 x 21 cm
Kröller-Müller Museum, Otterlo
F 1336r JH 767

54 *Digger in a potato field, February*
July–September 1885
black crayon with grey wash
on wove paper
54 x 42 cm
Van Gogh Museum, Amsterdam
F 1302 JH 859

55 *Peasant woman gleaning*
1885
black crayon on wove paper
51 x 41 cm
Museum Folkwang, Essen
F 1279 JH 836

56 Léon Lhermitte
The woodcutters
from *Le monde illustré* 1457 (1885)

57 after Jean-François Millet
Les travaux des champs
1853 (series of ten prints)
Van Gogh Museum, Amsterdam

58 *Woodcutter*
July–September 1885
black crayon with grey wash
on laid paper
45 x 55 cm
Van Gogh Museum, Amsterdam
F 1327 JH 902

59 *Peasant woman lifting potatoes*
August 1885
black crayon with grey wash
on wove paper
40 x 45 cm
Van Gogh Museum, Amsterdam
F 1273 JH 909

60 *Peasant working*
August–September 1885
black crayon on wove paper
44 x 33 cm
Kröller-Müller Museum, Otterlo
F 1326 JH 904

61 *Wheatsheaves and a windmill*
August 1885
black crayon with grey wash
on wove paper
44 x 56 cm
Van Gogh Museum, Amsterdam
F 1319v JH 911

62 *Portrait of a woman*
end December 1885
black and red-brown crayon
and black lithographic crayon
on wove paper
51 x 39 cm
Van Gogh Museum, Amsterdam
F 1357 JH 981

63 *The discus thrower*
first half February 1886
black crayon and black crayon
with hints of brown on wove paper
56 x 44 cm
Van Gogh Museum, Amsterdam
F 1364e JH 1080

64 *Standing female nude,
seen from the side*
end January–end February 1886
pencil on wove paper
50 x 39 cm
Van Gogh Museum, Amsterdam
SD 1699 JH 1013

65 *Seated girl and Venus*
October 1886–January 1887
black crayon on laid paper
47 x 62 cm
Van Gogh Museum, Amsterdam
F 1366v JH 1044

66 Charles Blanc
Grammaire des Arts du Dessin,
Paris 1867

67 *A guinguette*
February–March 1887
pencil, pen and brush
with black ink and white crayon
on laid paper (originally blue-grey)
39 x 52 cm
Van Gogh Museum, Amsterdam
F 1407 JH 1034

68 *A guinguette*
digital reconstruction
with original paper colour

69 *Gate in the Paris ramparts*
June–September 1887
pencil, pen and brown ink,
watercolour and gouache
on wove paper
24 x 32 cm
Van Gogh Museum, Amsterdam
F 1401 JH 1284

70 Hiroshige
*A hundred views of famous places
in Edo: View of the theatre street
Saruwakacho by night*
1856–1859
colour woodcut
34 x 22 cm
Van Gogh Museum, Amsterdam

71 *Entrance to the Moulin de la Galette*
June–September 1887
pencil, pen and black ink,
watercolour and gouache
on wove paper
32 x 24 cm
Van Gogh Museum, Amsterdam
F 1406 JH 1277

72 *Shed with sunflowers*
August–September 1887
pencil, pen and brown ink,
watercolour and gouache
on wove paper
32 x 24 cm
Van Gogh Museum, Amsterdam
F 1411 JH 1305

73 *Suburb of Paris,*
seen from Montmartre
1887
gouache, crayon, pen and ink
on laid paper
39 x 53 cm
Stedelijk Museum, Amsterdam
F 1410 JH 1286

74 *Self-portraits*
January–June 1887
pencil, pen and dark brown ink
on wove paper
31 x 24 cm
Van Gogh Museum, Amsterdam
F 1378r JH 1197

75 *Landscape with path*
and pollard willows
March 1888
pencil, reed pen and brown ink
on wove paper
26 x 35 cm
Van Gogh Museum, Amsterdam
F 1499 JH 1372

76 *Sunflowers*
1887
oil on canvas
50 x 60 cm
Kunstmuseum Bern, Bern.
Donated by Prof. H.R. Hahnloser
F 376 JH 1331

77 *Still life with cabbages and onions*
autumn 1887
oil on canvas
40 x 65 cm
Van Gogh Museum, Amsterdam
F 374 JH 1338

78 *Self-portrait*
1887–1888
oil on canvas
44 x 38 cm
Van Gogh Museum, Amsterdam
F 344 JH 1353

79 *Provençal orchard*
30 March–17 April 1888
pencil, pen and reed pen
with brown ink and gouache
on laid paper
39 x 54 cm
Van Gogh Museum, Amsterdam
F 1414 JH 1385

80 *The Langlois bridge*
April 1888
pencil, pen and watercolour
on wove paper
30 x 30 cm
Private collection
F 1480 JH 1382

81 *The road to Tarascon*
with a man walking
spring/summer 1888
pencil, reed pen and ink
on wove paper
25 x 34 cm
Kunsthaus Zürich, Zürich
F 1502 JH 1492

82 *The ruins of Montmajour*
reproduction in the
1928 catalogue raisonné

83 *Landscape with path*
and pollard willows
April 1888
oil on canvas
31 x 39 cm
Private collection
F 407 JH 1402

84 *The ruins of Montmajour*
May 1888
pencil, reed pen and pen
with brown ink on laid paper
31 x 48 cm
Van Gogh Museum, Amsterdam
F 1417 JH 1434

85 *The plain of La Crau*
May 1888
reed pen and pen with ink
on laid paper
31 x 48 cm
Museum Folkwang, Essen
F 1419 JH 1430

86 *Fishing boats on the beach*
at Les Saintes-Maries-de-la-Mer
June 1888
pencil, reed pen and black ink
on wove paper
39 x 53 cm
Private collection
F 1428 JH 1458

87 *Sketch in a letter to Theo of*
28 May 1888 [617/492]
Van Gogh Museum, Amsterdam

88 *Seascape near Les Saintes-Maries-*
de-la-Mer
June 1888
oil on canvas
50 x 63 cm
Van Gogh Museum, Amsterdam
F 415 JH 1452

89 *Street in Les Saintes-Maries-de-la-Mer*
end May–beginning June 1888
pencil, reed pen and brown ink
on laid paper
30 x 47 cm
Pierpont Morgan Library,
New York, Thaw Collection
F 1434 JH 1449

90 *Cottages, Saintes-Maries-de-la-Mer*
end May–beginning June 1888
reed pen, pen and brush
with brown ink on laid paper
30 x 47 cm
Van Gogh Museum, Amsterdam
F 1437 JH 1450

91 *Three cottages, Saintes-Maries-*
de-la-Mer
end May–beginning June 1888
pencil, reed pen and brush
with brown ink on laid paper
30 x 47 cm
Van Gogh Museum, Amsterdam
F 1438 JH 1448

92 *Two cottages, Saintes-Maries-*
de-la-Mer
end May–beginning June 1888
pencil, reed pen and brown ink
on laid paper
30 x 47 cm
Pierpont Morgan Library,
New York, Private collection
F 1440 JH 1451

93 *View of Les Saintes-Maries-de-la-Mer*
end May–beginning June 1888
reed pen and pen with brown ink
on paper
43 x 60 cm
Sammlung Oskar Reinhart
am Römerholz, Winterthur
F 1439 JH 1446

94 *The harvest*
June 1888
reed pen and brown ink,
watercolour and gouache
on wove paper
48 x 60 cm
Private collection
F 1483 JH 1439

95 *Fishing boats on the beach*
at Les Saintes-Maries-de-la-Mer
June 1888
oil on canvas
65 x 82 cm
Van Gogh Museum, Amsterdam
F 413 JH 1460

96 *The harvest*
June 1888
reed pen and brown ink, pencil,
black crayon, watercolour and
gouache on laid paper
39 x 52 cm
Fogg Art Museum, Harvard
University, Cambridge.
Legs Grenville L. Winthrop
F 1484 JH 1438

97 *The harvest*
June 1888
oil on canvas
73 x 92 cm
Van Gogh Museum, Amsterdam
F 412 JH 1440

98 *The Zouave*
June 1888
oil on canvas
65 x 54 cm
Van Gogh Museum, Amsterdam
F 423 JH 1486

99 *The Zouave, seated*
20–25 June 1888
pencil, reed pen and ink (now
brown) on wove paper
49 x 61 cm
Van Gogh Museum, Amsterdam
F 1443 JH 1485

100 *The Zouave*
end July–begining August 1888
pencil, reed pen and pen
with brown ink on wove paper
32 x 24 cm
Solomon R. Guggenheim Museum,
New York. Thannhauser Collection,
Gift, Justin K. Thannhauser
F 1482a JH 1535

101 *Portrait of Joseph Roulin*
end July–beginning August 1888
pencil, reed pen and pen
with brown ink on wove paper
32 x 24 cm
Getty Center, Los Angeles
F 1458 JH 1536

102 *La mousmé*
end July–beginning August 1888
pencil, reed pen and pen
with brown ink on wove paper
31 x 24 cm
Thomas Gibson Fine Art Ltd,
London
F 1503 JH 1533

103 *View of Arles from Montmajour*
May 1888
pencil, reed pen and pen
with brown ink on wove paper
48 x 59 cm
Nasjonalgalleriet, Oslo
F 1452 JH 1437

104 *Olive trees: Montmajour*
July 1888
reed pen with brown and black ink
on wove paper
48 x 60 cm
Musée des Beaux-Arts de Tournai
F – JH Add. 3

105 *The rock of Montmajour*
 with pine trees
first half July 1888
pencil, reed pen, pen and brush
with grey and black ink
on wove paper
49 x 61 cm
Van Gogh Museum, Amsterdam
F 1447 JH 1503

106 *La Crau seen from Montmajour*
first half July 1888
pencil, reed pen and pen
with ink (now brown and black)
on wove paper
49 x 61 cm
Van Gogh Museum, Amsterdam
F 1420 JH 1501

107 *Ruins of the abbey of Montmajour*
July 1888
pencil, reed pen and pen
with brown ink on wove paper
48 x 59 cm
Rijksmuseum, Amsterdam
F 1446 JH 1504

108 *Boats on the sea, Les Saintes-*
 de-la-Mer
end July–beginning August 1888
pencil, reed pen and ink
on wove paper
24 x 32 cm
Solomon R. Guggenheim Museum,
New York. Thannhauser Collection,
Gift, Justin K. Thannhauser
F 1430a JH 1526

109 *Landscape near Montmajour*
 with train
July 1888
reed pen and pen with brown ink,
black crayon and pencil
on wove paper
49 x 61 cm
The British Museum, London
F 1424 JH 1502

110 *Wheatsheaves*
June 1888
pencil, reed pen and pen
with brown ink on wove paper
24 x 32 cm
Staatliche Museen zu Berlin,
Kupferstichkabinett, Berlin
F 1488 JH 1517

111 *Harvest in Provence*
July 1888
pencil, reed pen and pen
with brown ink on wove paper
24 x 32 cm
Staatliche Museen zu Berlin,
Kupferstichkabinett, Berlin
F 1485 JH 1540

112 *The sower*
c. 17–28 June 1888
oil on canvas
64 x 80 cm
Kröller-Müller Museum, Otterlo
F 422 JH 1470

113 *Sower with setting sun*
July 1888
reed pen and pen with brown ink
on wove paper
24 x 31 cm
Private collection
F 1442 JH 1508

114 *The Langlois bridge*
July 1888
pencil, reed pen and brown ink
on wove paper
24 x 32 cm
Los Angeles County Museum
of Art, Los Angeles. Mr. and Mrs.
George Gard de Sylva Collection
F 1471 JH 1420

115 *Hayricks near a farm*
end July–beginning August 1888
pencil, reed pen and pen
with brown ink on wove paper
24 x 31 cm
Philadelphia Museum of Art,
Philadelphia. The Samuel
S. White III and Vera White
Collection
F 1427 JH 1525

116 *A corner of a garden*
 in Place Lamartine
end July–beginning August 1888
pencil, reed pen and brown ink
on wove paper
31 x 24 cm
Private collection
F 1449 JH 1534

117 *Wheatfield with sheaves*
July–August 1888
pencil, reed pen and brown ink
on wove paper
24 x 32 cm
Private collection
F 1489 JH 1530

118 *Street in Les Saintes-Maries-*
 de-la-Mer
July 1888
pencil, reed pen and ink
on wove paper
24 x 32 cm
The Metropolitan Museum of Art,
New York
F 1435 JH 1506

119 *A corner of a garden*
in Place Lamartine
August 1888
pencil, reed pen and pen
with brown ink on wove paper
24 x 32 cm
Menil Collection, Houston
F 1451 JH 1545

120 *Boats on the sea, Les Saintes-Maries-*
de-la-Mer
August 1888
pencil, reed pen and pen
with brown ink on wove paper
24 x 32 cm
Musées royaux des Beaux-Arts
de Belgique, Brussels
F 1430b JH 1541

121 *Wheatfields with Arles*
in the background
August 1888
pencil, reed pen and brown ink
on wove paper
31 x 24 cm
J. Paul Getty Museum, Los Angeles
F 1492 JH 1544

122 *The sower*
August 1888
pencil, pen and reed pen
with brown ink on wove paper
24 x 32 cm
Van Gogh Museum, Amsterdam
F 1441 JH 1543

123 *Park on Place Lamartine*
end April–beginning May 1888
pencil, pen and reed pen
with brown ink on wove paper
26 x 35 cm
Van Gogh Museum, Amsterdam
F 1421 JH 1414

124 *Courting couples in the Voyer*
d'Argenson Park in Asnières
spring/summer 1887
oil on canvas
75 x 112 cm
Van Gogh Museum, Amsterdam
F 314 JH 1258

125 *Garden of a public baths*
beginning August 1888
pencil, reed pen and brown ink
on wove paper
61 x 49 cm
Van Gogh Museum, Amsterdam
F 1457 JH 1539

126 *Cottage*
August 1888
pencil, reed pen and pen
with brown and black ink
on wove paper
61 x 49 cm
Private collection
F 1456 JH 1537

127 *Park with fence*
second half September 1888
pencil, reed pen and brown ink
on wove paper
32 x 24 cm
Van Gogh Museum, Amsterdam
F 1477 JH 1411

128 *Bank of the Rhône*
April 1888
pencil, reed pen and ink
on laid paper
38 x 60 cm
Museum Boijmans van Beuningen,
Rotterdam
F 1472a JH 1497a

129 *Sand barges on the Rhône*
August 1888
pencil, reed pen and pen
with brown ink on wove paper
48 x 62 cm
Cooper-Hewitt National Design
Museum, New York
F 1462 JH 1556

130 *Café terrace at night*
(Place du Forum)
c. 16 September 1888
oil on canvas
81 x 65 cm
Kröller-Müller Museum, Otterlo
F 467 JH 1580

131 *Café terrace on the Place du Forum*
September 1888
pencil, reed pen and brown ink
on laid paper
62 x 47 cm
Dallas Museum of Art, Dallas.
The Wendy and Emery Reves
Collection
F 1519 JH 1579

132 *The Yellow House ('The street')*
September 1888
oil on canvas
72 x 92 cm
Van Gogh Museum, Amsterdam
F 464 JH 1589

133 *The Yellow House ('The street')*
October 1888
pencil, reed pen and brown ink,
watercolour and gouache
on laid paper
26 x 32 cm
Van Gogh Museum, Amsterdam
F 1413 JH 1591

134 *A garden in the Place Lamartine*
(Weeping tree in the grass)
May 1889
black crayon, reed pen and pen
with brown and black ink
on wove paper
49 x 61 cm
The Art Institute of Chicago,
Chicago. Don Tiffany et
Margaret Blake
F 1468 JH 1498

135 *The courtyard of the Hospital in Arles*
May 1889
pencil, reed pen, pen and brush
with brown and black ink
on laid paper
47 x 60 cm
Van Gogh Museum, Amsterdam
F 1467 JH 1688

136 *Fountain in the garden of the clinic*
last week May–first week June 1889
reed pen and pen with ink, brown
crayon, scraped, on wove paper
50 x 46 cm
Van Gogh Museum, Amsterdam
F 1531 JH 1705

137 *Pine trees in the garden of the clinic*
end May–beginning June 1889
pencil, reed pen, pen and brush
with ink on pink laid paper
62 x 48 cm
Tate, London
F 1497 JH 1852

138 *Trees and shrubs in the garden*
of the clinic
end May–beginning June 1889
black crayon, brush with diluted
oils and ink (now brown)
on wove paper
47 x 62 cm
Van Gogh Museum, Amsterdam
F 1533 JH 1710

139 *Tree with ivy in the garden*
of the clinic
last week May – first week June 1889
pencil, reed pen and brush
with ink on laid paper
62 x 47 cm
Van Gogh Museum, Amsterdam
F 1532 JH 1696

140 *Steps in the garden of the clinic*
last week May–first week June 1889
black crayon, brush with diluted
oils and ink (now brown)
on thin card
63 x 46 cm
Van Gogh Museum, Amsterdam
F 1535 JH 1713

141 *Wheatfield with reaper*
July 1889
oil on canvas
73 x 92 cm
Van Gogh Museum, Amsterdam
F 618 JH 1773

142 *Walled field*
May–June 1889
pencil on paper
25 x 33 cm
Private collection
F 1559 JH 1717

143 *Sun above the walled field*
end May–beginning June 1889
reed pen and brown ink,
black crayon and white gouache
on laid paper
47 x 57 cm
Kröller-Müller Museum, Otterlo
SD 1728 JH 1706

144 *Walled wheatfield with rising sun*
mid-November–mid-December 1889
black crayon, reed pen and pen
with brown ink on pink laid paper
47 x 62 cm
Staatliche Graphische Sammlung,
München
F 1552 JH 1863

145 *Walled field with young wheat
and rising sun*
1889
oil on canvas
71 x 90 cm
Private collection
F 737 JH 1862

146 *Cypresses*
June 1889
reed pen and pen with brown
and black ink on wove paper
62 x 47 cm
The Brooklyn Museum, New York.
Frank L. Babbott and
A. Augustus Healey Fund
F 1525 JH 1747

147 *Cypresses*
1889
oil on canvas
93 x 74 cm
The Metropolitan Museum of Art,
New York. Rogers Fund
F 613 JH 1746

148 *Trees with ivy in the garden
of the clinic*
mid-June–2 July 1889
pencil, reed pen and pen with ink
(now brown) on wove paper
62 x 47 cm
Van Gogh Museum, Amsterdam
F 1522 JH 1695

149 *Wheatfield with cypresses*
mid-June–2 July 1889
pencil, reed pen and pen with ink
(now brown) on wove paper
47 x 62 cm
Van Gogh Museum, Amsterdam
F 1538 JH 1757

150 *Starry night*
1889
oil on canvas
74 x 92 cm
The Museum of Modern Art,
New York. Acquired through
the Lillie P. Bliss Collection
F 612 JH 1731

151 *Wild vegetation*
mid-June–2 July 1889
reed pen, pen and brush with ink
(now brown) on wove paper
47 x 62 cm
Van Gogh Museum, Amsterdam
F 1542 JH 1742

152 *Entrance hall of the clinic*
September–October 1889
black crayon and brush with oils
on pink laid paper
62 x 47 cm
Van Gogh Museum, Amsterdam
F 1530 JH 1806

153 *Corridor in the clinic*
September–October 1889
black crayon and brush with oils
on pink laid paper
65 x 49 cm
The Metropolitan Museum of Art,
New York. Bequest of
Abby Aldrich Rockefeller
F 1529 JH 1808

154 *Window in the studio*
September–October 1889
black crayon and brush with oils
on pink laid paper
62 x 47 cm
Van Gogh Museum, Amsterdam
F 1528 JH 1807

155 *Interior with people eating*
1890
pencil and black crayon
on wove paper
33 x 50 cm
Van Gogh Museum, Amsterdam
F 1588 JH 1954

156 *Dead tree in the garden of the clinic*
1889–1890
pencil on wove paper
30 x 17 cm
Van Gogh Museum, Amsterdam
F 1576r JH 1817

157 *Women working in the fields*
1890
black and blue crayon
on laid paper
24 x 31 cm
Van Gogh Museum, Amsterdam
F 1615v JH 2085

158 *Man scything in a field*
1890
black crayon on laid paper
31 x 24 cm
Van Gogh Museum, Amsterdam
F 1635v JH 2086

159 *Portrait of Doctor Gachet*
June 1890
oil on canvas
67 x 57 cm
Whereabouts unknown
F 753 JH 2007

160 *Wheatfield with crows*
July 1890
oil on canvas
50 x 103 cm
Van Gogh Museum, Amsterdam
F 779 JH 2117

161 *Old vineyard with peasant woman*
20–23 May 1890
pencil, brush with oils and
watercolour on laid paper
44 x 54 cm
Van Gogh Museum, Amsterdam
F 1624 JH 1985

162 *Landscape with cottages*
c. 23 May 1890
pencil, brush with oils and
watercolour on laid paper
44 x 54 cm
Van Gogh Museum, Amsterdam
F 1640r JH 1986

163 *Landscape with bridge
over the Oise*
end May–beginning June 1890
pencil, pen and ink, brush
with gouache and oils
on pink laid paper
47 x 63 cm
Tate, London
F 1639 JH 2023

Manager of publications:
Suzanne Bogman

Coordination:
Barbara Costermans,
Tijdgeest, Ghent;
Petra Gunst,
Tijdsbeeld & Pièce Montée, Ghent

Translation:
Kate Williams

Text editing:
Michael Raeburn

Picture editing assistant:
Patricia Schuyl

Graphic design:
Griet Van Haute, Ghent

Typesetting:
Griffo, Ghent

Color separation:
Kristin Van Damme,
Tijdsbeeld & Pièce Montée, Ghent;
Die Keure, Bruges

Printing and binding:
Die Keure, Bruges

Library of Congress Cataloging-in-Publication Data
Heugten, Sjraar van.
 Van Gogh : master draughtsman /
Sjraar van Heugten, with Marije
Vellekoop and Roelie Zwikker.
 p. cm.
 Includes bibliographical references
and index.
 Published to accompany a traveling
exhibition of Van Gogh's drawings.
 ISBN 0–8109–5848–1
(hardcover : alk. paper)
 1. Gogh, Vincent van, 1853–1890—
Themes, motives. I. Vellekoop,
Marije. II. Zwikker, Roelie . III. Title.

NC263.G56A4 2005a
741.9492—dc22
 2005016911

Published in Belgium, The Netherlands
and Luxembourg as *Van Gogh
Draughtsman: The Masterpieces*
Copyright © 2005 Van Gogh
Museum, Amsterdam, and
Mercatorfonds, Brussels

© Illustrations
All photographic rights reserved by
the institutions indicated in the list of
works (see pp. 185–191) and by the
following institutions and photogra-
phers: Rászó András, ill. 40; Martina
Bienenstein, ill. 144; Cooper-Hewitt
Museum–Matt Flynn, ill. 129; The
Menil Collection, Houston–Mickey
Robertson, ill. 119; The Metropolitan
Museum of Art–Malcolm Varon, ill.
147; The Museum of Modern Art,
New York–Scala, Florence, ill. 150;
Nasjonalgalleriet, Oslo–J. Lathio, ill.
103; President and fellows of Harvard
College, ill. 96; Joseph Zehavi, ill. 89, 92.

All works in the collection of the Van
Gogh Museum are the property of the
Vincent Van Gogh Foundation, with
the exception of the drawings with F-
numbers F895 (ill. 4); F1104 (ill. 34),
F1099 (ill. 33) and F 1443 (ill. 99),
which belong to the museum.

Published in 2005 by Harry N. Abrams,
Incorporated, New York

Printed and bound in Belgium
10 9 8 7 6 5 4 3 2 1

Harry N. Abrams, Inc.
115 West 18th Street
New York, N.Y. 10011
www.abramsbooks.com

Abrams is a subsidiary of
LA MARTINIÈRE

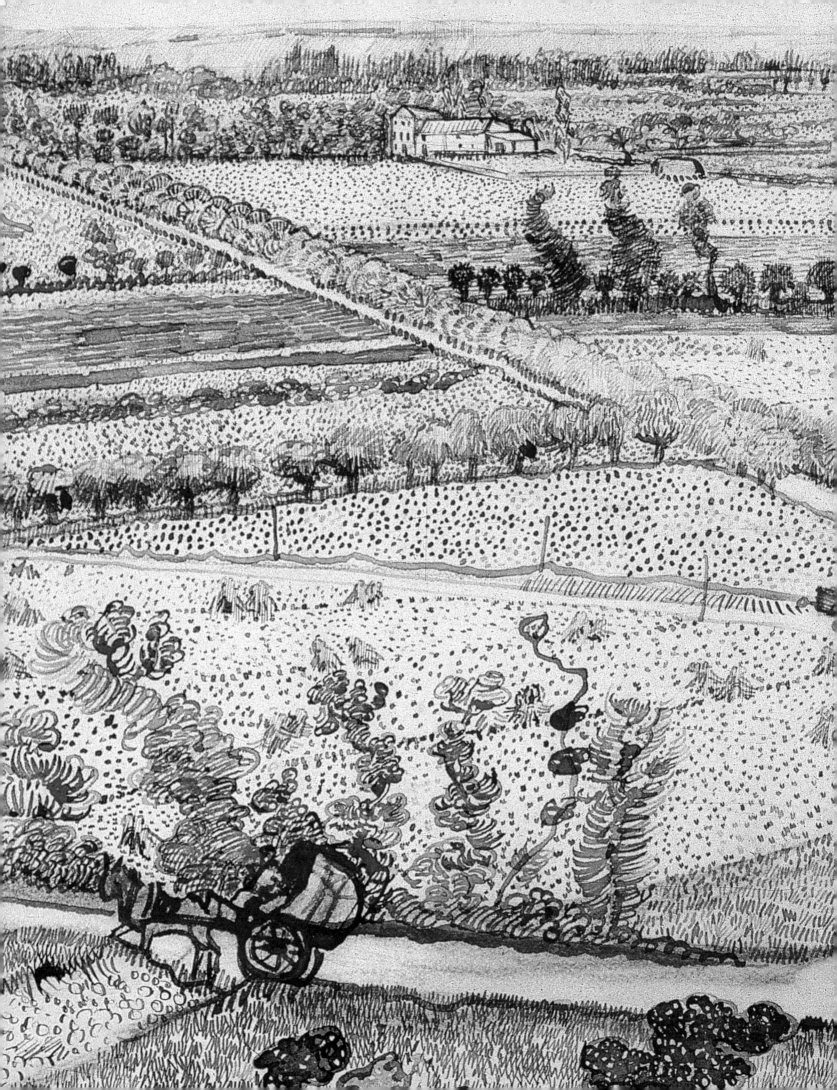